All About Acrylics

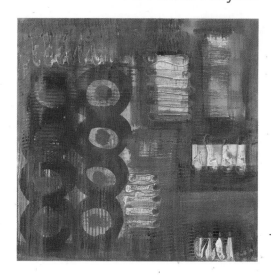

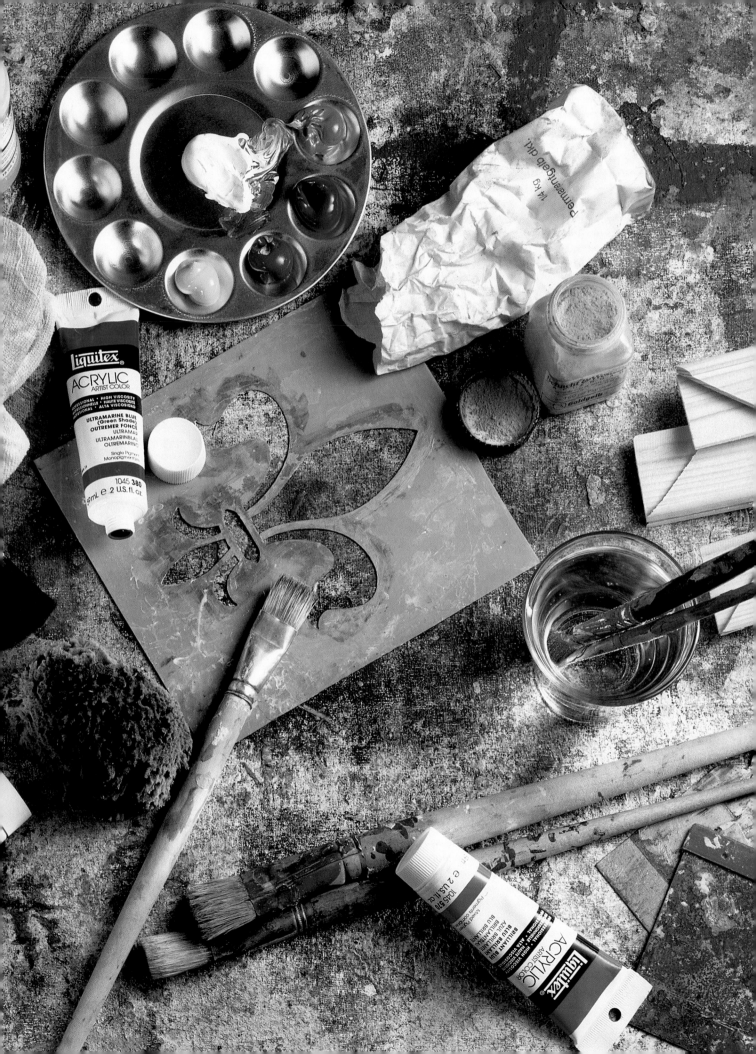

Oliver Löhr
Kristina Schaper
Ute Zander

All About Acrylics

A complete guide to painting using this versatile medium

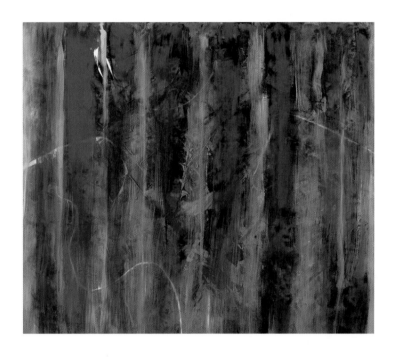

With Photographs by Stefan Boekels

Search Press

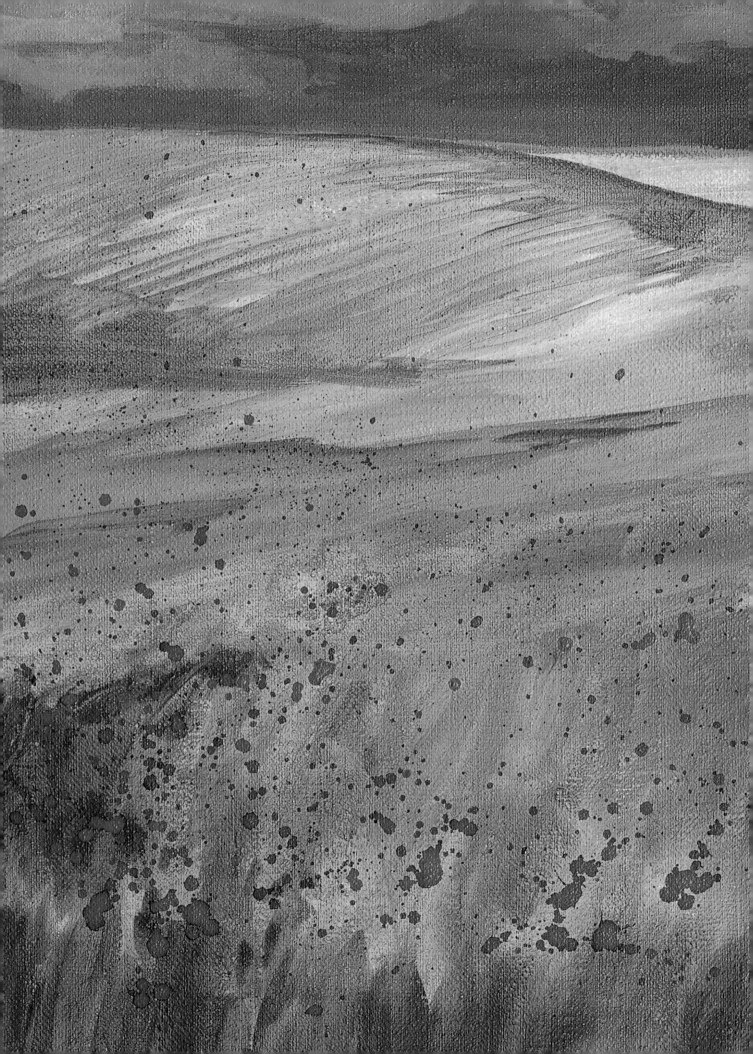

Contents

About this book

Acrylic paints have become an essential tool for artists in recent years. Their versatility in relation to a wide variety of techniques, their fast drying time and the potential for combining them with many other mediums, such as watercolours, tempera paints or pastel chalks, or using them as underpainting in oil painting, make it possible to link traditional painting techniques with experimental painting.

This book is a practical reference for both beginners who wish to familiarise themselves with acrylic paints, and more advanced artists who are looking for new ways to express themselves. Acrylic paints offer countless possibilities regardless of whether you want to try traditional or experimental painting. In this book we seek to present several techniques and to offer you a quick and easy introduction to the world of acrylic painting.

An overview of paints and how they work is followed by a comprehensive section on materials – describing all the paints and accessories, brushes and tools, as well as the many different canvas carriers, that are available. Next, a wide variety of techniques are explained, and finally we present some examples of how these are used in portraiture, still lifes and landscape painting.

Our aim is to give you a step-by-step guide to creating a painting and to offer you background theory and knowledge as and when your interest deepens. We hope that you will feel inspired to try out many new styles and techniques.

This book incorporates much personal experience from our work as fine artists as well as applied artists. We hope you enjoy reading it and developing your painting skills, and wish you every success in your artistic endeavours.

OLIVER LÖHR, KRISTINA SCHAPER, UTE ZANDER

Kristine Schaper, n. t.,
acrylic on canvas, 60 × 80cm
(23½ × 31½in).

6

Introduction and history

Acrylic paint originated in 1859, but the first paints did not become commercially available until the late 1920s. Acrylics were first used as protective coatings in industrial applications. At the beginning of the 1940s, American artists began to experiment with these paints. The search for new means of expression – especially for working on large formats – took artists out of the fashionable art styles of the time and into so-called Abstract Expressionism – experiments with paints that had different qualities from those of conventional oil paints. Artists such as the Americans Mark Rothko and Sam Francis opened up the expressive possibilities of acrylics which could not be achieved with traditional painting techniques. This was particularly because of the fast drying time of acrylics, and their potential for intense colour application and smooth glazing consistency without the risk of the surface crazing. Brushstrokes and patches of paint could also be applied next to or on top of each other without the colours running into each other.

This painting technique, much valued by abstract painters, requires a paint medium that allows a way of working spontaneously in several layers without the need for long drying periods. It took figurative artists longer to start using acrylics than the experimental abstract painters, who very quickly became familiar with this new type of paint.

Until the 1960s, figurative artists had been using oil paints almost exclusively. The first figurative artists who discovered acrylics were the exponents of Pop Art. The Englishman David Hockney, who adopted this medium after a trip to America in 1961, created a large part of his famous large-scale portraits with this technique. Other Pop Artists who painted in acrylic were the Americans Roy Lichtenstein and Andy Warhol. Both artists also used acrylic paints in printing techniques such as screen printing. Quite distinct forms of expression in acrylic paint can be found in another branch of representational art, so-called Hyper Realism or Photo Realism. Faithful depictions of nature can be achieved just as well with acrylic paints as with oils. The reason Photo Realists, such as the American Richard Estes, use only acrylics is because it enables them to work with templates and stencils.

Acrylic paint formulations were subject to constant development and improvement because of the close collaboration between paint manufacturers and painters, and the share of acrylic paints in the market for artists' materials grew steadily and is still growing today. Whereas the advantages and disadvantages of painting with the new medium were fiercely debated when acrylic paint first appeared, it is now widespread and many artists and amateur painters routinely use this fascinating medium.

Ursula Barlage, n. t.,
collage technique, acrylic on
paper, 10 × 15cm (4 × 6in).

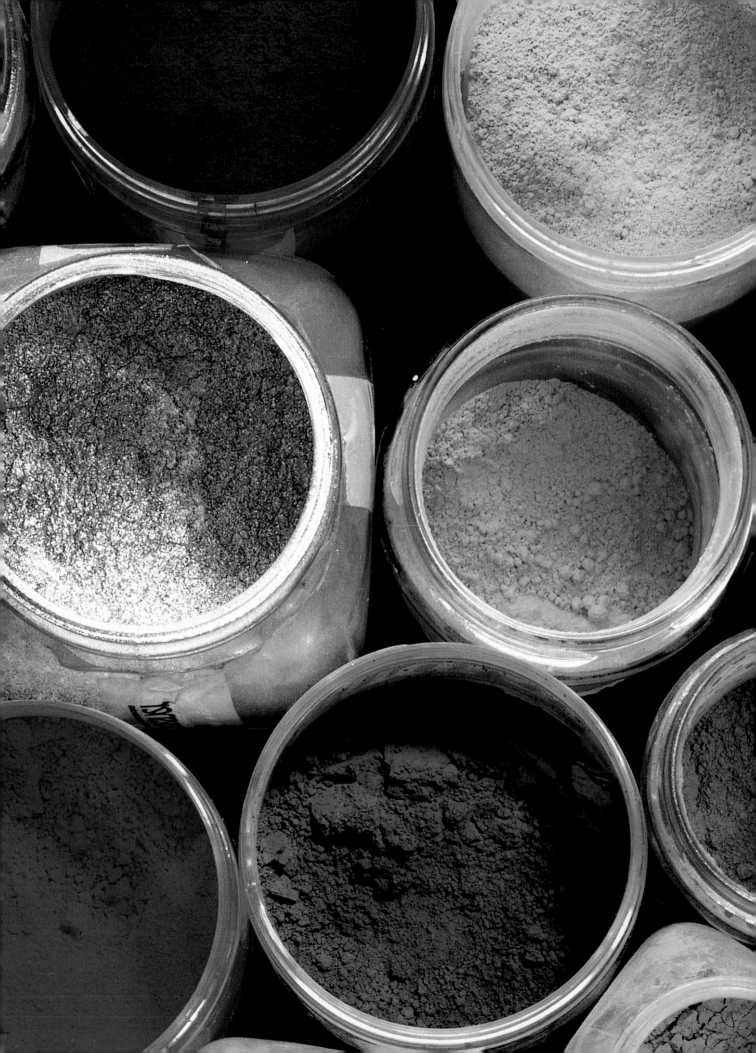

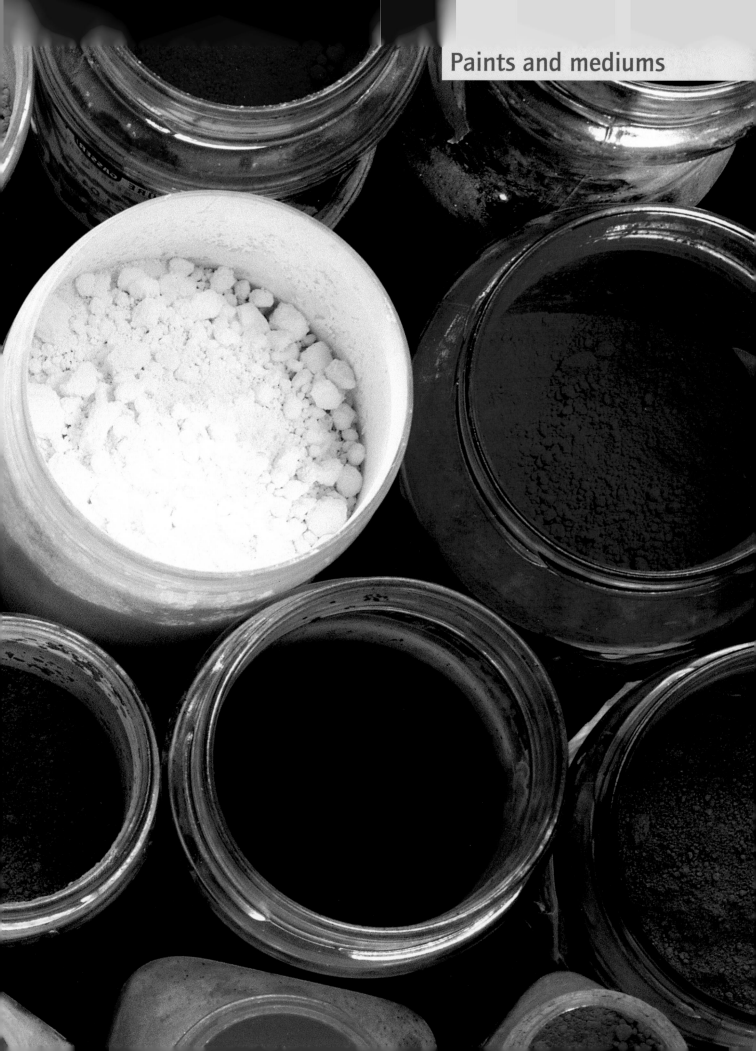

Properties of acrylic paint

The popularity of acrylic paint can be explained by its broad technical versatility yet simple application. It possesses a range of features that are important to both professionals in the fine and decorative arts and to amateur and hobby painters.

Vegetable-based oil is used as the binding agent or medium in the manufacture of oil paint; the oil dries out, however, as it absorbs oxygen from the air. This chemical drying process is an extremely slow one. Acrylic paints, by contrast, dry through the evaporation of the water contained in the binding medium. Drying times are very short, so that the paint may be dry within 10–30 minutes, depending on the thickness of the layer and its consistency. This is what makes working with acrylics so easy and efficient and enables a picture to be built up rapidly in layers.

Acrylic paint is water-based, thus dispensing with the need to use strong-smelling organic solvents, even for cleaning brushes. Unlike oil-based paints, acrylics do not become yellow, and the paint layers remain elastic so the surface does not craze like that of oil paints, which harden in the drying process and become brittle. Once dry, acrylic paint can no longer be dissolved in water so it is resistant to the influence of weather and therefore extremely durable. Acrylics can be adapted to a diversity of painting techniques, from delicate, watercolour-style colour flush to thick, brushed impasto and deep relief textures – everything is possible. Acrylic paint can invariably be used to create new and interesting effects, for example underpainting for oil painting, or in combination with other coloured mediums such as wax crayons, watercolours, pastels or gouache, or so-called window colour paints. Acrylic paint adheres to almost all types of popular painting grounds such as canvas, wood, paper and board, but also to metal, plaster and concrete, provided that these are free of dust and grease and, if necessary, are properly prepared for painting on. Acrylic paints are relatively simple to apply and a beginner can start painting straightaway – in contrast to painting in oils, where some basic technical knowledge is absolutely necessary for the success of a painting.

As versatile and as simple as handling acrylics may seem, a painter who is used to oil paints may nevertheless find them difficult to handle at first.

Because of the considerably shorter drying time, work on a picture cannot be interrupted randomly at any given moment, and each step in the process must be fully completed before moving on to the next. Breaks in your painting will be clearly visible, as any edges that have been allowed to dry can no longer be softened and blended in. Corrections can only be made by painting over the layers of paint.

The white acrylic binding medium often brightens up the more watery paint surface. Binding medium becomes transparent when it dries, with the result that many acrylic colours dry a shade darker. Acrylic paint dries with a satin sheen. In order to restore the gloss of freshly applied paint, you need to apply a final coat of gloss varnish. Because the water in acrylic paint evaporates, its volume reduces when the paint dries, in contrast to oil paints. This will sometimes have an effect on the surface textures or on the brushstroke.

Acrylic paints on the market

An extensive range of products for acrylic painting has become available over the years. Besides their paints, quite a number of manufacturers offer a great variety of painting tools, which we will cover later.

The current industrially produced paints are, in the main, of a very high quality – but there are differences which you should look out for when you buy paints. Acrylics are available in different quantities – you can buy them in tubes, bottles and jars and some types can be bought in buckets that hold several litres. Whether you decide to buy your paints in tubes, big bottles or jars depends, of course, on the size of the work you are going to create and on your personal preferences. Acrylic paints in fact have a very long shelf life, between one and two years, but they will not keep indefinitely. You need to bear this in mind when you buy. Depending on the manufacturer, paints are classified by the quality of the pigments and binding mediums used in their preparation, which shows in the paint's consistency, colour strength and opacity. Some types of paint are smooth and flow relatively well. These can be used undiluted and brushed into a smooth rendering and produce beautiful glazes when thinned with water. Other manufacturers offer paints with a very thick body which leave brush marks and create textures.

Despite having the same names, colours can sometimes turn out very differently depending on the manufacturer. Finding the hue or colour range you need to achieve your finished painting is trial and error. Paints from different manufacturers can, in principle, be mixed with each other and used in any painting. This also applies in most cases to the tools that are available. However, carry out some colour tests if you want to try out materials from a manufacturer you haven't used before. If the body of the mixed paint changes

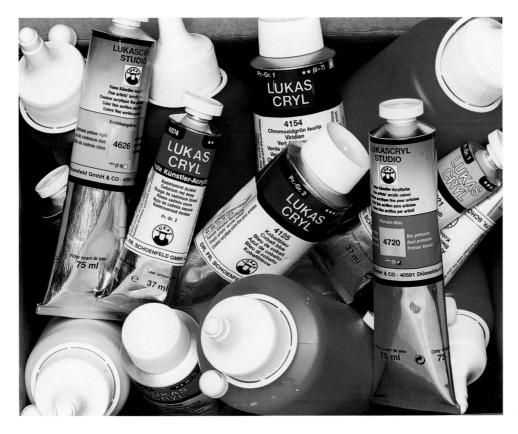

Lukascryl is artists' impasto with the maximum grade of colourfastness and brilliant glazing capabilities. Lukascryl Studio is a paint for students. It has a medium consistency that does not yellow and is highly elastic.

Akademie Acrylcolor made by Schmincke is a student paint for beginners. The range consists of forty-eight colour shades.

dramatically – for instance if lumps or flakes appear – do not use these mixtures because there is no guarantee that the paint will form a stable layer.

Many paint manufacturers sell various paint ranges. Most of the time they will have two qualities on offer: so-called student paints and professional artists' paints. Paints labelled 'Studio', 'Student' or 'Academy' usually cost less than professional artists' paints. In general, student paints contain less expensive pigments mixed with fillers. These paints have been specially developed for training purposes, for schoolchildren, students and beginners – but also for professional artists whose work requires larger quantities of paint. These acrylic paints are also eminently suitable for the execution of murals and the decorative treatment of furniture and objects. You will usually find a smaller range of colours if you buy student paints from a shop.

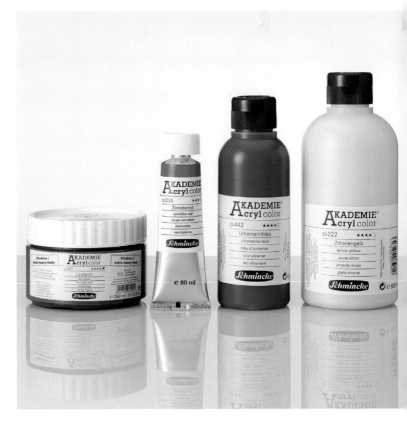

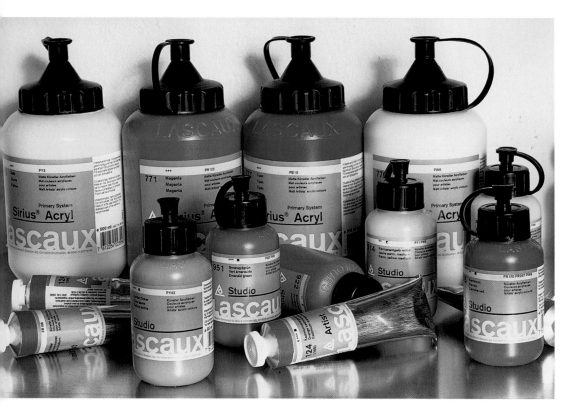

Lascaux Sirius is a highly concentrated, opaque acrylic paint, colourfast and resistant to ageing. Lascaux Studio is an artists' acrylic paint with maximum colour strength, which goes a long way in brushing out.

Professional paints are made from high-quality, finely ground pigments. The content of solids, in other words the concentration of pigment suspended in the medium, is higher in artists' paints than in student paints. That is why professional artists' paints stand out by their intense, brilliant colours which, even when heavily diluted, still create strong coloured glazes. The finer the milling of pigments the greater the covering power or opacity. Paints of a quality suitable for professional artists are more expensive than student paints; however they are essentially better value for money.

Since every painter develops his or her own preference, you should try out paints from different manufacturers to find out which products best suit your painting style.

Acrylic lacquer
The Lascaux company offers this acrylic-based watercolour paint as an enhancement to its traditional acrylic paint range. It is the finest pigmented paint, which dries quickly in thin, water-resistant layers so the dried colour layers can be painted over. The paint can still be washed out and remains soluble on the palette. Acrylic paints consist of a water-soluble acrylic resin and highly colourfast pigments.

Liquid acrylic paints (airbrush acrylics)
These acrylic paints have been specially developed for use with airbrushes and are highly concentrated. They are made with finely ground pigments to prevent blocking sensitive airbrushes. Using a very thin layer of paint will create bright tones. These paints can be applied with a brush in a watercolour style or worked with drawing pens. Airbrush paints are generally sold in eyedropper bottles, making it easy to measure the required quantity.

Acrylic lacquer
Acrylic lacquers are a special type of acrylic paint. The binding medium content is very high with acrylic lacquers, giving them a viscous but runny consistency. They are available from builders' suppliers and specialised art shops. The colour range is generally not that extensive, but it is possible to have specific colours mixed for you. Acrylic lacquers are particularly useful for experimental painting techniques, which we will look at separately later.

Emulsion paints (wall paint)
Full colour and tinting paints are also available from builders' merchants. In our view, it is advisable to make use of these economical emulsion paints in a painting only under certain conditions. The binding medium in emulsion paints is designed to smooth out into an even coat when applied with a roller. Because of these excellent flow properties, this dispersion-type paint leaves hardly any brush marks in a picture. Furthermore, crazing can occur with very thick impasto applications since wall paints do not dry with the same elasticity as acrylic artists' paints. Because of the relatively high proportion of white pigments, opacity also increases in thin paint layers. The consequence is that the paint has a far lower intensity than paints developed for artists.

The right choice of paint
If you want to buy a selection of colours and you are not sure which colours to choose, we have compiled a list for you here. It is a great temptation for a beginner to buy too many colours. Start first with a small selection. This will not only save you money, but will also have a significant effect on your progress.

The more colours you have to create that are not yet on your palette, the more you will find out over time about the way paint works and what it consists of. There is a multiplicity of beautiful colours and shades that you cannot buy as ready-made paint in shops.

Suggestion for a small colour palette
In theory, all colours can be mixed from the three primary colours: yellow, red and blue. However, in practice this is impossible because the mixed colours come out quite differently, depending on the colours you started with. You can, in any case, familiarise yourself with acrylic paints with the help of these hues, while at the same time acquiring the broadest possible colour range at a relatively low cost. You also need black and white to shade colours, to make them darker or lighter.

Cadmium yellow Magenta Cyan

Paints in the Studio Paintbox 3902 by Lascaux: yellow ochre, permanent medium yellow, lemon yellow, English red, vermilion, crimson, oxide black, dark ultramarine, cobalt, titanium white, permanent light green, emerald.

Suggestion for a medium-sized colour palette
So that you can create a wider colour range when mixing, you are advised to obtain the three primary colours in two versions: a cool and a warm yellow, red and blue. That gives you cool and warmer greens as well as brown shades with black and white. Many manufacturers have starter sets that contain a similar selection.

Every painter will, in time, arrive at his or her own individual palette. That depends of course on personal preference, but also on the particular subjects that are painted. For instance, in landscape painting the colours you need are a little different from those in portraits, whereas in abstract painting a multitude of bold colours can be adjacent to each other in stark contrast, and in figurative art the palette instead consists of a selection of tones that harmonise within a picture.

Special-effect paints

Besides the traditional colours, artists' material suppliers have also introduced special-effect paints. Iridescent paints contain pearlescent pigments that give the surface a lustrous, shimmering appearance. These are particularly effective against a dark background. Iridescent acrylic paints can be applied on their own or in combination with standard paints. They can also be used with texture gels and other mediums. Fluorescent, or 'neon', colours originally came from

Lascaux offers sixteen different iridescent colours under the name of Perlacryl.

the field of industrial paints. Used sparingly, both iridescent and fluorescent paints can produce interesting effects.

Ingredients of acrylic paint

Artists' paints consist in principle of three ingredients: the solvent, the binding medium and the colourant. Industrially produced paints also contain a range of additives, for example fillers to prevent decay.

Solvents

Solvents are the liquids that dilute or dissolve the binding agent or the medium and that evaporate from the paints in the drying process. In the case of acrylic paints, the solvent is simply water.

Binding medium

In paints, the binding medium, also called the binder, has the job of binding the particles of pigment together and bonding them to the substrate. The consistency or viscosity of the binding medium for a large part determines the properties of the paint, for example its flexibility, its adhesion, its miscibility and its resistance to water when dried.

Acrylic binding mediums are available in various qualities in the trade. Mediums consist basically of a high concentration of microscopically small polymer resin particles dispersed in water. Such liquids that have particles

distributed throughout are generically called dispersions. The water component evaporates in the drying process so the medium loses a little of its mass. This binds the particles more closely together so they bond into a stable, flexible film that cannot be dissolved by water.

The viscosity of the binder medium depends on the amount and size of the plastic particles. The finer the particles in the acrylic binding medium, the more transparent and fluid the medium becomes. This imparts the typical bluish lustre of acrylic varnish. Coarser acrylic dispersions are whiter and have a more viscous body.

Colourants

Any colouring substance can be used as a colourant. Colourants can be divided into two sub-groups: colouring substances and pigments.

Colouring substances

These are derived from organic substances and dissolve with the viscosity required for the application. They are commonly used for dyeing textiles or wood as well as for dyeing leather, paper, plastics and foodstuffs.

Pigments

Pigments are small, practically insoluble, solid particles. They are traded in powder form and are the actual colour medium in the manufacture of artists' paints. Artists nowadays have a multiplicity of chromatic and achromatic pigments at their disposal. Professional art restorers are able to draw on the entire spectrum of pigments used throughout history, but some have been replaced because of their cost or for health and safety reasons.

The various pigments have their own features which, like binding mediums, determine the particular painterly properties of the paint, namely the covering power and colour strength of a pigment.

The covering power, or opacity, of a paint is the capacity to conceal the colour of the ground it is painted on. Among other things, opacity is determined by the shape of the pigment particles, their crystalline structure and other specific properties of that particular substance. The colour strength of a pigment is its capacity to alter another colour. Pigments can produce powerful stains and dyes. Only very small amounts of strong colourant pigments are needed for mixing. Larger amounts of other pigments may be needed to modify a colour.

If you would like more comprehensive information about the origins, extraction and special properties of particular pigments, then we recommend that you ask for the technical product specification sheet of the relevant manufacturer or refer to the specialised literature.

Pigments can be divided into two groups: organic pigments are those that have a vegetable or animal origin; inorganic pigments come from mineral sources. A further distinction is made in both groups between natural and man-made pigments.

This division of pigments indicates their constituent elements but does not tell us about their other properties, such as their quality or associated health risks. Natural pigments are not necessarily superior to their artificially compounded equivalents.

Natural inorganic pigments

A distinction can be made within directly extracted inorganic pigments between earth colours and mineral colours. Ever since humans have used colour for painting images or for camouflage, they have known about earth colours. The composition of these paints has remained essentially the same to the present day; only the nature and method of their extraction and processing have changed. This mainly involves clay and chalk soils, which are coloured by bonding iron and manganese in a weathering or oxidising process. The colours are often named after their place of origin. Some types are ochre, Sienna red, umber, green earth, Veronese green, Naples yellow, graphite, slate black, chalk, calcite, mica and quartz. Besides the earth colours, smaller colour minerals milled to a fine powder are used in colour compounds, for example azurite, malachite or lapis lazuli.

Synthetic inorganic pigments

Besides natural inorganic paints, colours have also been artificially made since antiquity. These were mostly achieved with metal compounds such as lead white or lead oxides. Vermilion was made from mercury and sulphur, and verdigris was also used in painting. Pigments obtained in these ways are only used by restorers today. These paints are no longer in general use because they are harmful to health.

The chemical industry has constantly pushed development in paint manufacturing, and today's painters have many paints at their disposal whose lightfastness is substantially better than before. Other synthetic inorganic pigments include white zinc, titanium dioxide, blanc-fixe, chrome yellow, zinc yellow, viridian, iron oxide red and ultramarine, the modern replacement for lapis lazuli.

Natural organic pigments

Few of the colours that were previously derived from plants and animals in large quantities are well known. Many of the pigments used since the late Middle Ages have been replaced by identical or similar pigmented substances. Plant pigments used to be extracted from berries, coloured woods and barks, roots or flowers. Indigo and madder are examples of these pigments. Carmine from the cochineal insect and Tyrian purple from murex sea snails are pigments that derive from animals. The colour sepia was originally made from the ink squirted out by squids. Indian yellow was derived from the urine of cows

that were fed on mango leaves. These kinds of pigments are all produced synthetically these days.

Synthetic organic pigments

Most synthetic pigments of organic origin are created from processes involving coal tar and petroleum. Pigments were constantly improved as the complicated production process was modernised, with the result that it was possible to replace some natural organic pigments and colours, such as Indian yellow and madder. Other synthetic organic pigments include alizarin, phthalo blue, phthalo green and quinacridone.

Effect pigments

As well as pigments there is also a whole range of so-called effect pigments with special properties.

Metal effect pigments

These are sold as so-called powdered bronze and consist of aluminium powder or powdered zinc–copper alloys, where the proportion of zinc determines the colour (e.g. bronze gold, pale gold, sovereign gold, etc.).

All such bronze golds are subject to environmental influences – they will oxidise, because they are made from base metals. It is therefore necessary to seal works where bronze gold has been used.

Pearlescent pigments (fish silver)

Paints that contain pearlescent pigments will create a surface that shimmers like mussel shells, pearls or fish scales. Because the pigments are themselves transparent, this iridescence is achieved by incident light, which is refracted many times by the layers of pigment flakes. The type of colour that is created depends on the thickness of the flakes. Interference pigments are those where the colouring only derives from the refraction of light. Paints with an iridescent effect are generally mixed with a particular colourant to ensure a single unambiguous colour.

Luminescent pigments

'Neon' pigments shine under ultraviolet (UV) light because they absorb UV rays and turn them into light with longer waves in their own inherent colour. They are considerably less lightfast than non-fluorescent pigments of the same colour. For this reason they should not be used in works of art that need to be preserved for a long time.

Making your own acrylic paints

If you decide to mix paints yourself, you may be able to produce larger quantities at a relatively low price. Using high-quality pigments will give you brilliant, bright hues.

In the case of self-mixed paints, the individual hues will display different consistencies and covering power because the various pigments have distinct properties when they combine with water and binders. Industrial paints produced in series are optimised by the manufacturer with regard to the ratios between binder and pigment or pigment and filler, which means that uniform consistency or uniform covering power is guaranteed for so-called student paints.

It is certainly not possible to maintain consistently identical qualities when mixing paints yourself, but after gaining some experience you will be in a position to create individual paints that meet your own requirements.

If you mix your own paints, make sure that you do not breathe in any paint dust. Although most types of pigment are not generally harmful to your health, it is best to mix paints in the open air or to wear a ventilation mask. Very light substances such as bronze golds will be released into the air if you agitate them too vigorously. Once the pigment particles are wet you can work with them without risk.

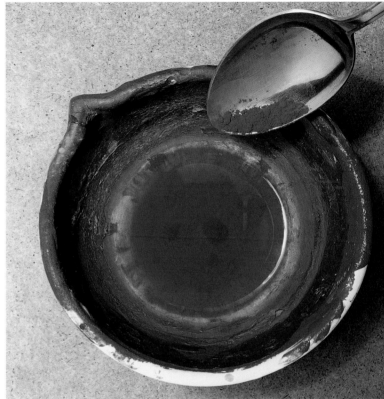

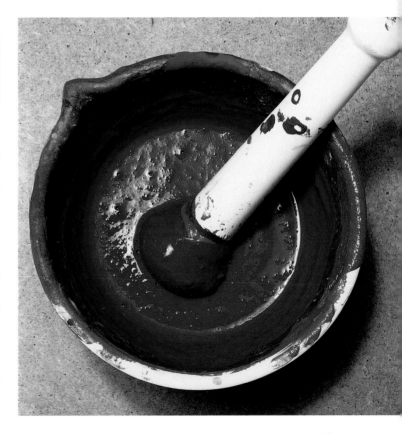

Materials

Pigments, acrylic binding medium, water,
mortar and pestle, spoon, glass container with lid

Step 1

Pour some water into a mixing bowl and gently sprinkle in the pigment powder. For pigments with a low density, add a couple of drops of methylated spirits to help reduce the surface tension of the water. Stir the pigment with the water to create a more creamy paint. Make sure you smooth out any lumps. Metallic pigments cannot absorb water so they must be stirred directly into a lightly thinned binding medium. There are some metallic pigments on the market that come ready mixed with binding medium.

The easiest way to stir acrylic paints is with a plastic pestle, which you can find in kitchen supplies shops. When using containers with a flat base, pigments might form lumps and the water cannot mix with them. It is best to take your time mixing paint to ensure the pigment absorbs the water.

Step 2

Add the acrylic binding medium. Most self-mixed paints will dry to a smudge-proof finish with a mixing ratio of two parts paint preparation to one part binding medium.

To make sure that sufficient binding medium has been added to the paint, you should perform a drying test. Brush a little paint on to a piece of paper and rub over the surface after the paint has dried (you can use a hairdryer to speed up the drying process). If the paint leaves traces on your hands you need to add more binder until the paint dries smudge-free.

Step 3

Pour the self-mixed paints into jars or tins and close them tightly. If you like working with tubes of paint, you can fill up empty tubes – which are available from larger shops – with your self-mixed paints.

These paints have a shelf life of only a few weeks, because the water will become putrid and the paints then become unusable. It is possible to increase the storage time for paints by using distilled water as well as high-quality binders (e.g. acrylic binder from Lascaux); the latter includes substances that slow down the paint's decomposition.

Mediums and modifiers

The products for painting with acrylics that have made the most impact on the market in recent years are mediums or modifiers.

It is possible to influence the consistency and the technical painting properties of acrylic paints with different mediums and other ingredients, which open up new possibilities for artistic expression.

Most manufacturers offer a varied range of additional resources along with their paint systems. The most important thing is that the products of different manufacturers can be mixed, just as with paints. Nonetheless it is necessary to do a test before making use of such substances in a painting.

The Liquitex company offers a very varied range of mediums.

Structure pastes by Nerchau in different package sizes.

Retarders

Acrylic paints dry because the water in them evaporates. The drying time depends on the room temperature, the absorbency of the ground and the degree of dilution. By adding retarders it is possible to work on acrylic paints for longer. It is advisable to make use of retarders if you are using a wet-in-wet technique or working with colour gradations. Retarders can also be used when applying paint in a watercolour style to keep the larger colour areas open for longer – but you should remember that the retarding effect will decrease the more you dilute the paint.

Thickening agents

Adding thickening agents will give liquid paint a more 'toothy' consistency. The paint can then be easily worked using an artist's knife or applied as a brushed impasto. There are also matt thickeners available that do not change the colour of the paint.

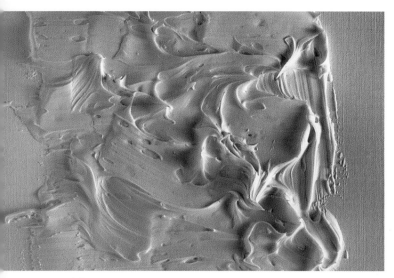

Light structure paste.

Fine sand structure paste.

Coarse sand structure paste.

Modelling pastes

Modelling pastes are light grey or white acrylic pastes, which are excellent for working with spatulas, collages and reliefs. They can be mixed or coloured with sand or other additives.

Some makers offer pastes that are already mixed with sand of varying coarseness. Most modelling pastes contain a large amount of solids and so shrink very little when they dry. Yet, if they are built up in several thin layers they remain flexible. Various materials such as wood, metal or glass particles, fabrics or stones can be embedded directly in the paste because it is a highly adhesive force. These pastes are suitable for repairing cracks or filling in pits in heavy impasto work. The additives and their consistency in the structural mass vary according to the manufacturer. The paste can be painted over or sanded once dry, which can take several hours, depending on the thickness of the layer.

Black lava

This unusual structure gel contains small, black, hexagonal plastic particles. After they dry they look like black, milled lava sand. This product looks very good when combined with watery painting techniques.

Light texture pastes

These pure white acrylic pastes are just as good for working up into strong three-dimensional picture elements as modelling pastes. They weigh very little and are therefore optimal for using on lighter painting grounds. After they

Black lava.

Modelling paste.

Clear paste with sand.

dry, these pastes form a hard elastic layer, which is age-resistant and lightfast, according to the manufacturers. Light texture paste can be mixed with paint, although this is not strongly recommended because it will lose its special light consistency. Once it is dry it can be painted over. In particular, translucent paint will create interesting effects on surfaces with light texture pastes.

Clear texture gels

In addition to white texture pastes there are also gels available that will dry transparently. They are particularly suitable for collages, which often include heavy elements, due to their highly adhesive nature. Their transparency preserves the character of the elements used for the collage. For this reason they are also suitable as a coating for finished acrylic pictures. (But they are not a substitute for varnish!) There are glossy and matt-drying clear gels, all of which can be mixed with acrylic paints or pigments. The paint manufacturer Liquitex offers gels that have a whole range of additional substances added to them (e.g. natural or resin sand, mixed fibres, glass balls or white opaque flakes), which will create very varied effects.

All of the mediums described above are based on acrylic and are therefore water-soluble, so you can clean brushes and tools in the usual way.

Such additional agents should be thinned only to a limited degree, otherwise they will not be effective and their properties will be lost.

Other texturing pastes

Some painters work with materials from builders' suppliers, such as plaster, polyester filler, roughcast, acrylic grouting or polystyrene glue. Such materials are often far cheaper than products specially developed for artists.

If you want to experiment with texturing products that do not dry elastically, you should work using rigid supports, such as plywood or MDF panels, to ensure that the relief does not peel off and to prevent cracking. It is advisable to test such materials to ensure that they are sound before using them in a painting, to avoid unpleasant surprises.

Matt/gloss acrylic mediums

The addition of these mediums will either increase or decrease the gloss of the paint when it dries. Adding mediums will also usually improve the paint flow.

Acrylic mediums

Acrylic mediums on sale in shops are usually pure acrylate emulsions, namely very high-quality acrylic binders. Naturally, water is the most commonly used medium and thinner in acrylic painting. Most acrylic paints are very highly saturated, so that even the weakest dilutions will be waterproof when dry.

The addition of mediums to paint will improve their adhesion to difficult, very smooth grounds. Mediums will also improve the binding of the pigments when it comes to glazes. In general, cheaper, less concentrated paints can be improved with the addition of mediums.

Varnishes

A varnish is a protective layer applied to a painting when it is finished and the paint is completely dry. Varnishes provide a glossy or satin finish that gives the picture more cohesion, intensifies the brilliance of the colours and gives the picture greater depth. Varnish also protects artwork from dirt and environmental influences. Some varnishes include a special UV filter to protect against fading caused by sunlight. Although acrylic paints are very robust and most can be wiped with a damp rag without any problem, it is still best to varnish particularly successful pictures or those intended for sale. A high-quality varnish can be removed and replaced if need be. For this reason acrylic binders or clear pastes should not be used as a substitute for varnish, because they will absorb dirt in the same way as these paints would, and it is virtually impossible to remove them later. Varnishes can be obtained from shops in spray cans or in bottles.

Once you have removed any dust or grease, you can spray or brush on a layer of varnish in one direction only. When the first layer has dried you can add another layer at right angles to the first one. Allow the picture to dry in a horizontal position and protect it from dust and hair.

Fillers

To reinforce or vary textures add various substances to modelling and texture pastes or to paints. Adding sand is a natural means of reinforcing the consistency. Sand is available in various grades and colours. The easiest one to obtain is bird sand from a pet shop, but building or quartz sand are also easy to work with. You can achieve interesting surfaces by sprinkling sand into wet paint or by applying it in combination with modelling paste using a painting knife. The immense adhesive power of texture and modelling pastes make it possible to incorporate larger items, such as granulates, stones, shells, woodchips or pearls. If you are going to embed heavy items into a collage, which will considerably increase the weight of the paint layers, you should use rigid supports such as wood. A stretched canvas could sag and paper would break. To reduce drying times and prevent cracking it is advisable to build up heavy textures in several thin layers and let them dry in between.

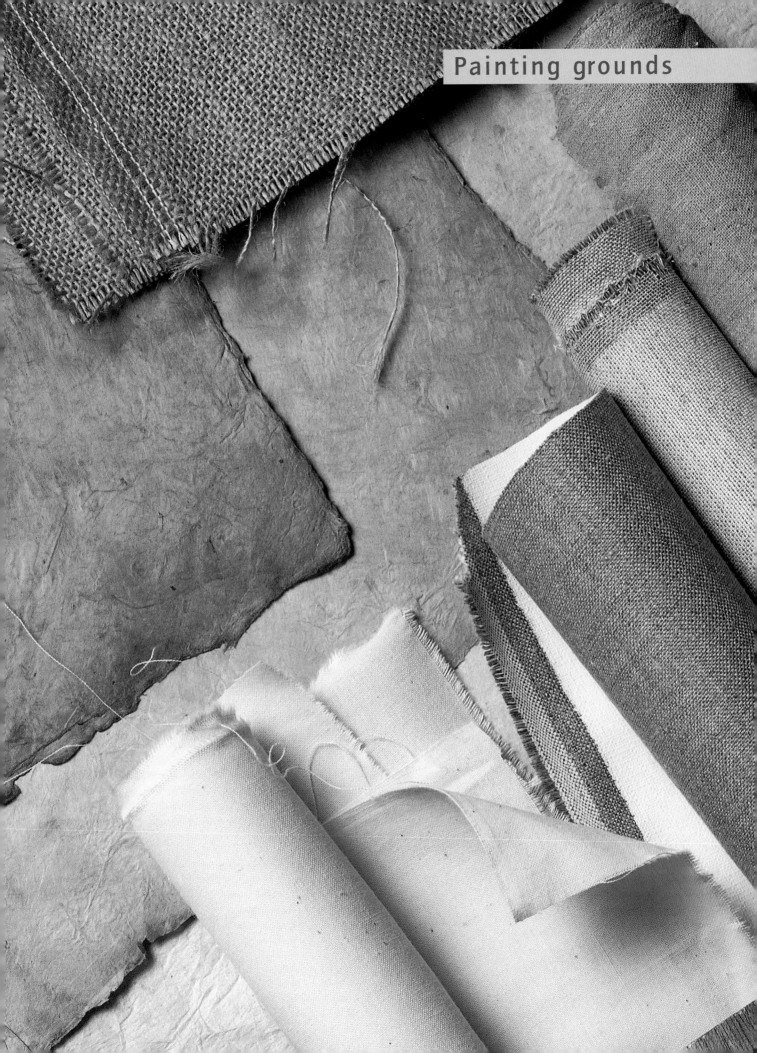

The ground is very important and needs to be adjusted to suit the technique you are using. Not every ground is suitable for every technique. Just as when you select paint and mediums, you should pay attention to quality if you are going to buy or make your own grounds.

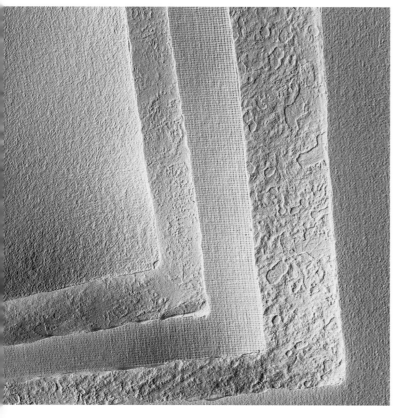

Paper

Paper is an excellent surface for acrylic paints. It is inexpensive and suitable for many techniques. Basically, acrylic paints can be applied to virtually any type of paper. The only exception is paper for oil painting; acrylics will not adhere to this very well because of the special surface treatment. Acrylic paint

contains water, and paper tends to stretch and curl in contact with water. The thinner the paper the more it will distort when you paint on it. To prevent it from curling it is necessary to stretch paper with a weight of less than 400g/m^2 (14oz/ft^2) on a wooden board. To do this you should dampen the sheet of paper on both sides (preferably with a sponge) so the paper can absorb water. Heavy paper can be held directly under running water. Leave the sheet of paper lying down for a while until it is evenly damp and no longer swells. Lay the paper on a wooden board and fix the edges on all sides with adhesive tape. The paper will shrink during the drying process and will tension itself flat again. You can also glue paper to a stretched canvas. For this you need to apply an acrylic binder to both the canvas and the dampened paper and then glue the paper to the canvas. Once everything is dry you can start your painting. Even very thin or highly textured paper, packaging or wallpaper can be turned into an interesting ground like this.

Acrylic painting paper

Some papers that have been specially designed for acrylic painting include a barrier layer which makes them exceptionally robust. A special cell structure gives these papers additional stability so they are suitable for executing painting techniques with a high mechanical load. These papers are generally available as pads in different formats. The special surface of these papers allows for both thin translucent painting and also working with fillers and other modifiers. Although most pads are glued at the edges, the sheets should be torn off and a seal applied if you are going to apply very diluted paints. Some manufacturers offer paper with a linen pattern – the surface of the paper resembles linen canvas. Ask your supplier to find the right paper for your needs.

The acrylic and oil/acrylic pads sold by Schleicher & Schuell are – like all products from this manufacturer – acid-free and exceptionally age-resistant.

Watercolour paper

Specialist suppliers offer a large range of watercolour papers with differing thicknesses and surfaces. These papers are best suited for acrylic painting. The paper structure is particularly good for watercolour techniques. The varying surface characteristics of these papers depend on their different 'tooth'. They are available in different formats as single sheets, in pads or as a roll. The makers' information and different labels, such as 'chlorine-free' or 'wood-free', tell you that these papers are lightfast and age-resistant and are made using environmentally friendly methods. The label 'genuine laid paper' refers to a particular manufacturing process. These papers are either handmade or have been made using a particular type of round sieve. These high-quality papers display a typical uncut deckle edge.

Ecopaper/specialist papers

Deckle-edged paper is mainly made from the inner bark of the Lokta or Daphne bush, which has been the main raw material in paper-making for centuries. The bark is harvested without killing the plants, preserving the ecological balance. The paper's purity is guaranteed because it is produced at an altitude of 2000m (6562ft) and only spring water is used. All these papers are dried in the sun, acid-free and unbleached. This type of paper is unusually resistant to tearing. The natural production method prevents mould and insect attack as well as rotting. For this reason it is particularly suitable for valuable scrolls and documents.

This paper has a variety of uses. Natural paper is good for painting and calligraphy, for binding books and also for prints and collages.

A selection from the Elke Oppek uncoated papers range.

Prepared painting boards

Painting cards and paperboards are made of card or pressboard and are laminated with linen, cotton cloth or paper with linen texture. These types of board are limited to glazing techniques because moisture makes them warp.

Cracks sometimes form when working with modelling paste in thicker layers because the substrate distorts. Painting card is generally somewhat cheaper than ready-stretched canvas.

Wood

Wood has been a traditional painting substrate for centuries. Wood is also very suitable for acrylic paints. It is preferable to use hardboard, waterproof marine plywood, coreboard or MDF board because high-quality wooden boards have to be seasoned for a long time to prevent warping. You can obtain these cut to size from a wood merchant. Wood supports generally need to be primed on both sides because they are very absorbent and will warp if they are painted only on one side. It is best to treat wood with very open pores with a special primer on both sides. Depending on the type of wood, it may be necessary to sand the surface after applying the first primer and then apply the second primer to smooth it out.

Cardboard

Solid boards with a relatively closed surface, such as mount board, presentation board or illustration board are suitable for acrylic painting. It is also possible to use the reverse of drawing pads and calendars as well as packaging materials (except for corrugated board). A gesso primer is useful for very absorbent card, such as grey cardboard, as this makes it easier to apply the paint. It may be useful to dampen the reverse of the board to prevent it from curling.

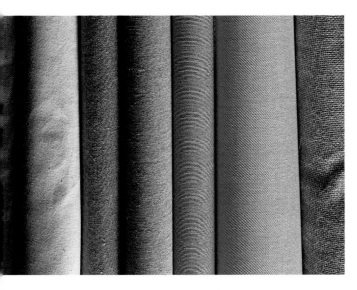

Artists' canvas

Woven linen cloth or artists' canvas are – next to paper – the most common materials for painting on. Professionally stretched and primed, canvasses are tight, but retain a little elasticity. There is a wide selection of woven material available in shops. These come in rolls or per metre piece, raw or primed. Pure linen is a very high-quality painting cloth, and with a fine, regular texture it is very stable. The finer the quality, the tighter and less grainy the weave of the linen. Cotton and cotton mixes are very suitable, less expensive alternatives, and are very popular with amateur painters. Hessian is a cheaper and very coarse cloth, which must be very carefully primed. Choosing which grain of cloth to use depends on the nature of the picture you are going to paint. If you use powerful brushstrokes, a cloth with a coarse weave can be very appropriate, but for gentle, detailed brushwork, a smooth and finely woven cloth is best. The cloth you choose will also depend on the size of your painting. Too coarse a weave can dominate a small painting and distract from the picture.

Pre-stretched canvasses

If you do not have time to stretch your own canvasses, you can buy them pre-stretched and primed. They are available in standard sizes and a range of cloths. Bespoke sizes are always available on request from professional suppliers. Be sure to check that the tensioning is accurate and ensure the stretcher bars and frame are not warped. Acrylic paints do not always adhere well to primers intended for oil paints, so be sure to buy stretchers that are primed for acrylic paint.

Stretching your own canvas

You can make your own painting grounds by stretching a canvas yourself. This may be an inexpensive alternative to buying ready-made stretchers and you have the advantage of being able to make stretchers in any size you like.

Tools

Stapler, hammer, screwdriver, pliers, set square, scissors and possibly an electric staple gun

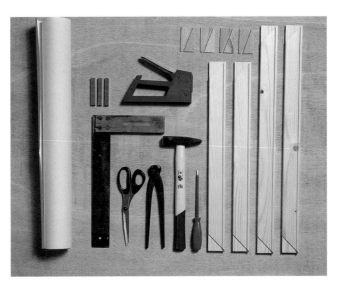

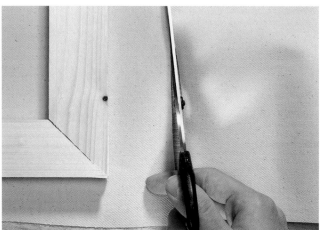

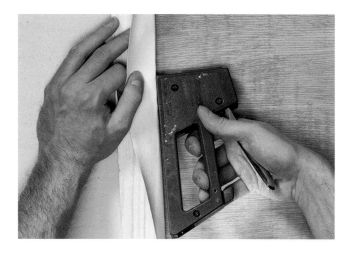

The staples need to be about 6–8mm (¼in). Stretcher bars are available in many sizes and have rounded front edges over which the canvas is stretched, to prevent the frame from pressing through the canvas when you paint.

Make sure that you buy seasoned wood and not freshly cut timber which will warp with heat and damp. It is also essential to make sure that the bars are parallel to one another. Place the bars next to each other and if there are any gaps, the bars are not suitable for what you need. A stretcher frame with warped bars would not lay flat against a wall.

If your frame exceeds 1 × 1m (39¼ × 39¼in) you will need a cross brace and additional bars to stabilise the frame to ensure that the longer sides of the frame do not bend. For very large canvasses you will need several cross braces; ask a professional for advice. Do not forget to buy wooden wedges to reinforce the frame; this will give you a tight surface, which is easier to work on.

First, put the bars together – you may need to use a hammer for this. Check that the frame is at right angles – this is particularly important with large frames – you can use a set square to do this or measure the diagonals. A straight door frame can also be used to check the angles. Now you need to cut and fit the canvas to size. The canvas must be at least 5–10cm (2–4in) longer on each side than the wooden frame. Place the canvas with the side you want to work on face down on a flat surface and put the completed stretcher frame on top of the canvas with the front side down. Pull the canvas around the stretcher and fix a staple in the middle of each bar. The four staples are intended to hold the cloth temporarily.

Now we come to the actual stretching. Stretch the cloth in the direction of the corners of the frame and fix the staples diagonally in the frame, preferably while keeping the canvas under tension. Start in the middle of the bars and work towards the corners. To ensure equal tension across the canvas, work first on one side and then the opposite side. The distance between the staples should be approximately 8cm (3¼in). Remove the temporary staples from each side and fix new ones to stretch this spot. It is easy to gently lever out the staples with a screwdriver and once they are loose you can remove them with pliers.

Now stretch the canvas further on the other two sides, paying close attention to the equal distribution of the staples.

Once all sides are stretched, fold the corners of the canvas inwards and fix these under tension with at least two staples. You should be careful that the gap at the corner where the stretcher bars come together is not fixed with a staple, otherwise it will not be possible to use wedges to stretch the canvas further.

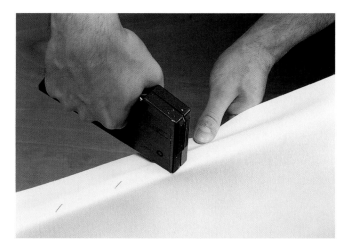

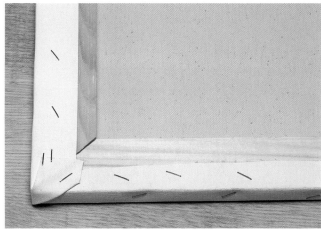

Ease the canvas over the edge at the back of the stretcher frame and fix it with staples. These staples must always be inserted at equal distances to even out the tension across the canvas and prevent the edges from ripping.

Next the wedges are inserted into the frame. Every stretcher frame needs eight wedges, two for each corner. These can be carefully tapped into their slots with a hammer. Place one wedge per side in order to ensure even tension from the centre of the canvas. If the canvas is still not tensioned sufficiently tightly or there are still a few wrinkles, brush some water on the back in that area. It will then pull smooth in most cases.

Priming the canvas
Canvas, wooden board, paper and cardboard can be primed with a base coat of acrylic primer. The picture surface must be primed at least twice so that a smooth painting ground is obtained, to which the next layer will stick.

Given that acrylic ground dries quickly, it is necessary to work rapidly with a broad brush or a roller. Allow every layer to dry for some time before you do any further work. A traditional ground consists of gesso: animal glue and chalk. Modern, industrially manufactured, synthetic gesso primers consist of acrylic emulsions with white pigments. They are permanently elastic, oil-free and do not yellow.

A tear in a stretched canvas.

A piece of ramie cloth is glued to the back of the picture with wood glue.

Acrylic semi-chalk primers are also available within the range of gesso primers. These are semi-absorbent and prevent paint from soaking into the canvas. Most primers available in specialist shops are also suitable for mixed techniques and not solely for work with acrylic paints.

Emulsion paints are also good as primers, but make sure to use a very high-quality product. Cheap emulsion paints are easily absorbed and are neither sufficiently age-resistant nor elastic.

If you prefer a coloured background, you can alter the primer colour with acrylic paint (e.g. with Raw Sienna or black). If you want to retain the original colour of the canvas then it is best to use a primer of thinned acrylic binding medium.

Primer
In order to pre-treat a so-called 'critical' ground, for example over old layers and lacquers or smooth plastics, it is necessary to utilise a primer specially designed for this purpose. This primer provides good adhesion for subsequent paint layers. The added filler smoothes out small furrows in the ground and the primer can be easily sanded.

Repairing stretched canvasses
If a stretched canvas is damaged during transportation, for example, then it is not always necessary to stretch it again because small tears or holes can be repaired.

Next, apply filler to the front of the canvas.

For this purpose you need to turn over the stretched canvas and apply acrylic binder to the damaged part (wood glue is also suitable). Cut a piece of canvas or ramie cloth to fit, place the cloth on to the wet glue and press on to the damaged part of the canvas.

Once dry you can apply filler to the damaged section with a spatula and sand it if need be.

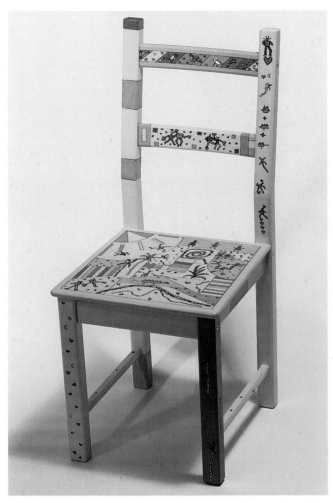

Painted chair.

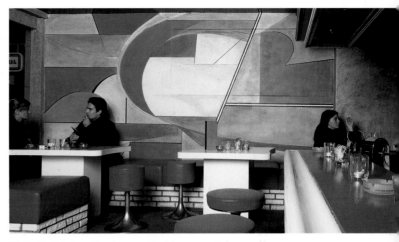

Wall painting in a Hamburg cocktail bar.

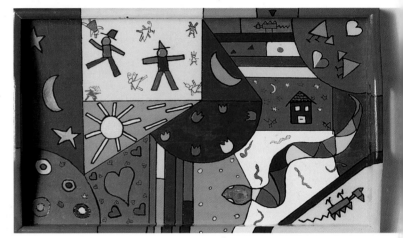

Picture on a tray.

Painting objects and furniture

The excellent adhesive qualities of acrylic paints allow for very diverse applications. These paints are therefore suitable for painting sculptures and plastic but also for creating various craft objects, as well as for use on traditional paint grounds. Furniture and other household objects can also be decorated with acrylic paint.

Painting stone, plaster and concrete

Acrylic paints are suitable for painting internal walls and decorating facades outdoors, given that they are weather-resistant and very durable. It is essential to check every surface for cracks and holes and have these repaired in a professional manner before beginning to paint. It is also necessary to remove older paint layers if these are coming loose and flaking off. Old distemper needs to be washed off to ensure that the new ground adheres properly. It is necessary to prepare concrete with primer before applying a paint layer. Surfaces need to be completely sealed for outdoor designs.

Petra Damke-Rönsch, wall painting in the Goetheschule Einbeck.

33

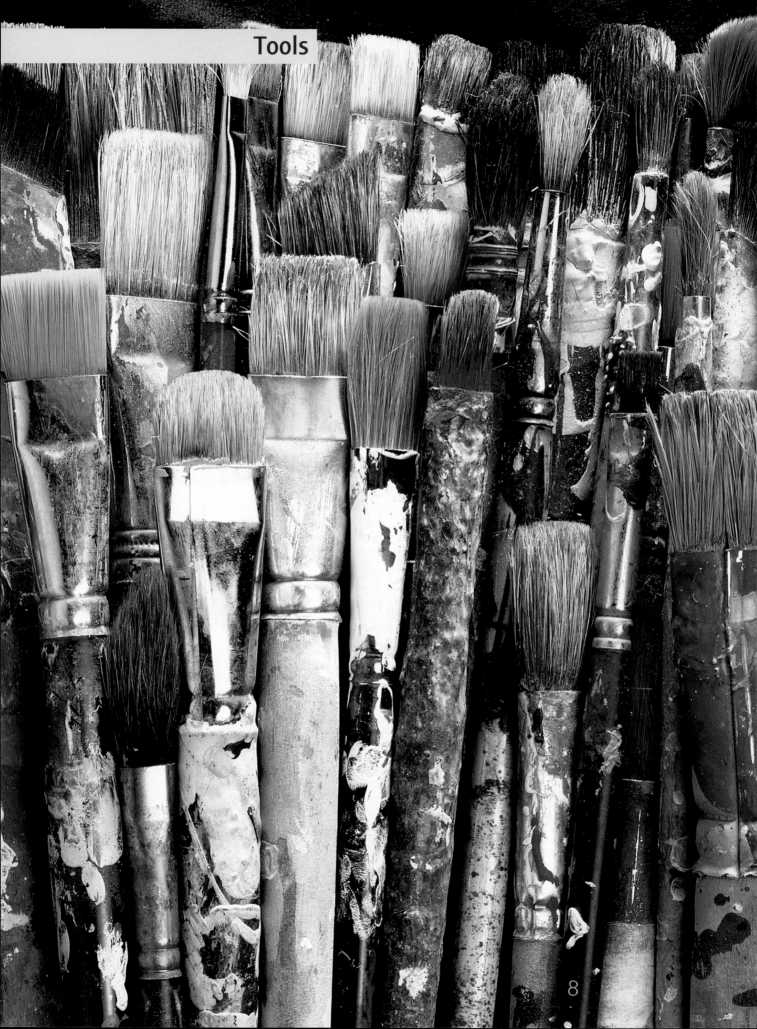

Brushes

Just as with oil and watercolour painting, there are also brushes specially developed for acrylic painting. Although any type of brush can be used for painting with acrylics, brushes will quickly wear out because of the rapid drying time of the paint and the acids they contain. Expensive natural hair brushes, as used for watercolours, will quickly become useless. The type of brush you use depends also on the kind of painting you want to do. Bristle brushes will leave very expressive brush marks. Soft synthetic or natural hair brushes allow for smooth transitions without leaving any brush marks.

Brushes are your most important tool. The quality and texture of a brush will have a decisive impact on the character of your painting. It is therefore important to pick the right brush. The choice of brush is a very personal decision and also depends on your painting style. Apart from this, it is not always absolutely necessary to buy the most expensive brushes. It is generally possible to use simple brushes from builders' suppliers for large-scale, structured, abstract painting as well as for priming. Well-made, high-quality brushes are essential for detailed working, especially for figurative painting. The following are the most commonly used brush types in acrylic painting.

Brush shapes

Brushes are available in different forms and sizes. Each shape leaves its own characteristic marks, depending on the type of hair that is used.

Round brushes

Round brushes take up paint efficiently because of their shape and will form fine points, depending on their size and the type of hair. Round brushes can be used to apply heavily diluted paint with gentle strokes; they can also be used to apply impasto colours with expressive gestures. Smaller soft hair brushes are good for developing detail.

Flat brushes

Flat brushes have a wide, long brush body, which makes them particularly suitable for laying down areas, glazing over textured substrates and for graining.

You can use the end or side of the brush to paint fine lines and calligraphic elements.

Filberts

Filbert brushes are a combination of round and flat brushes and they have a lightly rounded tip. This rounded tip makes it possible to create a smooth stroke with a pointed end. These brushes can be used to blend colours using wet-in-wet techniques.

Fan brushes

Fan brushes can be used to achieve the finest tonal gradations in oil painting. Blending or incorporating paints as in oil painting is only possible to a limited extent with these brushes due to the consistency and rapid drying of acrylic paints. The particular shape of these brushes makes them useful for creating very attractive shapes for trees and leaves in watercolour-style painting.

Rigger brushes

Riggers or poster paint brushes are available as flat or round brushes. They have long elastic hairs and can load a lot of paint. They will dispense an equal amount of paint over a long stretch, making them useful for drawing long, thin lines.

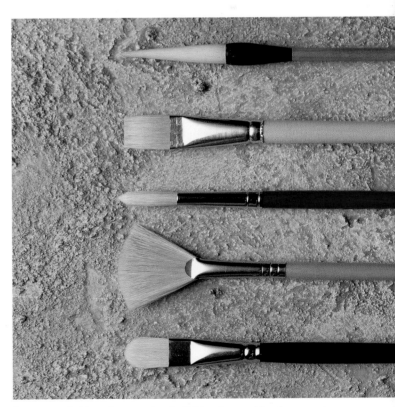

From top to bottom: Japanese brush, flat brush, round brush, fan brush, filbert brush.

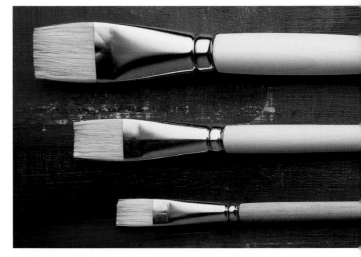

Calligraphy brush (Japanese brush)

Various kinds of Asian brushes with handles made of horn, bamboo or porcelain are available.

You may be able to find goat-hair brushes, which are relatively inexpensive. Badger, pony, weasel and sheep hair are also used. Goat-hair brushes are suitable for glazing and applying paints on a sensitive ground, for example on thin Japanese paper. These brushes are usually flat and relatively broadly bound and have short, soft hair.

Pony, weasel and sheep-hair brushes are rounded and have a long trail. The types of hairs used in Asian painting are mostly very soft and inelastic, which can cause difficulties if the brushes are being held with a European-style grip – at an angle to the painting. In Asia brushes are held perpendicularly to the painting surface, so the paint flows lightly and evenly.

Japanese brushes are particularly suitable for calligraphy.

Simple bristle brushes, da Vinci, series 7179.

Stencil brushes

As their name suggests, these specialised brushes with their short bristles are particularly suitable for working with stencils. Dabbing paint when using stencils aims to achieve clear outlines and ensure that the paint does not leak under the edges of the stencil. These brushes are also useful for dabbing or stippling techniques in the usual acrylic style and other experimental techniques.

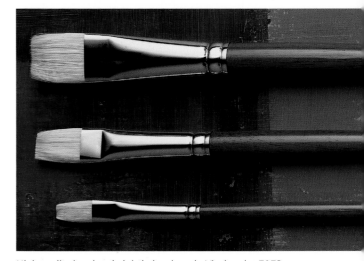

High-quality handmade bristle brushes, da Vinci, series 7173.

Bristle brushes

Bristle brushes are very suitable for working with acrylic paints. These are hog bristles which are robust and fairly thick. Each bristle divides into several ends to which the acrylic paint adheres extremely well. There is a distinction between bristles and hairs: each hair has only one point. Bristle brushes leave a hard, lively brushstroke and are therefore suitable for an expressive painting style. More basic-quality brushes with unlacquered handles and aluminium ferrules are more suitable for simpler working and a flat paint application.

The bristle quality is of vital importance. In the case of a high-quality, handmade brush series, the individual naturally curled bristles are held in the ferrule in such a way as to maintain the shape of the brush and stop the bristles from separating. The handles are lacquered to protect them from water and are more comfortable to hold if you work for hours at a time. The best bristles come from the Chinese city of Chungking.

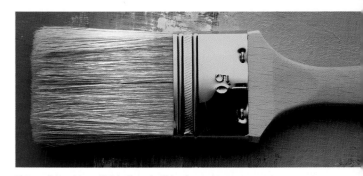

Flat wall brush, available from builders' merchants.

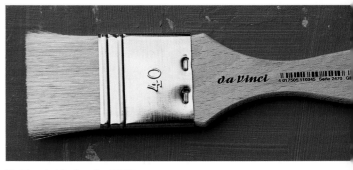

Mottler, da Vinci, series 2470.

Lacquering brushes, available from art shops, allow energetic paint application in larger formats. These brushes need to take up a lot of paint, so the ferrules are usually thicker than on artists' brushes.

Mottler brushes are bristle brushes with broad, flat ferrules and short bristles. They are particularly suitable for priming canvas since it is easy to rub the primer thoroughly into the cloth without leaving any brush marks.

Synthetic hair brushes

Brushes with synthetic hairs are generally cheaper than natural hair brushes. They are highly elastic and allow for sweeping strokes. Rapid-drying acrylic paint is easy to rinse out from these brushes. Synthetic hair brushes have a somewhat longer lifespan than natural hair brushes. They are very suitable for applying paint in the style of watercolour painting. In particular, the very fine, soft, yellow hairs are good for techniques that use a lot of water and gentle colour transitions. Synthetic hairs are, however, too fragile for impasto working, and it is necessary to select tougher brush types for this. The somewhat more solid, dark red nylon hairs are better for even paint application and for distributing large paint quantities across a canvas. They keep their shape very well and can resist greater mechanical forces.

Natural hair brushes

The range of natural hair brushes is very varied, ranging from high-quality red sable hair to squirrel, goat, marten, ox, badger and economical pony hair. There are brushes for the most varied requirements.

As we have already stated, there is no need to buy a range of expensive brushes for acrylic painting; in fact it would almost be a pity to do so, given that it is very difficult to clean the paint out of them. Because of their rough hair surface, natural hair brushes are able to absorb a lot of water and to release it slowly. They are therefore excellent for washes and watercolours (e.g. a flat squirrel hair brush). The tips close up very well thanks to the natural elasticity of the hairs. This is one of the reasons why these brushes are used in both representational painting and for adding detail in abstract paintings.

Ox hair brushes

The hairs from the ears of certain types of cattle are used for these brushes. They are elastic and strong, and the ends do not come to a very fine point. These hairs are very suitable for rectangular brush heads.

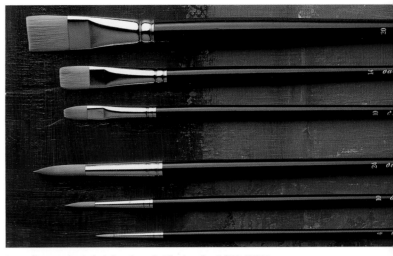

Extra fine synthetic hair brushes, da Vinci, series 1670/1870.

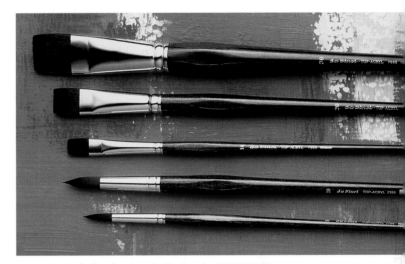

Strong synthetic fibre brushes, da Vinci, series 7785/7385.

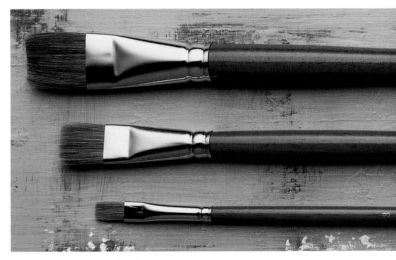

Ox hair brushes, da Vinci, series 1887.

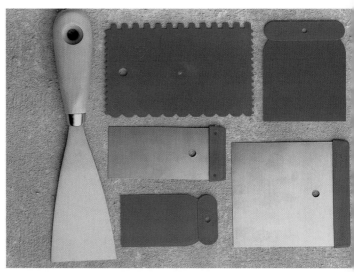

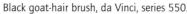
Black goat-hair brush, da Vinci, series 550.

Squirrel hair brushes

Squirrel or Siberian squirrel hair is fine but not very elastic. Squirrel hair brushes are less expensive than red sable. They form a good point but are not springy. Squirrel hair brushes are very suitable for working on larger areas with glazing technique due to their softness.

Mixed-hair brushes

The range of mixed-hair brushes available has increased in recent years. These consist of a mix of synthetic fibres and natural hair. The advantages of the two types of hair are supposed to complement each other.

The advantage of nylon hair, for example, is that it is easier to clean, given that it is smoother than natural hair. Nylon hair does not wear out as quickly as natural hair. Natural hairs provide a more uniform brush point, which remains closed even after much use. They also hold more paint due to their coarser surface. They are generally more difficult to use for making brushes than synthetic hairs. The production costs are reduced by mixing the two types. Mixed-hair brushes are suitable for representational painting, given that the brushstroke is highly accurate because of the very closed tips. Paint application is smooth and tight, which is why these brushes are also used for portrait painting.

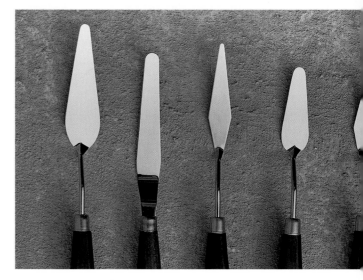

Spatulas

Using painting knives to apply paint will generally result in rougher textures than using brushes. Builders' merchants offer a whole range of different painting knives, from inexpensive plastic Japanese spreaders and scrapers to metal or serrated spatulas. Spatulas differ mainly in their shape and the size of the blade as well as the texture of the handle. Textures will vary depending on whether you use Japanese spreaders, steel knives with wooden handles or plastering tools, as well as the angle and pressure that you use. Some painters use different painting knives when priming fabric, thus creating a strongly textured ground.

Palette knives

Various smaller knives, known as palette knives, are available. The different shapes and flexible blades make it possible to achieve a more detailed paint application than is possible with relatively large builders' spatulas, and so are also suitable for representational painting.

Colour Shapers

For a number of years, rubber spatulas or paint spreaders have been available, which are sold under the name of Colour Shapers.

These have a point made from a special rubber mixture and allow painters to link traditional painting with a new technique. These paint spreaders are suitable for almost all paint types and can be used for both removing or spreading paint; they can also be used to create textures.

You can buy them in white, grey and black. White Colour Shapers are soft and are good for fluid paints. The grey spreaders have somewhat harder points, allowing for precise working with heavy-bodied paints. Those with hard black points are suitable for creating textures. The larger models are intended for carving and modelling and allow you to apply paint in large quantities.

There are various shapes for different degrees of hardness, with different uses. Those with concave points have been designed for detailed working and for lifting off paint. The candle-shaped Colour Shaper is ideal for sketching and wiping charcoal and chalk pastels. The flat chisel is good for mixing paints on your palette. Its elastic sides allow for even and flat paint application. A corner tool has a long, sharp edge with which you can create expressive textures. The bell-shaped rubber spatula is a useful tool for heavy-bodied paints and the particular shape gives you good control over the paint application.

Rollers

Paint rollers of very different designs (available in professional paint shops and builders' suppliers) can be used for more than just applying primers. They are also useful for achieving numerous interesting effects, for example using a lambswool roller to work on paint that has dried a little. Foam rollers – originally intended for lacquering – can be used to make individual surface designs if you cut patterns out of them. Paint can be applied solely with a roller to larger formats.

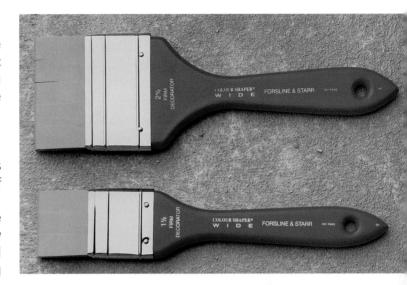

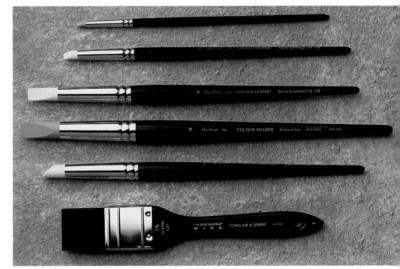

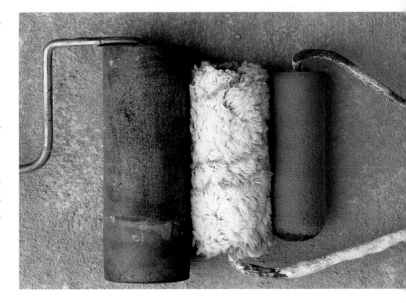

Paint guns

Paint guns allow paint to be applied in a very even and clean fashion on a painting ground. The principle is always the same: the paint is sucked up by the rapid air flow. When droplets of paint are sucked into the air flow, they are atomised and expelled on to the painting surface. The atomisation process results in an extremely smooth paint application. Art shops stock various models of paint guns – they vary in the size and power of the jet that expels the paint mist – allowing you to work on everything from large areas to the tiniest detail.

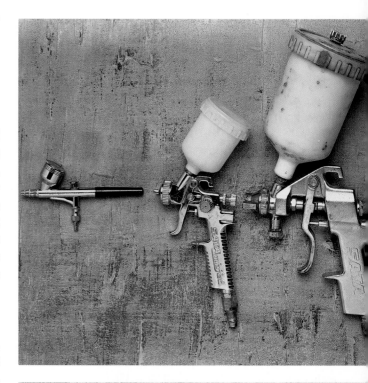

Other tools

There is no limit to the potential for creating textured, lively surfaces. Numerous items can be used to apply acrylic paints: pieces of cardboard, old telephone cards, combs, brushes, a sponge or a piece of fabric. You can also leave your individual mark by applying paint with your bare hands to the canvas.

Cleaning tools

Because tools are essential for painting, they need to be treated with care and looked after.

Brushes and tools need to be cleaned immediately with clean water. Acrylic paints dry very quickly and can be easily removed when dry using Lascaux brush cleaner.

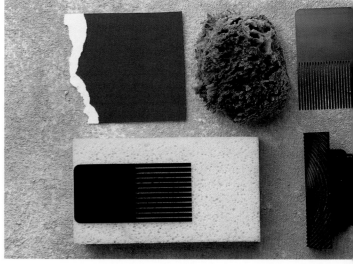

Brushes must not be left standing for lengthy periods in water containers otherwise the brush ends will lose their shape and the water will be absorbed into the handle, which will then swell up. Wood shrinks when it dries, causing the ferrule to come loose and wobble.

Brushes need to be washed out with bath soap from time to time. Once you have used your fingertips to squeeze out the end of the brush, it is best to dry the brush lying down. If you are using new brushes for the first time it is necessary to rinse them first with warm water to remove the protective layer. To stop protruding hairs from being bent out of shape, do not use the protective plastic sleeve any more. Dried brushes can be stored vertically in a container.

The paint residues need to be removed from plastic or metal knives once you finish work. This will keep the edges clean and ensure even paint application.

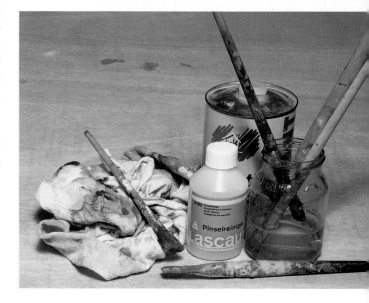

Metal spatulas from builders' suppliers need to be dried after rinsing to prevent rusting. Sponges, and particularly natural sponges, need to be thoroughly rinsed out with water after use.

Specially designed brush-holders or tubes can be used to store brushes. It is important not to keep brushes in airtight containers otherwise they may go mouldy and the brush ends should not be bent for a long time. To stop this from happening, you can use brush mats – available from artists' shops in various sizes and materials.

Palettes

Wooden palettes – as generally used in oil painting – are not suitable for acrylic paints because the paint would soak into the porous surface and be almost impossible to remove.

The palettes available in shops for working with acrylic paints are made of plastic. Because the paints dry to an elastic film and do not adhere much to the smooth plastic surface, it is very easy to remove the paint residues. The best thing is to soak the palette overnight in water, which will soften the paint. Indentations will prevent more liquid paints from running into each other.

Paper or tear-off palettes are made of transparent paper, which should first be made wet so that the paints dry more slowly. Once you finish what you are doing you can throw the top sheet away.

You can of course also use other objects as palettes. Bucket lids (e.g. from large paint buckets), a piece of glass with a piece of fabric tied around the edges, or even chocolate box trays can be used, as they already have wells in them for mixing paints. An old telephone directory can function as a very inexpensive paper palette, if the print doesn't bother you.

Work area

When you set up your painting area, it helps to select the correct equipment so that you can concentrate entirely on your painting. Ideally, we would all like our own studio where we can keep our paints, canvasses and tools, but unfortunately it is not always possible to create such optimum conditions. You can still work in your own home as long as your working area is suitably equipped. Good lighting is important – daylight is ideal. If you use artificial light, make sure that the bulbs produce light that is as similar as possible to daylight because coloured light will distort the

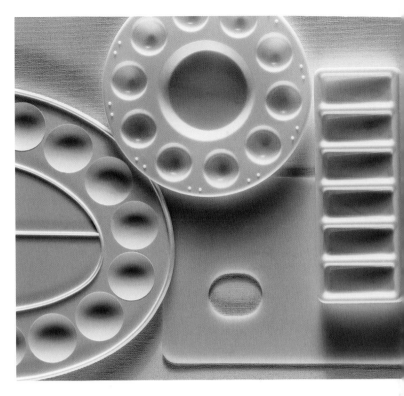

way you perceive colour on your painting. Daylight bulbs are available from specialised suppliers. Light sources need to be distributed in such a way that light falls indirectly on the work surface to prevent irritating reflections on wet areas of paint. Ensure that you do not stand between the light source and the picture when working to avoid shadows falling on the paint surface. The same thing applies to light that comes in from the side. If you are unable to achieve indirect light incidence, then, depending on which hand you use, the work surface needs to be positioned in such a way that no shadows from your hand fall on the end of the brush.

An easel makes it possible to move around freely, in particular with large formats. You can take a few steps back at any time and view your work from a distance, which is helpful when checking shapes and the composition. This also makes working with perspective easier, for example correcting optical foreshortening effects with larger formats which are laid flat. If you are working in a large format with thin glazes, then you should place the support flat on the ground so that you can maintain the correct distance and walk around the canvas and work from all sides. Cover the entire working area with foil or paper so you can work with wide strokes and, if need be, beyond the edges of the format. Always keep a soft, absorbent rag to hand to blot excess water and paint from your brushes and tools.

If paint falls on to appliances, sealed wooden floors or linoleum, you can remove it when dry, like a film. Paint can also be removed using water from fabrics, as long as the paint is still wet.

As well as your easel, you need a small table to store your rags, brushes, tubes or bottles of paint and tools. It would be useful to have another work surface or a cupboard where you can neatly organise all of your materials. It is important that everything runs smoothly and you don't need to waste time searching for things while you are trying to concentrate on your work.

Be sure to organise your working area systematically. You should have at least two water pots as part of your equipment, one for thinning paint and the other to clean brushes, as well as further empty, sealable pots (such as jam jars) to keep leftover paint. It is absolutely necessary to label any jars or food containers from your home that are filled with paint or brush cleaner, and make sure they are out of reach of children.

Only small amounts of old paint should be flushed into drains. Collect the leftover paint and leave it to dry separately. You can then dispose of acrylic paints with your domestic waste. Empty bottles and tubes should also be left open to dry before you throw them away. Bottles and tubes still containing liquids are generally considered special waste. Read the manufacturer's instructions carefully when disposing of your painting materials.

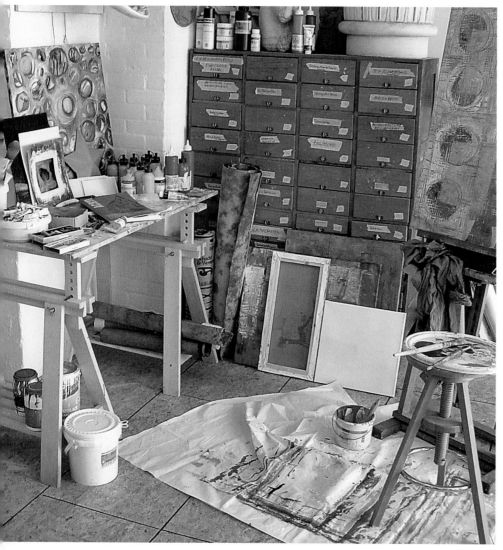

You could organise your working area like this.

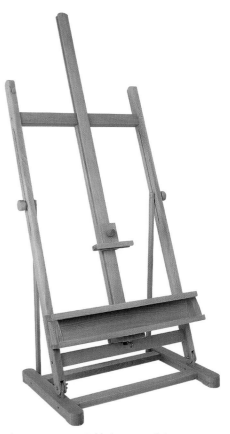

Studio easel from the Jax art company, very stable because of the runners.

Painting outdoors

You can do landscape painting in your studio using your memory after making preparatory sketches and taking photos, but painting in the open air also has its attractions. Trips to locations require a certain amount of preparation and some suitable painting equipment. If you want to make some longer trips to paint your subject, you will of course need to select your paints, brushes, easel and supports to avoid carrying excess weight. A field easel can be useful when working outdoors. Field easels are lighter than studio easels and can be folded into a portable size.

You will need to take a reduced palette of colours in a box. Art shops offer a range of paint boxes. Some are made of wood or metal with an unfolding lid that can be used as a palette. A box easel has space for materials and can be folded up like a suitcase with a carrying handle. The legs can be adjusted for a seated or standing position. When choosing a box easel you need to see whether your acrylic tubes or bottles will fit inside it as well.

If you find a suitable container for your paints but there is insufficient room for your brushes, it is advisable to transport the brushes in a roll-up brush mat. You need to take sufficient paint rags and water for thinning paint and rinsing brushes. Take a small folding chair if you are not used to working standing up in front of an easel.

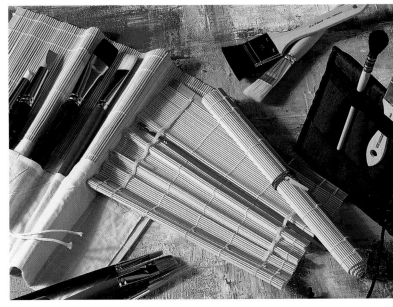

Different ideas for storing brushes.

It is useful to take a cardboard mount to look for subjects if you are working outdoors. Cut a window in the middle of a black piece of cardboard of about 12 × 10cm (4¾ × 4in) in the same proportions as your picture. It is easier to judge the balance of the forms and colours if you look at sections of the landscape using this window. In addition, the straight angles of the mount are useful for observing lines of perspective.

Once you have gathered your equipment, you need to decide where to set up your work. Do not place your easel in bright sunlight otherwise you will be unable to judge light–dark contrasts. Work in a location that is sheltered from the wind to protect damp paints from dust and leaves.

Rapid and sketchy painting, which is generally the case with *plein air* painting, has its particular attractions, regardless of whether you are going to continue to work on the pictures in your studio or at home, or if you wish to accept the sketchy nature of the impressions you have captured just as they are. Pay attention at the end of a working day that your pictures are in fact dry to prevent them from sticking together. Damp pictures can be transported with a canvas carrier. A canvas carrier can take two canvasses, one on either side.

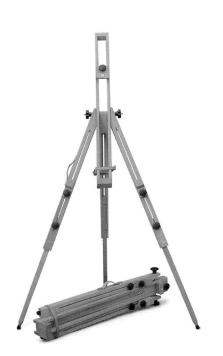

Field easel from the Jax art company.

Frames

Acrylic paintings that are painted on stretched canvas frames, wooden boards or cardboard are usually framed without a mount. The correct choice of frame shape is very important when the painting and the frame are in direct contact because unsuitable shapes and fussy details will detract from the picture.

Countless types of ready-made frames and profile strips in different materials are available from art shops. Here we only wish to give an overview of the most common framing possibilities. There are no fixed rules as to which profile is most suitable for which picture, but there are some pointers that will make it easier to find a suitable frame.

The spatial effect of landscape paintings and portraits with a background that is given perspective will be emphasised by a frame with mouldings because these will lead the eye into the picture. Frames with profiles that lead the eye away from the picture are suitable for paintings without perspective elements, for example paintings of flowers, still lifes or portraits without a spatially developed background. Flat frames are suitable for modern works because of their simplicity, which enhances the impact of a painting unobtrusively.

You should nevertheless pay attention to the total impression you are trying to achieve. If soft forms and flowing lines predominate in a picture, then a frame with a rounded profile is often more suitable than one with angled, architectural profiles.

The colour of a frame plays an important role as does its shape. As a basic principle one should make sure that the frame does not compete with the picture. The colour scheme of a painting can be drained by the frame or it can be emphasised by a contrasting frame colour. Gold frames usually fit from a colour viewpoint, given that gold, as an 'abstract colour', provides a neutral transition from the painting to the space. Silver-coloured frames are particularly suitable for contemporary art. Silver is generally cool and severe, but shows off abstract forms to their best effect. Natural wooden frames are suitable for modern works. Depending on the nature of the wood they give a simple or rustic feel. The latter is good for pictures in a naïve style.

These days many paintings are no longer framed. If the edges are also painted carefully, so that the nails or staples are no longer so clearly visible, then framing is not absolutely necessary. Some paintings appear wider if they are not framed, for example large-scale landscapes in soft colours. Abstract paintings are also more often hung without frames these days.

Works that have been drawn on paper (in particular mixed techniques with pastel chalks and charcoal) are far more fragile than paintings on wood or canvas and therefore need to be framed behind glass. There are special types of glass that reduce UV rays; ask a professional for advice. Non-reflective glass breaks up incident light and so prevents disturbing reflections. This kind of glass is only suitable if the distance between the image and the piece of glass is very small, otherwise there is a blurring effect and the picture looks out of focus.

To prevent the sheet of glass from touching the painting surface, it is normal to insert a mount. This is a frame made of strong acid-free card, which helps to create the visual connection with the picture and which may emphasise the message of the picture as well as creating a gap between the painting and the glass. The edges of the inner area are usually cut at a 45-degree angle, to create the optimum picture and depth effect.

Framing collages

It is possible to frame flat paper collages, just as other works on paper. The more three-dimensional the different parts of a painting appear, the more difficult it can be to design a frame for it. If a mount is used, then it should be thick enough to clear the highest part of the work, so that the collage will be situated either in the same plane as or some distance away from the glass in the frame. There is also the possibility of using a double or multiple mount, which may be made from cardboard in any colour. If you decide not to make use of a mount, the distance between the sheet of glass and the picture must be created by using hidden strips. Seek advice from a good art shop. A professionally made frame will underline the quality of the picture and at the same time form a component of the entire work.

To create atmosphere, achieve depth in landscape painting or develop skin tones in portraiture – these are all areas where colours interact, and it is essential to understand how to mix colours and how to make use of them. This is why colour and contrast theory has a central role in almost all courses or training sessions that try to teach painting or graphic skills. Knowledge of the fundamental rules of colour theory will allow you to include the entire spectrum of colours on your palette when you paint and to achieve the effects that you want by targeting the way you use paints.

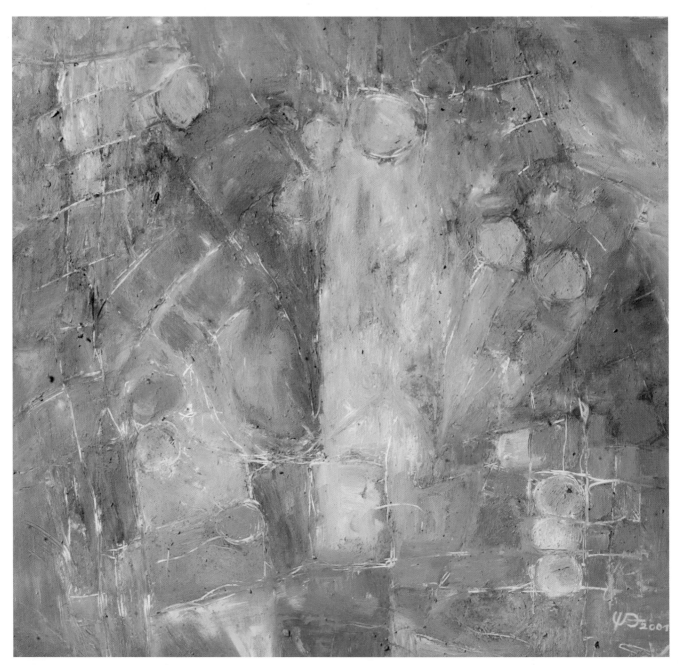

Wulf Peter Bestmann, 'Garden of fools', acrylic and sand on canvas, 110 × 120cm (43¼ × 47¼in).

Colour theories

In previous years numerous artists carried out in-depth studies of the physical technical properties of colours and, most of all, their effects both on each other and on the human senses. Some of them developed theories that were named after them. The most famous colour theories are those of Itten, Küppers and Goethe, but also artists such as Kandinsky, Runge and Klee dealt extensively with the effects of colours and wrote treatises on the subject. Look at these texts if you want to find out more about these colour theories.

The colour wheel

The primary and secondary colours can be organised into a wheel. From these we can mix every other colour, including the grey and brown shades and neutral colours. It is important that the colour wheel is always made up of colours from the colour system that you are going to use in your own painting. You will need to use the acrylic colours that you have chosen for your picture if you are going to make up your own colour wheel. There are various different colour wheels with multiple colours which cover all the basic primary and secondary colours, but they may include differing intermediate shades and tertiary colours, depending on which colour theory they follow.

Primary colours

The primary colours (red, yellow and blue) are equidistant from each other on the colour circle. These colours cannot be made by mixing other colours. Theoretically, all other colours can be mixed using these colours. In practice it is difficult because pure primary colours do not exist as such as pigments in paints.

Secondary colours

Secondary colours are made by mixing two primary colours in equal parts. This creates three secondary colours from the mixture of each pair of primary colours on the colour circle.
Red and yellow produce orange.
Yellow and blue produce green.
Blue and red produce violet.

Tertiary colours

A tertiary colour arises when a primary colour is mixed in equal parts with the neighbouring secondary colour on the colour wheel. Because there are always two secondary colours next to a primary colour on the colour wheel, there are six tertiary colours from these mixtures.
Red and orange produce red-orange.
Red and violet produce red-violet.
Yellow and orange produce yellow-orange.
Yellow and green produce yellow-green.
Blue and green produce blue-green.
Blue and violet produce blue-violet.

With both of these colour wheels, which were created using the Lascaux company's Sirius Primary System, we can see how differently the mixtures of the intermediate shades come out when differing basic colours are used. The shades in the colour wheel on the left derive from three basic colours: cyan, yellow and magenta. The colours look pure. The colour wheel on the right uses the warm tones of ultramarine and red instead of cyan and magenta. These shades are more muted. You will only obtain the largest colour spectrum and the purest mixtures by using all five basic colours in the Sirius System (see page 55).

When primary and secondary colours are mixed in different proportions, a wide spectrum of colours is created. If we mix one of the colours that we have just created with one of the original primary colours, this will create an intermediate colour. Continuing in this way creates an almost continuous gradation of hues.

Contrasting and harmonious colours

Colours can be related to each other in two basic ways: either they harmonise with each other if they are close to each other on the colour wheel, or they will have a contrasting effect if they are far apart on the colour wheel. Hues that are close to each other on the colour wheel create associated colour resonances. The closest association is between different tones of a single hue or between a primary colour and its secondary colour, which contains this primary colour, for instance between red and red-orange or red-violet.

Complementary colours

Hues that are situated opposite each other on the colour wheel are termed complementary colours. They create strongly contrasting colour effects. Complementary colours are created by mixing a primary colour with the secondary colour that consists of the other two primary colours.

Red is the complementary colour for green.
Yellow is the complementary colour for violet.
Blue is the complementary colour for orange.

These complementary colour relationships can also be used for secondary colours. Thus red-orange complements blue-green, blue-violet complements yellow-orange, etc.

When complementary colours are placed next to each other, they mutually reinforce each other's effect. If complementary colours are mixed, they will neutralise each other and this will result in 'broken' hues. Thus, the intensity of a bright red can be muted by the addition of green.

Warm and cool colours

Colours that fall into the red–orange–yellow area on the colour wheel are termed warm colours, while colours from the green–blue–violet spectrum are termed cool colours.

Warm colours appear to come towards the observer while cool colours appear to recede, so the contrasting effect of these colours is used to create spatial depth.

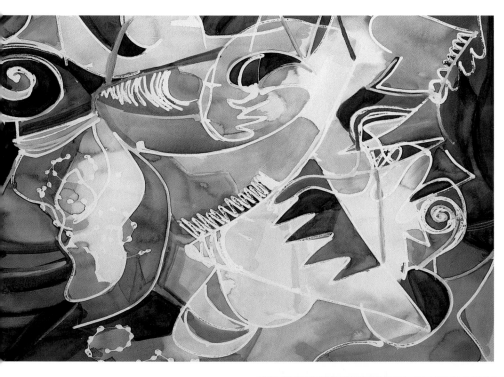

Above and below
Heinke Böhnert, n. t., acrylic on paper, 50 × 64cm (19¾ × 25¼in).

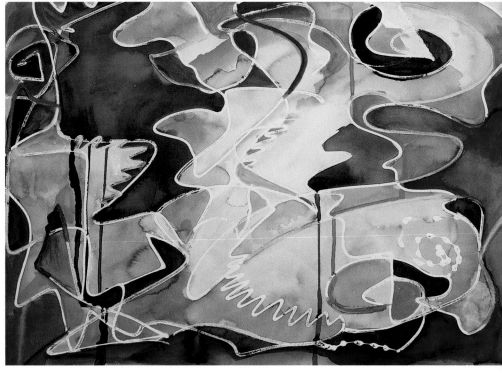

49

Colours and their effects

Colour is a sensory impression that occurs in the brain. The human eye perceives light in different wavelengths, where the perceived colour shade is caused by a light impulse of a particular wavelength. The human eye can distinguish some 160 shades of colour. If we direct what we perceive to be white sunlight through a prism, then it will be split up into the colours of the spectrum, which appears to be an almost continuous transition of red, orange, yellow, green, blue and violet. These colours also appear on the colour wheel. The colours made by light itself are called additive colours, while the colours reflected by opaque surfaces are called subtractive colours.

The colour perception of opaque surfaces arises because a part of the colours in the incident light is absorbed and the rest is reflected back. When the reflected light hits the retina we perceive that the object in question is coloured. When we mix paints, the pigments absorb various parts of light, and we see the part of the light that is absorbed the least. This process is called subtractive colour mixing. Grey or black colour impressions occur because no part of the spectrum is reflected more than any other. If light waves from different colours in the spectrum hit the eye at the same spot on the retina, then a single colour impression arises. This mixture of coloured light creates what is called additive colour mixing. Therefore, a white surface illuminated with one green and one orange lamp will appear yellow.

Colours are a lot more than just a physical phenomenon. They have a fundamental effect on our perceptions and emotions. When we see colours the impressions are directed via the optic nerves in both eyes to the brain. The electrical impulses that are received are converted into perceptions in the visual cortex, which is connected to the brain. The visual cortex is connected to the nerve cells in other areas of the brain as well as with the overall memory functions of the cerebrum. This is the reason why we have more associations with colours than simply the perception of hue. Many artists have connected colour with sound. We also often speak of colour 'notes' and 'tones', or we say that we 'compose' paintings. When we perceive colours, we often perceive smells at the same time because of the connection with memories. People with a very highly developed sense of smell can assign smells to different colours and vice versa. The classification

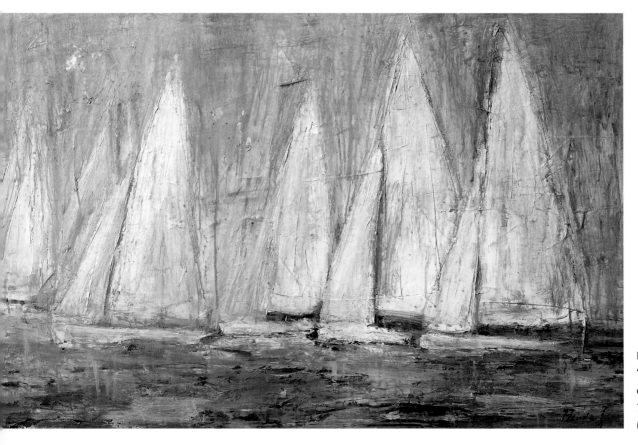

Heinke Böhnert,
'The race', acrylic
on canvas,
70 × 100cm
(27½ × 39¼in).

into warm and cool colours is also a result of the interplay between different impulses from other senses with the perception of colours.

Colours are ascribed different meanings in different cultures and can have symbolic values in painting. The Ancient Egyptians depicted some deities in particular colours because these stood for attributes that the deities embodied. The symbolic content of Christian altar painting in the Middle Ages can be interpreted by looking at how colours are used for robes and other objects as well as the figurative and spatial presentation. Kandinsky, one of the founders of abstract painting, composed his paintings in colour values that stood for emotional states. In modern advertising, colours are used according to the effect they have on buyers.

There are countless examples of how people in the same cultural circle assign the same or similar concepts to certain colours. The colour red is generally associated with fire or blood, as well as love, passion or aggression. Red can be viewed negatively or positively: love, warmth and passion are the counterparts of aggression, fire or bloodletting. Red is also used as a signal. We experience blue as cold. Blue is the colour of water and the sky. Phenomena such as spirituality, depth or purity were related to blue even in very early periods of art. Blue was used in images of the Virgin Mary because it stands for purity and divine origin.

Because colours in an image are always influenced by surrounding colour tones, they generate different emotional responses in relation to each other. This depends on the degree of purity the colours being used have, their tonal values and the contrasts they are used in.

Tonal value

The tonal value of a colour is its degree of brightness or darkness. The colour with the highest brightness is white and the lowest is black. All the other colours can be classified between these two according to their tonal value.

Orange has a lighter tonal value than dark blue. Light green and light red are different colour shades but they have similar tonal values. Differing tonal values can create contrasts in a painting, and these will emphasise certain parts of the picture.

Modulation of tonal values is essential in figurative painting to achieve plasticity and spatial depth.

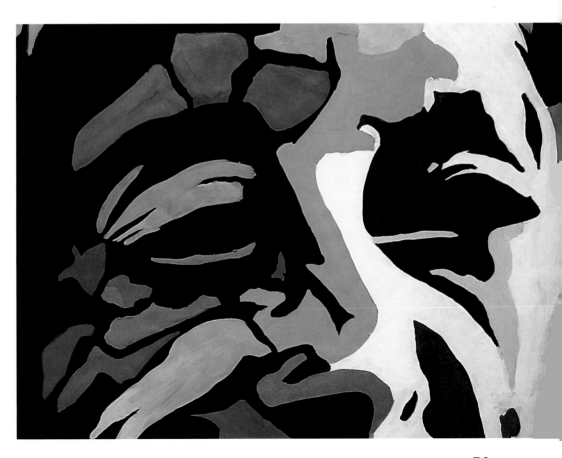

51

Saturation

Saturation in colour depends on how closely it approaches the purity of colour that corresponds to it in the colour spectrum. All colours are contained in their purest form in the spectrum. The more they are modified, the more intensity and luminosity they lose. Colours can be tonally modified by adding either white or black, as well as mixing with complementary colours.

Contrasts

Hues that are placed next to colours with different colour and tonal values or with a different saturation will create a strong effect. The meeting of colours with opposite properties creates contrasts, which are used in painting to achieve various effects. There is a whole range of contrasts, of which a few are presented here.

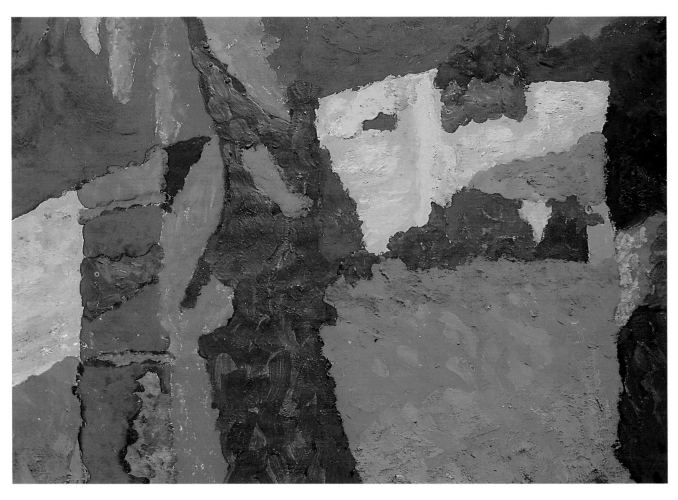

Tonal contrast

Bright shapes are contrasted with dark areas in a contrast of light and dark. The interaction between light and shadow and its skilful use in painting leads the eye through the picture. If we view several paintings very quickly, it is the pictures with skilfully constructed light–dark contrasts that will create a more powerful impression.

Renaissance painters exploited light–dark contrasts to create dramatic effects or spatial depth. Artists like Caravaggio were masters of *chiaroscuro* – creating contrasts of light and shade – and used a subtle control of light as a method of composition in their paintings.

Oliver Löhr, n. t., acrylic on black Canson paper, 61 × 48cm (21 × 19in).

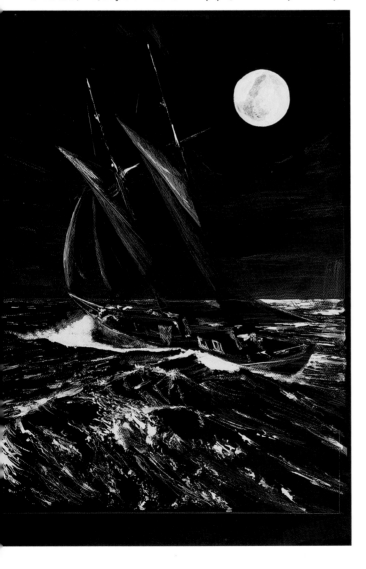

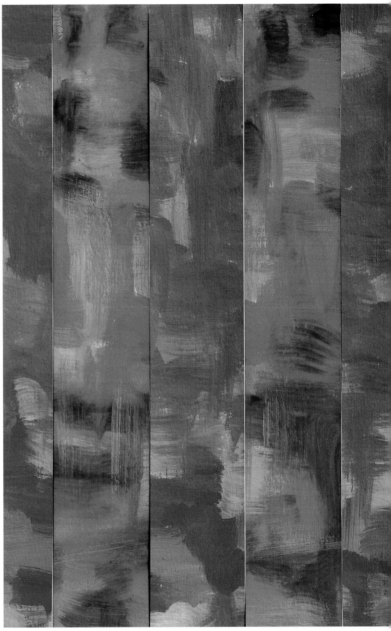

Warm–cool contrast

The contrast between warm and cool colours is important for defining space and creating mood. Because warm colours appear to stand out and cool colours to recede, the warm–cool contrast is frequently used in landscape painting. The Impressionists used the effects of warm and cool colours to depict atmospheric phenomena and to reinforce depth effects. The Expressionists often used such contrasts to describe emotional states.

53

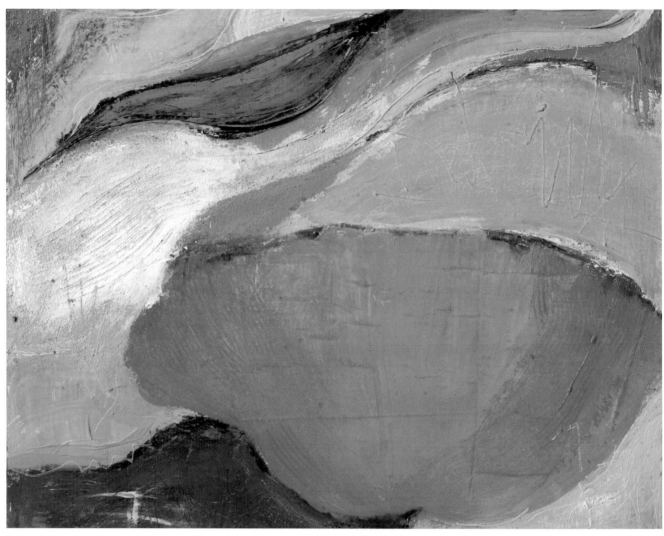

Heinke Böhnert, 'Mohn pur' ('Pure poppies'), acrylic on canvas, 60 × 60cm (23½ × 23½in).

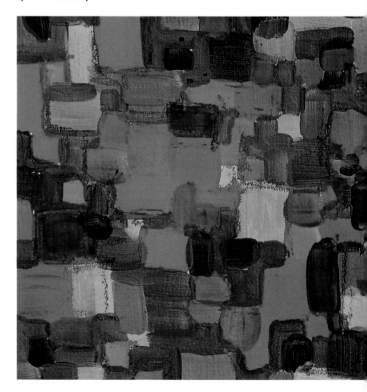

Colour-in-itself contrast

Pure colours create contrast when they are put next to each other. In accordance with the colour theory of Johannes Itten, the strongest contrast arises when yellow, red and blue are used unmixed. Pure colour shades can be used to build tensions and make an immediate impact on the observer.

Complementary contrast

When complementary colours are placed next to each other they mutually reinforce their effect. Orange-coloured areas appear brighter on a blue background than on a neutral one. The contrast effects that can be achieved depend on the size of the areas as well as the saturation of the complementary colours and their tonal values. The strongest contrast effect is achieved by matching complementary colours with the same saturation and same tonal value. Large equal areas that are placed next to each other create a harsh, dynamic effect, while the colour intensity of the background can be increased by placing small areas on to a ground of a complementary colour.

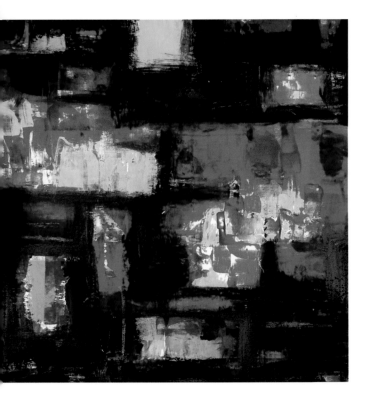

The Swiss paint makers Lascaux offer their Sirius Primary System, a colour system based on five primary colours: magenta, red, yellow, cyan and ultramarine. Mixed in equal quantities they will produce neutral black.

Every conceivable colour can be mixed from these five primary colours. Black and white complete the colour palette. The colour wheels shown in this book and the mixtures of other shades were produced using this system.

Simultaneous contrast

Pure colours are more brilliant if they are contrasted with muted or neutral colour fields. One can emphasise areas by placing pure colours in areas that are dominated by neutral shades. Here, too, the viewer's eye is led through the picture by the interaction between pure and neutral colours.

Accenting contrast

If certain areas need to be emphasised or you need to create a focal point, it is important that the viewer's eye is directed towards the contrast-rich areas of the picture. If there are tonal areas in a composition that are more dominant than the actual focus of the painting, then attention will be drawn towards them. Giving contrasting colours different values will result in a balanced composition. Large dominating colour fields can be harmonised by means of small accents in a different shade, or important parts of the painting can be brought out from a neutral ground with the use of contrasting colours.

Paint mixing systems on the market

As we stated above, the results of systematically mixing colours can be very variable, depending on the basic shades that are used.

In order to follow the basic principles of colour theory it is important to make use of colours that match each other, so as to create a balanced colour wheel. Some paint manufacturers have ranges of colours that have been specially designed to meet this need.

Grey shades can be made not only by mixing black and white; various shades can also be made by mixing complementary colours. The grey resulting from these mixtures is often much livelier.

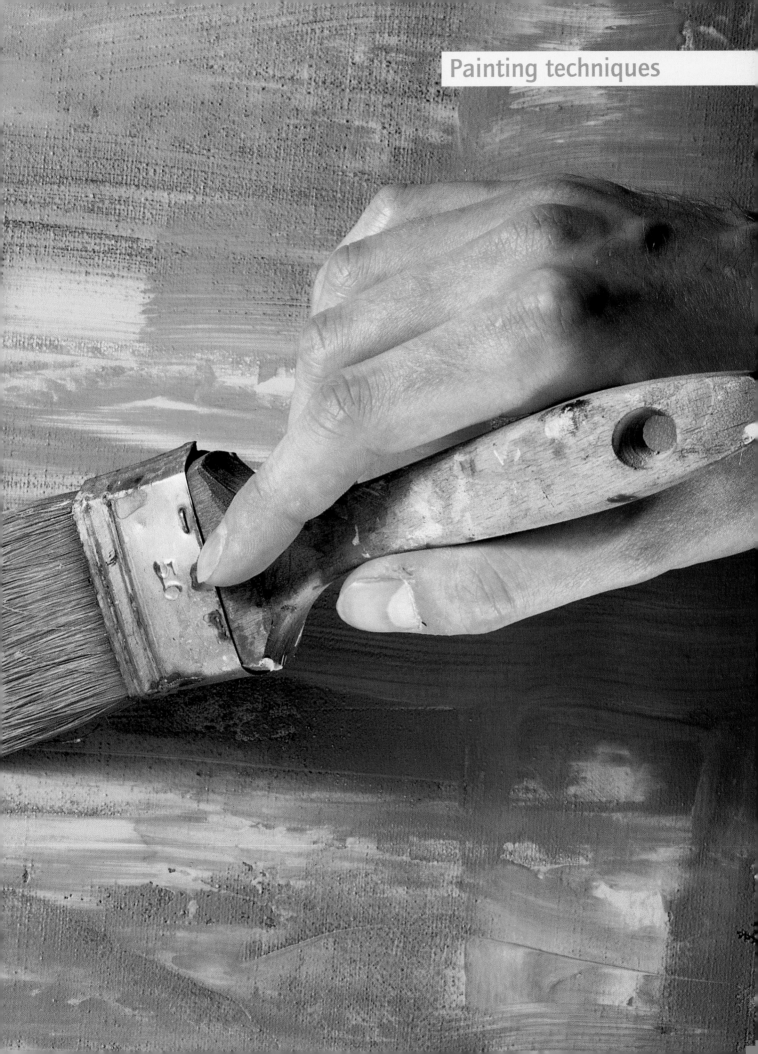

Basic principles

Brushstroke
There are numerous ways to apply paint with a brush. The characteristic style – the changing stroke thicknesses left by the brush – depends partly on the nature of the brush, such as its hair quality, but is, of course, determined to a far greater extent by the person who is actually holding the brush. Brushstrokes are the means by which artists express their personality. In time, you will develop your own brush style, which is just as characteristic as your handwriting.

If you are not experienced in handling paint and brushes, then we advise that you do some warm-up exercises: first forget the idea that you are now going to have to create a complete painting. Select some of your favourite paints and try out various ways of applying them. In this way you will quickly discover how different shades can be mixed directly on a surface while you are painting.

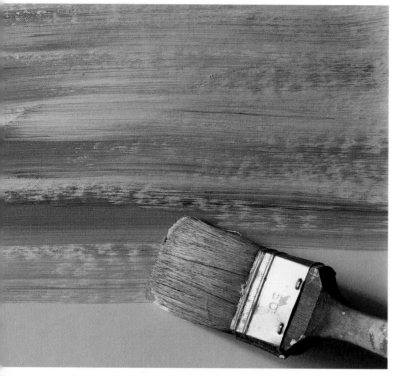

Paint application with a wall brush.

Dry-brush technique: it is possible to alter the shade of areas of paint that are already dry by gently applying a thin layer of paint that does not cover the dry section. Here, you need to brush out paint until hardly any remains on the brush. In this way the original colour appears through the paint layer that you have just applied. It is best not to thin the paint.

Sweeping paint application in a single direction.

Apply the paint with crossways brush movements.

Cloudy paint application.

'Pointilliste' paint application, dabbing or stippling small points or smudges, creates spatial depth by superimposing several layers in different shades.

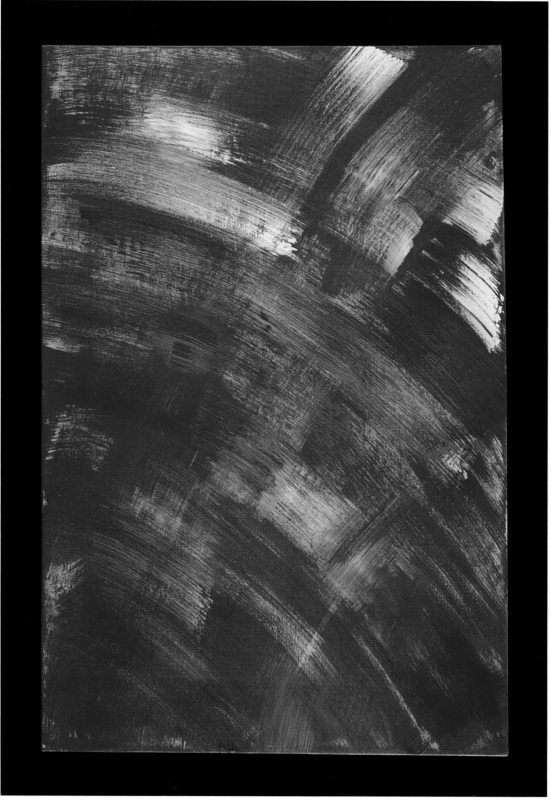

Ute Zander, 'Fuorco', acrylic on canvas, 120 × 80cm (47¼ × 31½in).

This dynamic effect has been achieved by applying paint using a wallpaper brush.

Working with spatulas

Knives, spatulas and scrapers are very useful when working with paints and texturing mediums. They make it possible to work quickly over large areas and they also create very attractive, interesting textures. Of course, you cannot paint with the same accuracy as with brushes, but with a bit of practice you can learn to control the way the paint is applied. A scraper can be used both to apply and remove paint.

When applying paint you should pull the scraper with light pressure across the surface. The scraper should lie in a relaxed position on the fingertips and should be held only by the thumb. The flatter the scraper is to the painting ground, the more the paint breaks up and the more attractive the effects are. When removing paint you need to hold the scraper vertically and apply pressure. This way you can alter areas in a picture that were painted over too hastily or create interesting new patterns.

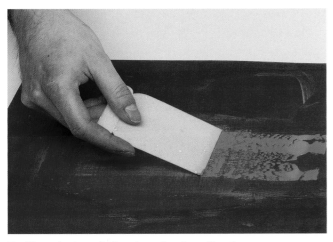

The blue paint is applied to the surface by pulling the scraper with little pressure.

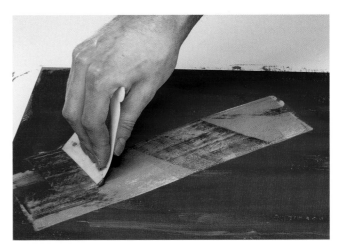

The blue paint is removed with strong pressure and the ground is exposed again.

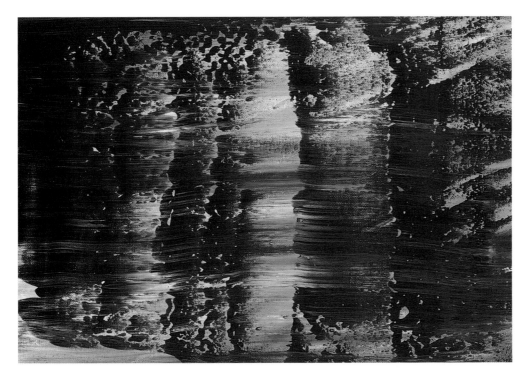

In this example the dark blue paint was applied in a single pulling motion with a piece of cardboard across the width of the canvas. The German painter Gerhard Richter is a well-known exponent of this style of paint application.

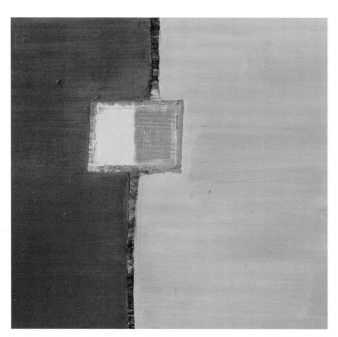

Regine Koster, n. t., acrylic and wax crayons on canvas, each 40 × 40cm (15¾ × 15¾in).
The small colour fields in these works were scraped out using a Japanese spreader, so that the colour of the substrate was exposed again. There is a pleasing contrast between the calm, opaque areas of colour and the lively details. The accents were done with oil pastels.

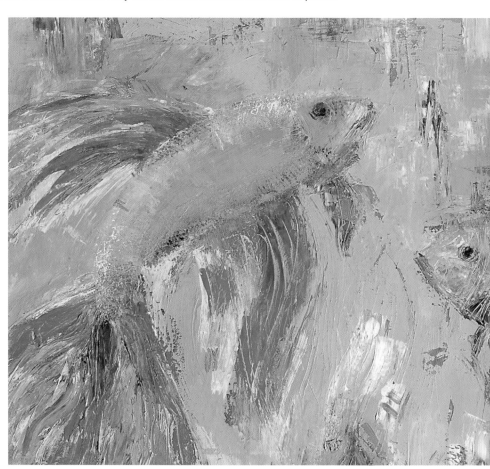

Heinke Böhnert, 'Fische im Dialog'
('Fish dialogue'), acrylic on canvas,
50 × 50cm (19¾ × 19¾in).

Glazing

Acrylic paints dry very quickly and become waterproof. For this reason they are particularly suitable for glazing techniques. In glazing techniques the paint is thinned so much that the painting ground or the layers of colour underneath shine through. The areas of colour formed by glazing therefore appear lively and have a particular luminosity. If several layers of paint in different shades are applied one over the other, then the colours will mix optically and the viewer will see the different shades. In this way it is possible to achieve shades that would be difficult to mix on a palette.

For the purpose of glazing acrylic paint can be thinned with water. Very thin shades will, however, appear rather dull when they dry. Add gloss mediums to strengthen the transparency of colours without affecting their luminosity.

63

Opaque paint application

In opaque paint applications, paints are hardly thinned, so the surface or the layers of colour underneath are completely covered. This technique allows for good control over paint application and the precise development of detail and areas of colour. Waiting until the paint in the neighbouring areas has dried before applying the next colour will result in sharp outlines. Painting different colours into each other when wet will result in gentle transitions.

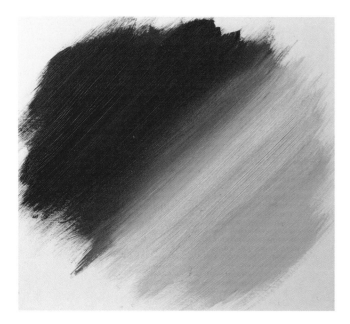

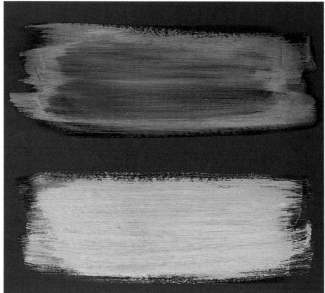

If you want to apply a light colour over a dark one, you can first apply white paint to the areas to be painted over so that you completely cover the layer underneath (bottom: yellow with a layer of white underneath; top: yellow on a blue ground).

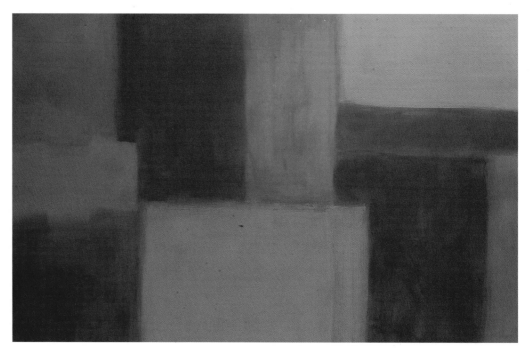

Ute Zander, 'Red', acrylic on canvas, 80 × 120cm (31½ × 47¼in). Colour fields have been applied in several layers with a soft, broad flat brush.

Blending

Painting two colours into each other creates a fluid transition between two paints. Unlike oil paints, it is not possible to paint over a blend again until you have the desired result, because of the short drying time of acrylic paints. You can extend the working time by adding retarder mediums.

Wet-in-wet blending

Place two areas of colour next to each other without touching and then paint over the two areas with a clean, damp brush with a light brushstroke.

Painting over dry paints

You can also achieve even transitions between two colours by using loose dabbing and somewhat drier brushstrokes. To paint over a sharp edge between two dry colours, use a mixed shade of the two colours and apply this loosely on top of the line between the colours.

Two areas of colour are applied in parallel ...

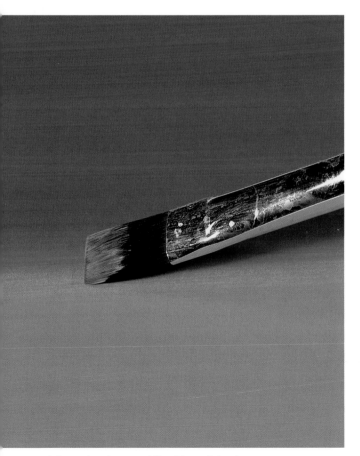

... and then painted over rapidly with a soft brush.

The mixed shade of the two colours is applied over the edges.

65

Opaque painting techniques

Alla prima

Alla prima painting, or direct painting, is a technique that seeks to take the most direct path to the finished result. 'Alla prima' is from the Italian for 'the first time'. The intention is to capture the essence of the subject intuitively and to reproduce it with a lively, fresh style. Underpainting is deliberately omitted, while the colours that are applied directly to the surface and which could possibly form the final colouring, are premixed on the palette. With this technique, a painting is finished in a single stage.

The Impressionists were the first to make use of this technique in a grand style in painting. Painting theorists until this time considered that building layers was the sole means for working on serious themes. It was the Impressionists who first turned to the *alla prima* technique, which had formerly only been used for studies and sketches. As proponents of *plein air* or open air painting, they generally worked directly from nature and so created a style with which they could capture the effects of light and movement.

The *alla prima* technique requires self-confidence and practice if you are going to apply colours rapidly and in large strokes. Working with acrylic paints in particular, which dry much more quickly than oil paints, requires spontaneity and a clear idea of the final result. It is generally not possible to work on very large paintings using this technique with acrylics, because the paints dry too quickly and so it is necessary to resort to overpainting anyway. To keep paint damp for longer, it is necessary to add retarder.

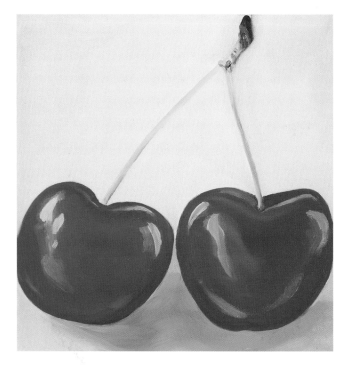

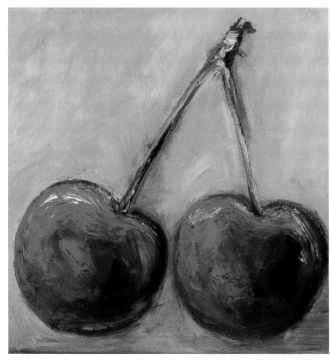

The same subject was painted twice using the *alla prima* technique. This is an example of how different the results can be. Oliver Löhr used soft synthetic hair brushes for his work (left), while the cherry motif (right) was painted with bristle brushes with intersecting brushstrokes by Kristina Schaper. Retarder was added in both paintings.

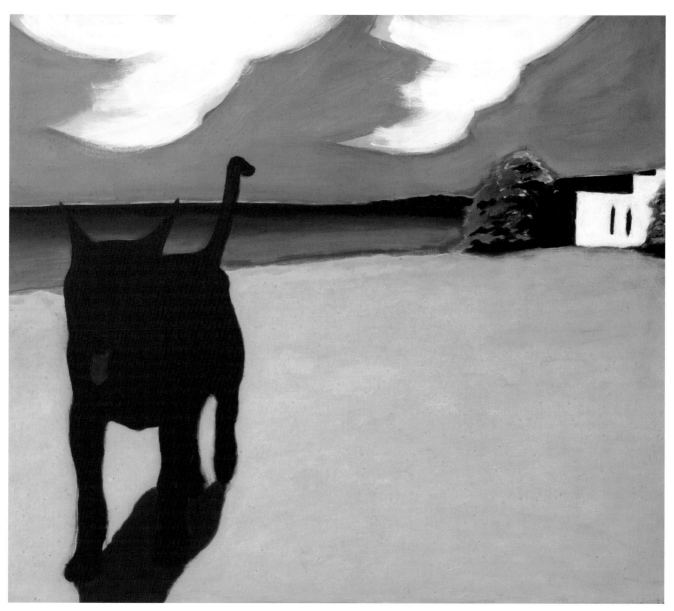

Sabine Lange, n. t., acrylic on hardboard, 50 × 60cm (19¾ × 23½in).

Impasto

Unlike painting with glazing – superimposing thin layers of paint – in the impasto technique thick layers of paint are applied on a ground so the marks of the materials used remain clearly visible. This results in an irregular textured surface with raised peaks and valleys.

Because acrylics are somewhat less fluid than oil paints and lose volume in the drying process, it is necessary to add a medium to increase the consistency of the paint.

The impasto technique uses various tools to apply paint to the ground, such as palette knives and narrow pieces of wood as well as flat bristle brushes. Another possibility for creating an impasto effect is to apply acrylic paints directly from the tube on to the ground. The impasto layer can then either be left as it is or worked further using brushes or palette knives.

To be able to employ the intuitive effect of the impasto technique effectively, it is necessary to plan ahead to some extent, just as with the *alla prima* style. If paints are mixed too thoroughly they lose their vitality. This also applies if you stir for too long paint that is applied directly to the ground. Each stroke with the brush or knife will mix the different pigments slightly. To avoid a smudgy impression or a paint surface that has been 'painted to death' it is advisable to look out for the point when you are going to come to the end of your work.

Step 1: The preliminary drawing was applied with wax crayons. This is followed by a first watery application of pigment. This serves partly to check the composition and partly to reduce the white of the canvas.

Step 2: The sky was painted in with a broader brush. The colour planes of the fields and meadows were worked rapidly with a palette knife. If you work like this, make sure that you don't mix the different colours for too long! It is better to wait a little until the paint starts to dry before continuing work.

Step 3: Once the entire painting has been given a layer of paint, the sky is lightened somewhat, otherwise it would be too dominant. This is followed by further layers applied with a knife; the trees and the house have also been further developed.

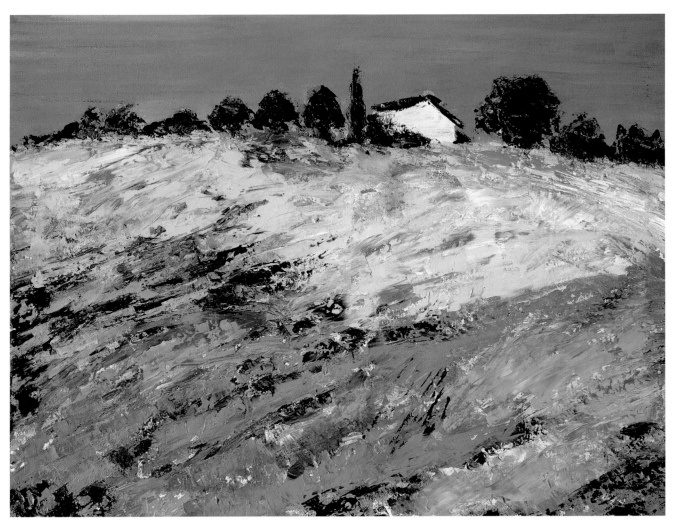

Step 4: Palette knives with fine blades make it possible to apply individual colour accents.

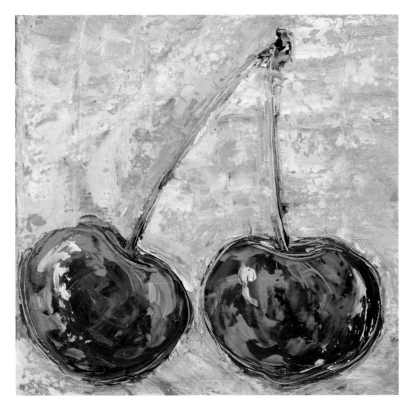

This decorative cherry shape was also developed in several layers with a palette knife. Thickening paste was added to the colours. The contours of the fruit were scratched with the brush handle.

Sgraffito (scratch technique)

This is not a painting but a scratching technique that was developed in the Renaissance to decorate facades (Italian *sgraffare*, to scratch). In this technique two coloured layers of lime plaster are superimposed and areas or lines are scratched out in the top layer so they take on the colour of the layer below.

Transferring this to acrylic techniques involves scratching patterns, writing or outlines with the end of a paintbrush or other sharp object in damp areas of paint. The colour of the substrate is exposed again as a result.

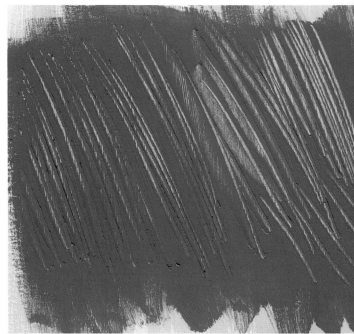

Traces scratched in opaque colours.

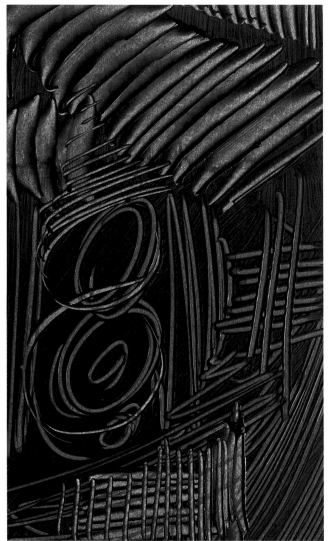

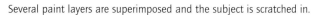

Sgraffito with two colours. The bottom, dry layer of paint is exposed.

Several paint layers are superimposed and the subject is scratched in.

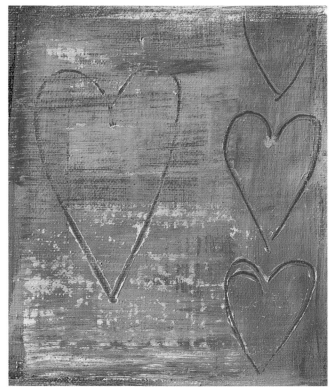

70

Textured surfaces

It has long been a tradition in art to add and mix in substances to modify paint. During every stylistic era, artists have searched for materials that could change the consistency and versatility of their paints. Restorers often have to deal with the results of such experiments, because some of the additives have undergone chemical or physical reactions that have damaged the surface or longevity of a work.

Technical developments in the industrial manufacture of modern paints and texture pastes and gels have gone so far that these can be used in conjunction with non-paint materials without any concern. It is nonetheless necessary to ensure that no materials are used that will themselves change over time, for example start to shrink or go mouldy.

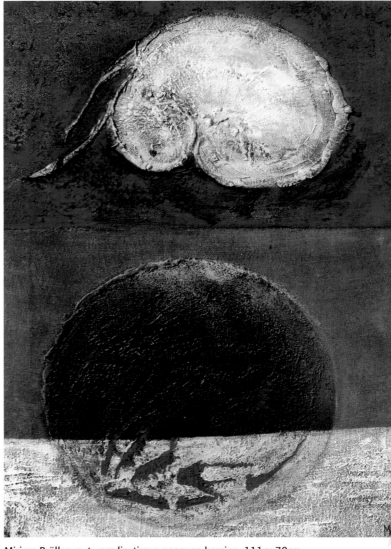

Miriam Bröllos, n. t., acrylic, tissue paper on hessian, 111 × 70cm (43¾ × 27½in).

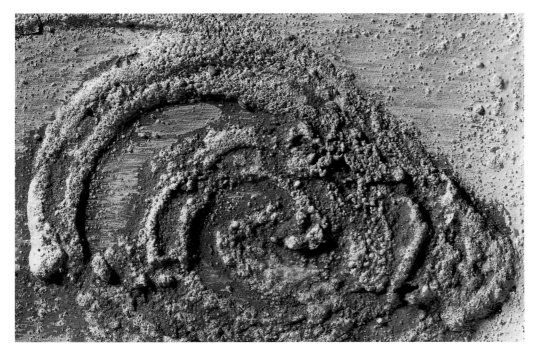

Sand has been sprinkled in the wet paint, giving a raw, grainy surface.

Incorporating fillers into paint

Because of their good adhesive properties, acrylic paints can be mixed with a great variety of substances. This is a way to thicken the paints and create interesting surfaces resembling a bas-relief. The texture, to some extent, depends on the type of tools that are used but also, of course, on the quality of the filler materials. Almost any more or less coarse materials like sand, sawdust or plastic granules are suitable. The paint paste that is made from this needs to be of a thick consistency. You need to be careful not to add too much filler, otherwise the paste will be too dry and no longer stick properly to the ground. You should be particularly careful with absorbent substances such as sawdust, which will absorb moisture from the paint.

The first layer needs to be carefully applied to the canvas with a brush to ensure good adhesion. After that, you can continue working with a brush or knife.

Acrylic paint is mixed with bird sand and can then be applied to the painting ground.

This holiday photo inspired Rüdiger Steffens to make a painting. He mixes his paints with bird sand, creating a finely textured surface.

Step 1: The outlines are prepared on the canvas in coloured pencil. Details are ignored or highly simplified – the painter is concentrating on the broad composition of surface planes and shapes.

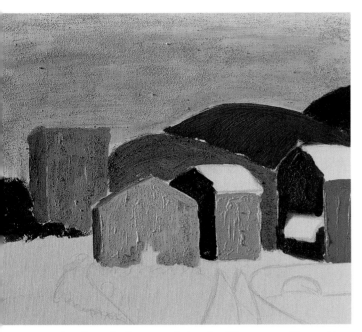

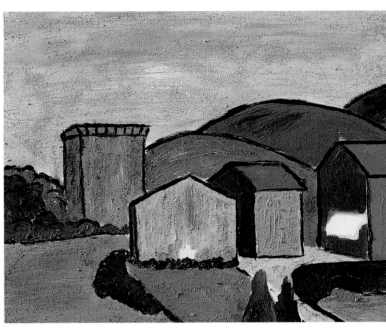

Steps 2 and 3: Paint is now applied to the different areas. The sand is already mixed with the paint on the palette. Once the first layer of paint has been applied, the surfaces are worked further. The grains of sand create a rough substrate, which will absorb newly applied paints in an irregular way. This technique creates unusual colour effects. The outlines are then applied using black paint. The outlines define the composition and intensify the brilliance of the colours.

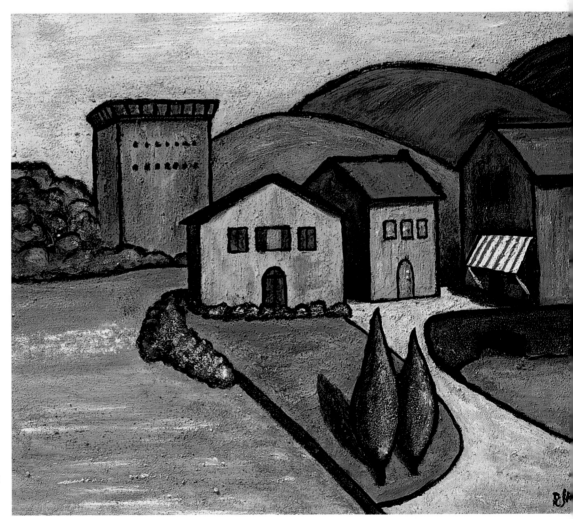

Step 4: The colour areas are given their last nuances, and shadows and details are added.

Use of modelling paste

Today it is possible to find a wide range of varied modelling and texture pastes or gels, specially designed to meet the needs of artists. These make it easy to build up thick layers. These pastes can in fact be applied and worked with a variety of tools: there are no limits to what your imagination can achieve. If you want very thick textures it is important to apply paste in several thin layers. You need to allow a drying phase between each work session, to prevent cracking.

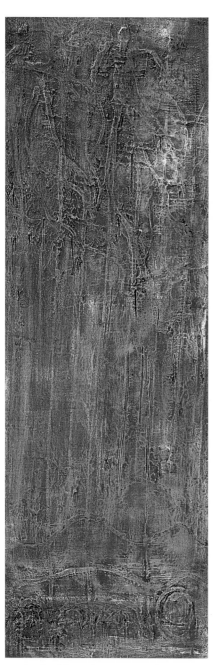 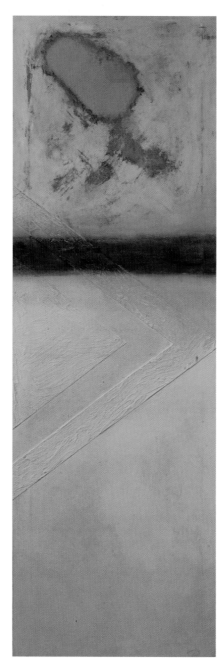 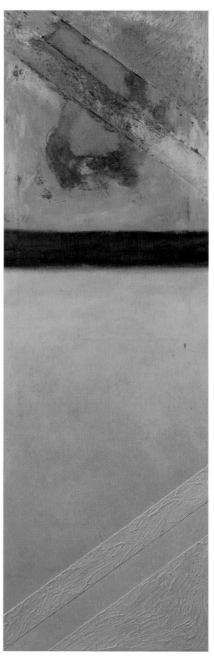

Ute Zander, 'L'acqua', 120 × 50cm (47¼ × 19¾in). Canvas, modelling paste and finally several layers of glaze.

Regina Porip, 'Dynamik' ('Dynamic'), acrylic on canvas, each 120 × 40cm (47¼ × 15¾in).

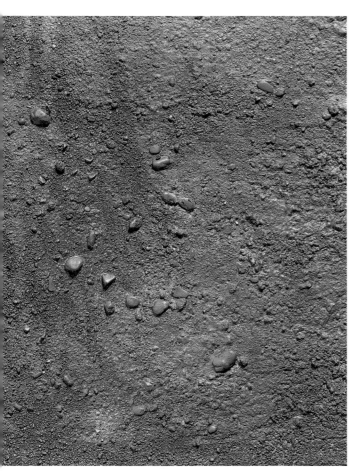

Sand and grit have been embedded in an impasto-style mix of modelling paste and paints. To ensure that most of the material actually sticks to the painting, it is necessary to paint over the surface several times with acrylic binder. Once you have done so you can continue working.

Incorporating fillers into modelling paste
When incorporating texturing materials into modelling paste the same rules apply in relation to the proportion of filler to paste as when incorporating mediums into paint. You will achieve various surface textures if you sprinkle sand or similar substances into modelling paste that you applied earlier. Once the painting is dry the surplus grains are shaken off simply by tapping. This may create further colour effects.

Modelling paste is mixed with sand and spread over the ground.

Sand is sprinkled on the damp modelling paste. The grains remain at the top; the surface is different from that resulting from mixing paste with sand.

Use of acrylic-based sealant
You can buy acrylic-based sealant for gap joints at builders' suppliers. (Do not confuse it with silicone sealant!) Acrylic sealant is sold in cartridges and is easy to apply to a painting surface.

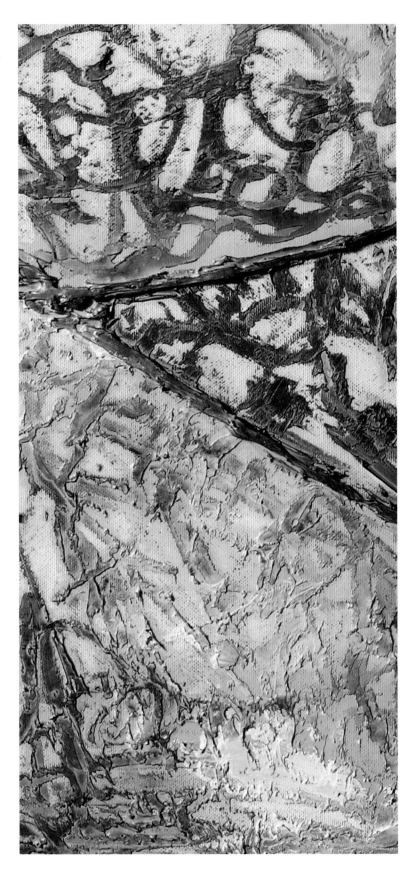

Black acrylic sealant has been used in this example.

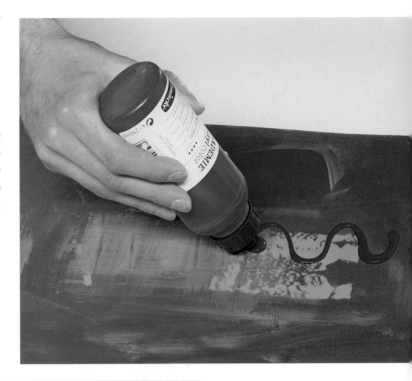

Painting straight from the tube

Applying paints straight from the tube or bottle will create very plastic effects. You can add a rough surface to these elements by sprinkling sand on the damp paint. Once the areas you have worked on are thoroughly dry, you can tap off the surplus sand and continue working on the other areas.

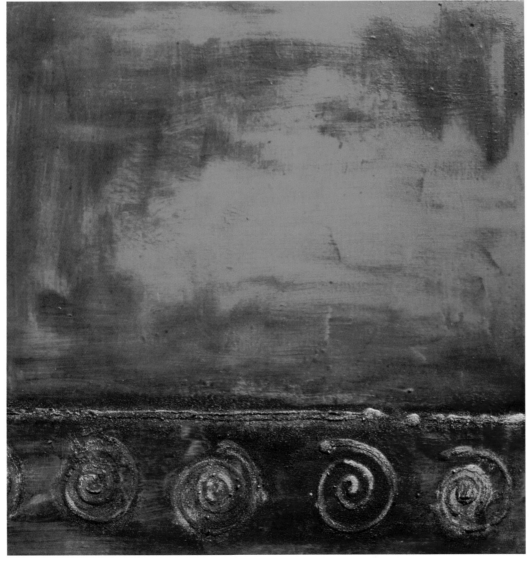

Ute Zander, n. t., acrylic, sand on canvas, 80 × 80cm (31½ × 31½in).

The spirals were applied with paint from a tube and then sprinkled with sand. After complete drying there followed several semi-opaque applications of paint.

Use of window colour paints

Window colour paints are extremely popular with amateur painters. These are acrylic-based paints, which are very elastic, so they can easily be peeled off smooth surfaces. These window colour paints adhere very well to rough, somewhat absorbent supports such as canvas or paper. They are available from craft shops in handy bottles with very fine nozzles. They are excellent for writing texts or for drawing contours and are easy to paint over. Make sure that the paint has dried properly before you paint over it, otherwise it may crack.

Step 2: Apply opaque paint over the text. Because acrylic paints lose volume when they dry, you can still see the writing. The written elements are linked to the background in this way and recede somewhat. If you want a stronger definition between the plastic areas and other parts of the painting you can also apply window colour paint at the end.

Step 1: If you are going to write text, it is advisable to make a preparatory model with chalk or ballpoint, to be certain that the words are positioned correctly. Apply the writing with an even pressure on the bottle of paint. If you make a mistake you can simply wipe off that part and write over it again.

Step 3: You will now need to apply several layers of glazing to the painting. This emphasises the handwriting.

Step 4: To emphasise the text even more, use a light colour to add granulation.

In this example, golden window colour paint is written over a ground that has already been worked on.

Working on textured surfaces with colours

Glazing

Glazing paints are particularly useful for working on textured surfaces. The liquid collects in the recesses and flows away from the raised areas. This makes it possible to accentuate the more three-dimensional areas and gives the picture depth.

Multicoloured glazing.

Turquoise glaze on a ground formed from modelling paste.

Granulating

If you draw a brush or knife with light pressure over an area then the paint will adhere to the crests. The higher the crests, the clearer these areas are in the foreground. Use unthinned paint as far as possible with this technique and make sure that your brush is dry, otherwise the water will run down from the ferrule while you are working and the paint will be too weak.

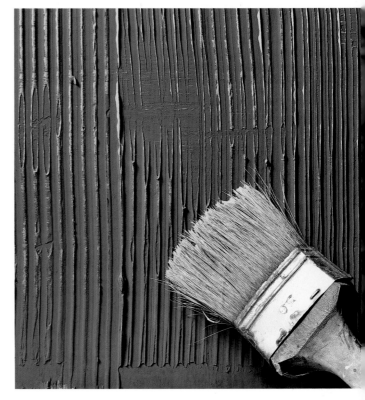

Collages

The term 'collage' is derived from the French verb *coller*, meaning 'to glue', which refers to the different methods of including objects in a picture.

The original meaning was a process where torn or cut paper shapes were glued to a picture.

Historically, there were a great number of artists who used materials other than just paper in their painting. This art form has its roots in the Cubist movement. Artists such as Pablo Picasso, Georges Braque and Juan Gris started to incorporate foreign objects such as stamps, pieces of newspaper, envelopes or theatre tickets in their works in the early twentieth century. While Gris made use of imitation objects in his early pictures to give the impression of grained wood or the feel of wallpaper, his fellow artists Braque and Picasso replaced such imitations with real objects soon afterwards.

Miriam Bröllos, 'Mariko', collage, acrylic on canvas, 40 × 45cm (15¾ × 17¾in). Postcards from a Japanese penfriend were incorporated into these atmospheric images.

The Dadaists adopted the collage technique and modified it to some extent. Thus, in 1918 Raoul Hausmann invented photomontage, in which he arranged and glued together photos and illustrations. The collage technique was to reappear again and again in subsequent stylistic trends, including in the work of Kurt Schwitters and in the 1960s when it was used by the Americans Jasper Johns and Robert Rauschenberg. With the latter, the embedded elements became increasingly three-dimensional and so the picture surface dissolved to such an extent as to produce semi-sculptural works. In the case of some of these so-called assemblies, for example the famous 'Migof-Labyrinth' by Bernard Schultze, the collage components became so substantial that they expanded into complete three-dimensional installations. Many modern artists increasingly incorporate collage elements into their pictures in combination with acrylic paints.

Basic principles of collage art

The strong adhesion not only of acrylic paints but also particularly of texture pastes, makes it possible to experiment with a wide variety of materials in the collage technique. Many collected or used objects such as old wrapping paper, newspaper cuttings, bits of fabric as well as three-dimensional elements such as shells, driftwood, glass or shards of tiles and pieces of metal can easily be incorporated into a collage with the help of filler.

One of the great advantages of filler is that when objects are glued on to the painting ground it makes it possible to link the textures that are created seamlessly with the textures of the materials that are already glued in. Texture mediums make it possible to glue these materials on a background that has already been painted. Combined with painting, these collage elements can also be painted over after they have been sealed with clear pastes. Plant parts, for example, that are to be used in a collage must be dried first. You should avoid using perishable substances. Dry foods such as pasta, rice or pulses need to be treated with care and are not necessarily suitable for techniques using water. All collage elements need to be glued with care. It is usually the raised parts that are damaged later on – careful spraying with varnish will increase resistance and will again bind the individual elements to each other.

Collage material needs to be incorporated in different ways, depending on the effect you want to achieve. Make sure that the individual parts of enclosed, abstract surface areas that are meant to look organic, will form a harmonious whole. It is important that the various elements blend into each other. It is preferable to tear rather than cut paper, so the transitions can be more easily smoothed over. Stronger types of paper need to be moistened before being glued in order to prevent swelling and creasing.

Miriam Bröllos, 'Mariko', detail.

Only very thin paper such as tissue paper can be glued on directly. If you often work with pictures or cuttings from magazines, remember that the colours in print media are not colourfast. If it is necessary to fix these collages for a lengthy period, you will need to apply at the end varnish that contains UV protection, and you should not expose your collages to direct sunlight.

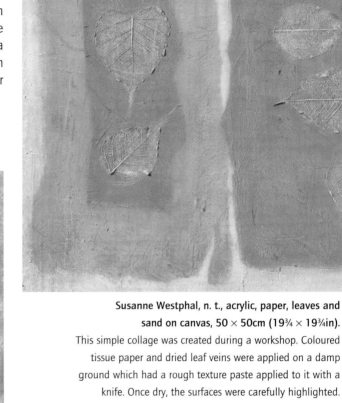

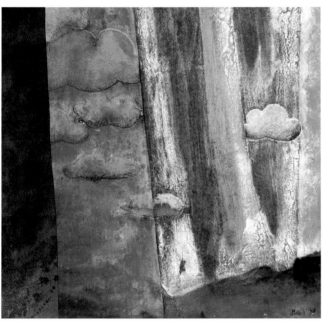

Miriam Bröllos, 'Mariko', detail.

Susanne Westphal, n. t., acrylic, paper, leaves and sand on canvas, 50 × 50cm (19¾ × 19¾in). This simple collage was created during a workshop. Coloured tissue paper and dried leaf veins were applied on a damp ground which had a rough texture paste applied to it with a knife. Once dry, the surfaces were carefully highlighted.

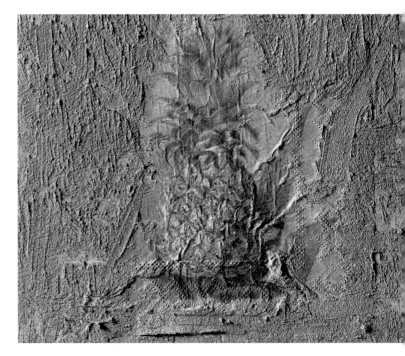

Ute Zander, 'Ananas' ('Pineapple'), acrylic, sand and paper on canvas, 50 × 60cm (19¾ × 23½in). The pineapple motif derives from a paper serviette. The motifs were cut or torn out in this so-called 'serviette technique'. A surface was prepared with acrylic medium and then only the top coloured layer of the serviette was carefully pressed into it. When it was dry, the thin paper had medium applied to it again, after which it could be worked on further.

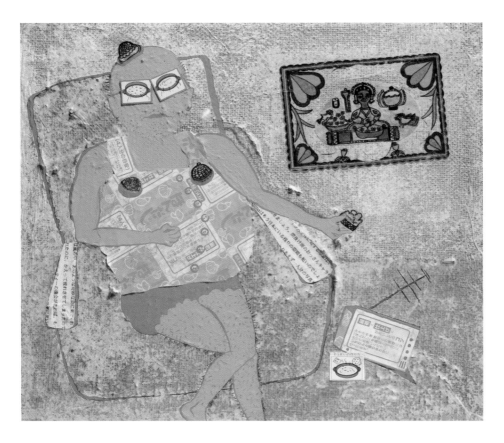

Top and bottom:
Miriam Bröllos, 'When esoterica erotica
Erika left her couch-potato-papa',
paper collage, acrylic on canvas,
each 40 × 45cm (15¾ × 17¾in).
It is a good idea to collect a stock of
materials for this type of work, which you
can use later in your work. You can create
your own pictorial world in this way from old
magazines, objects found in flea markets, bits
of old works or leftover film.

Miriam Bröllos, n. t., acrylic, fine tissue on hessian.
The collage elements in this work are also made of hessian and have been bonded with acrylic binder medium.
The hat has been emphasised by painting over it with a mixture of powdered paper and paint.

Incorporating heavy objects into modelling paste

When incorporating heavy objects you need to be generous with the modelling paste to guarantee a solid bond with the substrate. Hollow items (shells, for example) need to be filled with paste as well. Once the collage has dried, it may be advisable to coat it with acrylic binder to fix any loose parts. It is easier to fix heavier objects with modelling and clear texture pastes than with acrylic binder. The painting ground needs to be adapted for the objects you are going to use. It is advisable to use a heavier ground, depending on the weight of the objects and the strength of the layer of modelling paste. Heavy collage elements need to be incorporated into a rigid support. Light but solid wooden grounds are best.

Shells embedded in modelling paste.

Pieces of mosaic embedded in modelling and clear texture paste.

Use of clear drying texture pastes

If you are going to use collage elements and you do not want to change their own colour or only a little, such as photographs, newspaper cuttings and so on, then these items can be glued with clear pastes. If you add a little paint to clear paste you will obtain layers that dry transparently.

Tissue paper collage

Certain characteristics make tissue paper highly suitable for collages. Their absorbency allows for very spontaneous work because there is no need to soak tissue for long. Applying tissue papers in layers creates very discreet, restrained textures as well as very strong ones.

Shells embedded in clear paste.

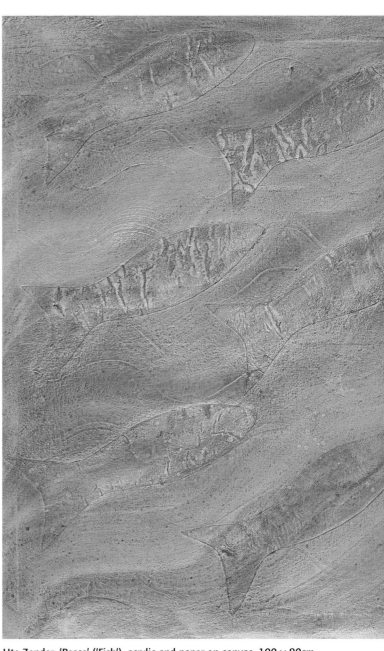

Ute Zander, 'Pesce' ('Fish'), acrylic and paper on canvas, 100 × 80cm (39¼ × 31½in).
The fish were cut out of thin Japanese paper and then stuck to a damp, coloured ground using acrylic binder.

Layers of paper will absorb glue well and can still be shaped easily. Tissue paper can be used to create free forms and areas as well as precise shapes for working figuratively.

Tissue paper is widely available in various colours. The coloured types are neither lightfast nor water-resistant; the paint will bleed strongly. If you paint over an area that has coloured tissue paper stuck to it with a lighter colour, the pigment in the paper will seep through the layer of paint on top: an exciting effect, if that is what you want!

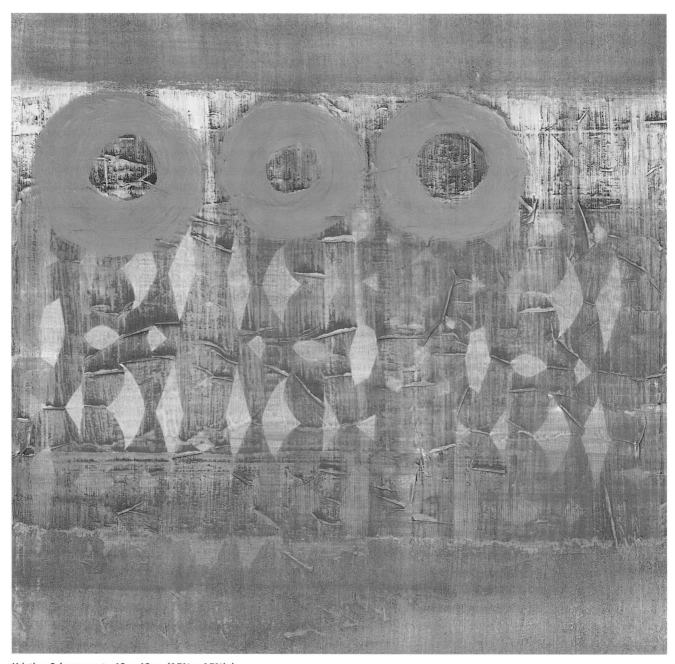

Kristina Schaper, n. t., 40 × 40cm (15¾ × 15¾in).
With this work you can see that the pigment in the red tissue paper has seeped through the layers above it.

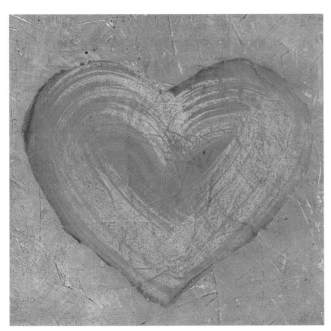

Susanne Westphal, 'Herz' ('Heart'), acrylic and tissue paper on canvas, 40 × 40cm (15¾ × 15¾in).
The ground for this work was created using modelling paste and a spatula. After the colours were applied, a heart torn out of red tissue paper was glued on using acrylic binder.

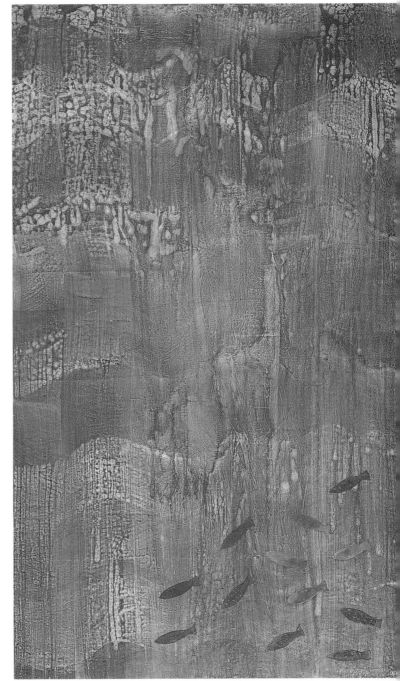

Ute Zander, 'Maroccain' ('Moroccan'), acrylic and paper on canvas, 120 × 80cm (47¼ × 31½in).
This picture was created using many layers of glazing, with acrylic binder painted over the final layer, which has made the paint roll off. Next, small paper fish were glued on with clear medium.

Watercolour techniques

Acrylic paints are well suited to watercolour techniques and make an interesting alternative for keen watercolourists. Unlike watercolour paints, acrylics are not water-soluble when they dry, so the glazing technique opens up other possibilities given that the layers underneath cannot be affected.

The pigment concentration in artists' quality acrylic paints is very high, so it is still possible to blend paints in the same way as in a classic watercolour, even when the paint is very diluted. We advise you to work with artists' quality acrylic paints if you use a watercolour technique.

Thinned acrylic paints are not just for watercolour-type glazing techniques. They have many uses, such as preparing grounds by glazing large areas or to cover the entire painting with glaze and to create different colour effects by glazing figurative or abstract parts of a picture. This technique is also used in layered painting, where dark areas can be built up using glazing.

Varied effects can be created with the addition of mediums and other objects, depending on the painting ground and subject. As with all experimental techniques, the rule here is to test them out before using them in a painting.

Washes

Washes (fade effects) are fundamental to watercolours. Washes are used in different ways depending on the subject, for example depicting the sky or areas of water. Broad washes, with even tones, are often used to colour the painting ground with a uniform background colour.

The effect of a wash depends on the pigment that is used, namely the quality of the acrylic paint, the extent to which the paint is thinned and the nature of the painting ground. The types of washes typical for watercolours are best done on paper, and particularly watercolour paper. The grain – the surface texture and size – affect the way that the paint will dry.

You need to practise applying a streak-free wash to a large area. When working on paper it is necessary to stretch it first to prevent creasing (see page 26). Gentle, gradual fading of colours can be acheived by wetting large areas of the ground with a sponge. Paint spreads out more evenly on wet paper because pigments flow better on a damp surface without altering their colour value. Washes can also be applied on dry paper, but it is necessary to work quickly to prevent the appearance of edges.

Note that it is necessary to mix sufficient paint of the right consistency for large-scale washes. If you run out of paint halfway it is difficult to mix more before the areas you have started on have dried.

Work with a large soft brush and apply even brushstrokes with light pressure. There is less risk of creating stripes if you apply a few broad strokes. You can also control the flow of paint more if the ground is at a slight angle.

It is advisable to add ox gall liquid (available from artists' shops) to reduce the surface tension if you are going to apply washes to smooth, non-absorbent surfaces.

Wet-in-wet painting

The technique of wet-in-wet painting gives the most expressive and beautiful results in watercolour painting. This technique is best used on watercolour paper. Be sure not to use very smooth or heavy paper – rough, absorbent papers are ideal.

A great deal of practice and experience is needed to achieve certain effects with wet-in-wet painting. With time you will be able to judge how wet the paper needs to be and how much to dilute paints to be able to control spreading and running. For figurative subjects, you should first make a preliminary drawing with a pencil if you are going to dampen the entire surface of a piece of paper evenly with a sponge or a large flat wall brush, to make it easier to apply the different colour shades.

This technique, however, must be applied with a resolute and broad approach. Allow the areas of paint to run into each other, without drawing the brush over the surface of the sheet for too long.

You can blot excess paint with a tissue. If you lose control over areas of paint or they run in the wrong direction, you can also absorb paint with a dry brush.

If the paint is applied too thinly at first, more layers can be applied using the same technique when it is thoroughly dry, giving the picture greater depth. You can also achieve colour effects and textures by means of superimposing several strongly flowing paint layers, which one would not be able to do using an opaque technique.

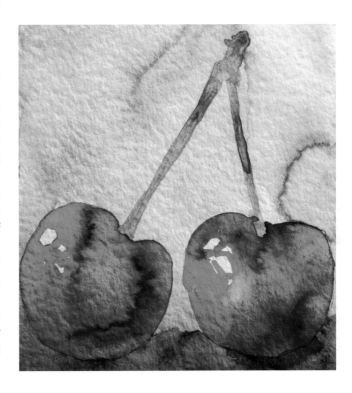

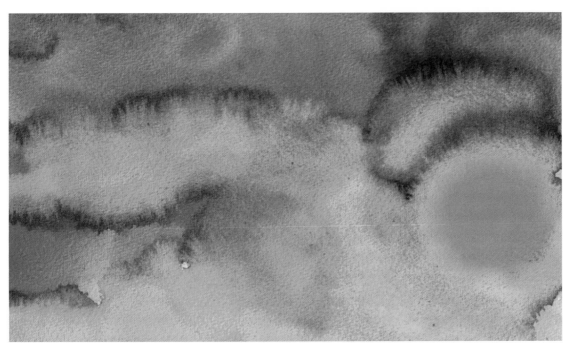

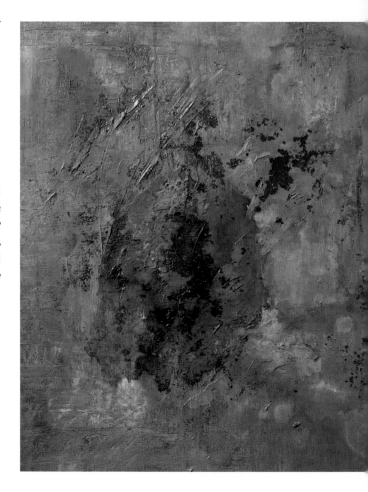

Effects with methylated spirit
You can achieve interesting textures and bizarre shapes if you drizzle some methylated spirit between the thin layers of the glazing. The methylated spirit displaces the water and any pigments in it. This rather random effect produces shapes which would be difficult to paint by hand. This method achieves the best effects on grounds that are only slightly absorbent or not at all absorbent.

Bronze gold powder is sprinkled on a watery surface. Spraying on methylated spirit will displace both the bronze powder and the water.

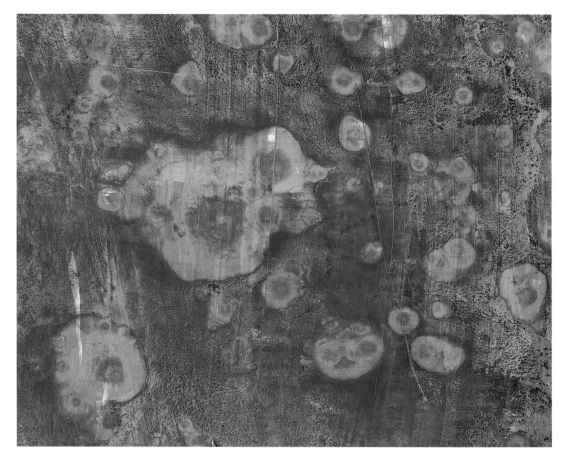

Effects with salt

Other effects can be achieved by sprinkling salt on wet paint. Sprinkle cooking salt or coarser sea salt on a layer of wet paint as it begins to dry – when it loses its surface shine. The salt absorbs the water, resulting in unusual textures. This technique requires somewhat longer drying times.

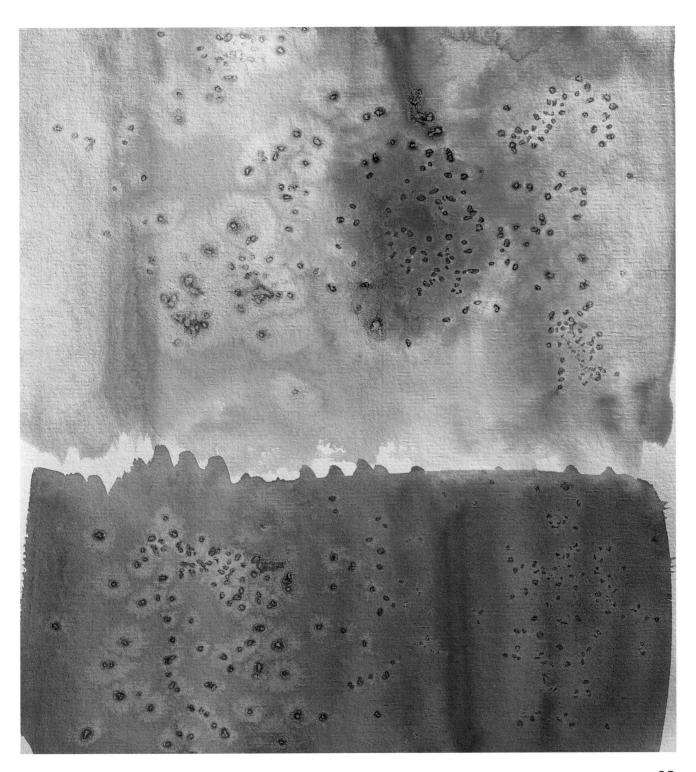

Wet-on-dry painting

In this classic technique, shades of colour are superimposed on to glazed layers. Each layer has to dry completely to prevent the paints from running into each other. Thin superimposed glazes give a fuller colour effect than a flat wash in a rich tone. Particularly fine-detailed work can be created using this technique.

Unlike the wet-in-wet technique, smooth, surface-treated papers are preferable here because they provide a ground on which paint will take longer to dry. In the case of pure glazing, you need to ensure that you do not superimpose too many layers, in order to retain a fresh colour effect. As with most acrylic painting techniques, you need to stop in good time to avoid 'painting to death'. When you are painting make sure that the brushes you use to apply pure, bright glazes are clean – rinse them thoroughly between sessions and regularly replace the water that you use to thin the paint.

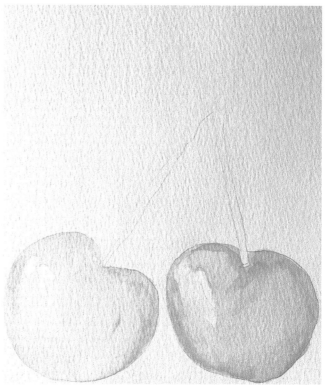

Airbrush paints were used for these cherries. After a light preparatory drawing with a pencil, the first weak layer of colour was applied to the background. The cherries were first painted once the background was dry to prevent the paints from running into each other.

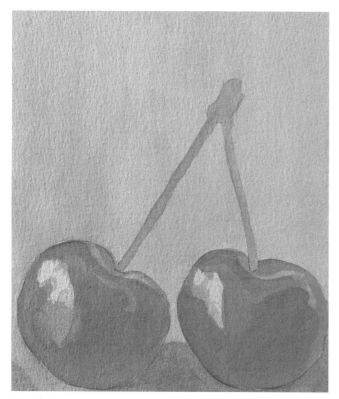

After drying, the next paint application follows with some more intense colours. The bright areas are done in reverse here.

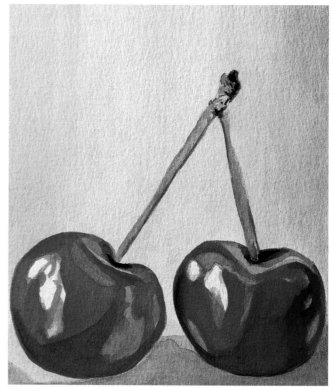

Further light towards dark layers are applied in this way, while thinning the paints less and less.

Applying highlights

In classic watercolour technique a picture is mainly built up from light to dark, and the highlights are usually created by leaving white areas unpainted ('reserved'). White as a paint is completely absent in traditional watercolour techniques; the paint is applied most thinly in the brightest parts of the painting, so that the white of the ground shines through. If you want to use acrylic paints for watercolours, you can follow the same rules as the traditional watercolour technique when it comes to pure wash techniques, if you want to achieve the same results. Adding white paint would make the transparency disappear.

Use of white paint

It is also possible to apply highlights or lighten areas with white paint as a final touch to an image built up from layers of glazing.

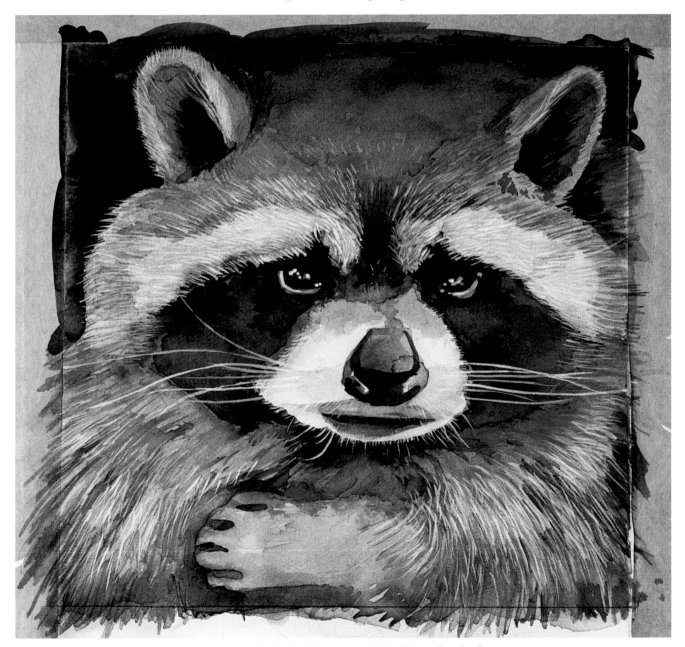

The white hairs and the light in the eyes have been applied with white opaque paint in this small study of a raccoon.

Lifting off paint

Another possibility for creating highlights is to remove damp paint with a cloth or a cotton bud. The highlights created in this way have soft edges compared with the reserved areas. This is a way of creating colour transitions that can be used when painting clouds or matt objects. Note that it is only possible to remove acrylic paint when it is damp, unlike watercolours. Exposing layers of paint by lifting them off achieves varied colour effects.

Scratching out highlights

Very fine highlights can be scratched out using a scalpel or cutter. Be careful when using this scratch technique so as not to damage the ground. It is usually easier to work with coarse, rough paper than with canvas. Use sandpaper of different grades if you need to work over large, flat areas.

Airbrush paints were applied with a brush in this study of a dog's eye. The bright areas were scratched with a scalpel.

Masking fluid

If you wish to reserve white areas within a detail use masking fluid before applying the first layer of paint. Masking fluid is a rubbery white liquid that is colourless when dry and can be rubbed off afterwards. Watery colours will roll off the surface and paint will not cover a ground that has been masked in this way.

It is useful to make a preparatory drawing when working with masking fluid in order to define the areas that are to be masked. Applying the fluid with a brush creates fine detail as well as interesting structures. The brushes you have used to apply the masking fluid need to be cleaned immediately after use; the dried masking liquid will glue the hairs together and is very difficult to remove. It is advisable to use very old or cheap brushes for this kind of work.

The great advantage of masking is that it avoids the need for laborious painting of very fine highlights. Once it has dried, masking fluid is easy to remove with a plastic eraser or your fingertips when the glazes on top are completely dry.

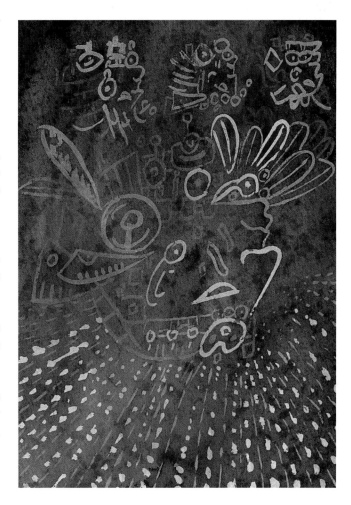

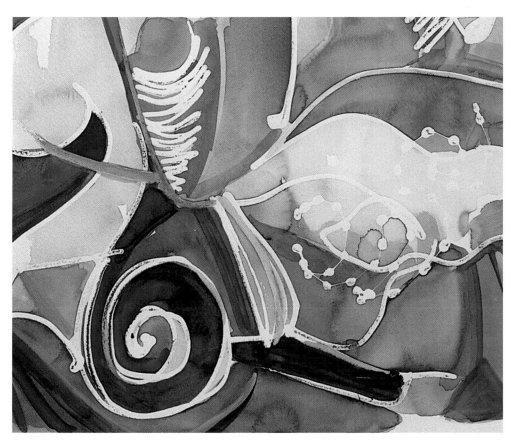

Resist technique

Another method of creating highlights or lighter shades is the lift-off technique. With this technique you go over the painting ground or areas that have already been painted using materials that repel water, and which therefore repel acrylic paint.

Wax (candle wax) or wax crayons and chalks are suitable for this, as are oil pastels or turpentine. Each material has its own particular effects.

The resist technique also works well with transparent-drying adhesives or wood glue as well as acrylic binders. Structures with joint sealant also give interesting effects. Follow the manufacturer's instructions in all cases. These materials also resist paint and the raised textures of the materials that you apply can be used as elements in the design. Unlike masking fluid, these materials remain on the substrate.

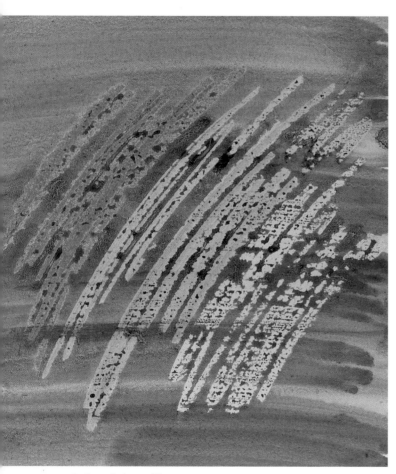

Resist technique with wax crayons.

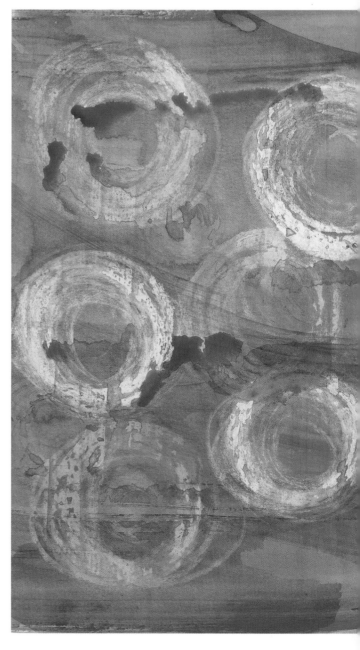

Resist technique with candle wax.

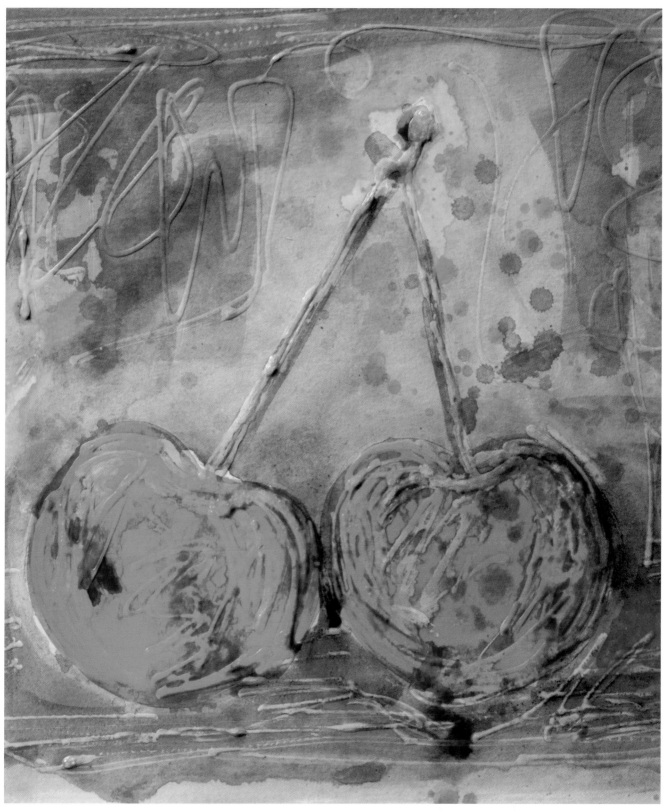

Resist technique with transparent all-purpose adhesive. This is worked from light to dark. Further areas of the picture are covered with glue after each session.

Watercolour-style paint application on a textured ground

Use of texture pastes

The texture pastes that are available for applying impasto and raised surfaces can also be used to liven up the ground if you are using the watercolour technique. Light texture pastes are particularly suitable for working on paper. The contrast between the raised textures of the pastes and the soft colour transitions can be very engaging.

Carving technique

If the paper is carved with a sharp object (e.g. with an etching needle) before paint is applied, then the paint will particularly penetrate those places and make the lines look darker. Watercolour paper should be used for this technique.

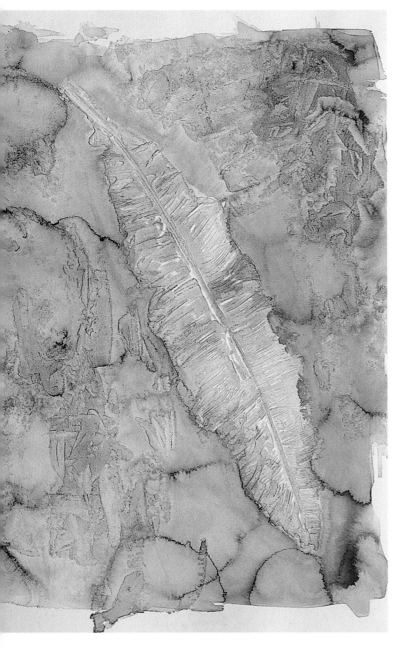

Texture with white paint

You can achieve a very fine texture if you first paint the subject with a bristle brush and unthinned white paint. Once the paint has dried you can apply the glazing layers as usual.

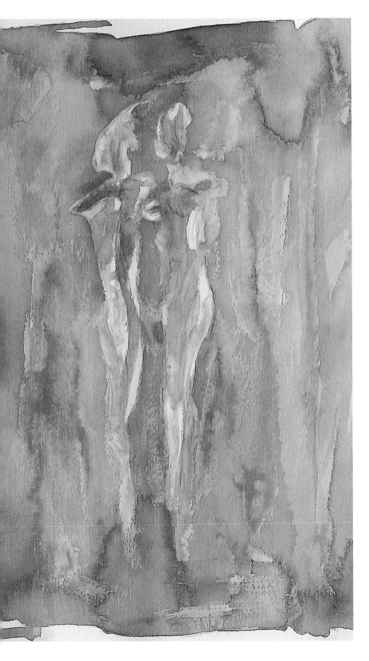

Layer painting

The classical treatises on painting techniques and their classifications differentiate between *alla prima* painting and layer painting, the latter concerning mainly tempera and oil painting. Pure glaze painting is generally considered to be typical of watercolour painting.

Acrylic paints can be used with virtually every technique, from building up colour in watercolour glazing via opaque painting, to heavy impasto, without the need to be concerned about the physical characteristics of the paints while you work, as is necessary with other paint systems. For this reason the distinctions between different painting techniques are less clear when using acrylics. The short drying times make it easy to paint over previous sections where you have used a layering technique. Consciously making use of layering as part of your method is a different thing altogether. This type of layer painting, which is often somewhat confusingly called the 'old master technique', is a method of organising the structure and colouring of your painting that assumes that the layers of paint are applied to a monochrome underpainting.

One approach is to apply a monochrome glaze using grey or ochre on top of a preparatory drawing in Siberian chalk (compressed charcoal) or chalk that has been fixed with thinned paint. The lines of the preparatory drawing shine through this *imprimatura*, which forms the basis for the underpainting. A grisaille – a painting technique that uses only shades of grey (French *gris*), ranging from the lightest shades to pure impasto white and, in the darkest shadows, from dark grey to black – is then applied. Once you have finished the grisaille, in which you have focused only on modelling the forms and the light–dark shading, the colours are applied in thin layers with glazing or semi-transparent techniques, so that the underpainting shows through the colours. This method often uses the principle that light parts are semi-transparent while darker shades are created with glazing techniques.

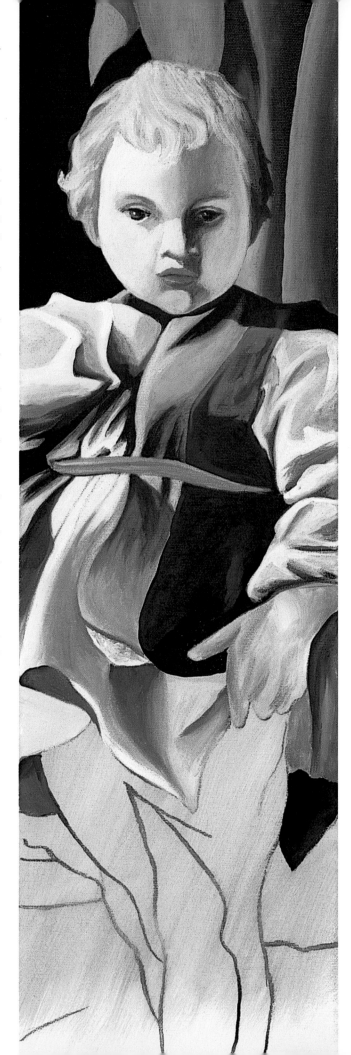

While pure grisaille is a neutral underlay for all colours, coloured underpainting will affect the subsequent colour effect. Renaissance painters worked according to two different principles with coloured underpainting. The underpainting was either created using shades similar to the subsequent layers of colour, which is how Leonardo da Vinci often worked, or the contrasting effects of complementary colours were used in the underpainting. Thus, the old Sienna masters, such as Michelangelo, used an underpainting of green earth, known as *verdaccio*, as a complementary contrast in flesh tones for figures or portraits.

In the case of all these underpaintings, which were mainly painted in tempera, a finishing layer of egg tempera or oil paint was applied either as a glaze or semi-transparent layer in accordance with the old rule of 'fat over lean' (i.e. flexible over non-flexible).

This technique of painting in layers over a preparatory underpainting can also be used with acrylic paints. The final result will look somewhat different from the same picture in oil or tempera, mainly because acrylic paints lose volume when they dry.

Unlike with acrylic paints, the real thickness of the layers increases during the combined oil and tempera painting process because oil and tempera paints retain their body after drying.

In modern painting, polychrome, highly coloured underpainting, is used. No artist would call this an 'old master' layer painting method, even though the process is similar – the design is applied in the first underpaintings which then partly determines the colour effect of the subsequent layers.

This example gives a simplified view of how a picture is built up in layers. The preparatory pencil drawing is followed by a grey primer in Raw Sienna. The underpainting was then applied in black and white and only then were the colours developed.

Spattering acrylic paints

Spattering

Spattering paint can create gentle accents or enliven whole areas of a picture. This technique can also be used to give shape to flowers and fields in landscape painting. You should thin the acrylic paint with water until you can spatter the surface using rapid flicking movements of the brush. First practise spattering paint using a trial piece. This will help you to learn to control the paint mix and use this technique effectively.

Ute Zander, 'Mare' trilogy, acrylic on canvas, 120 × 50cm (47¼ × 19¾in).

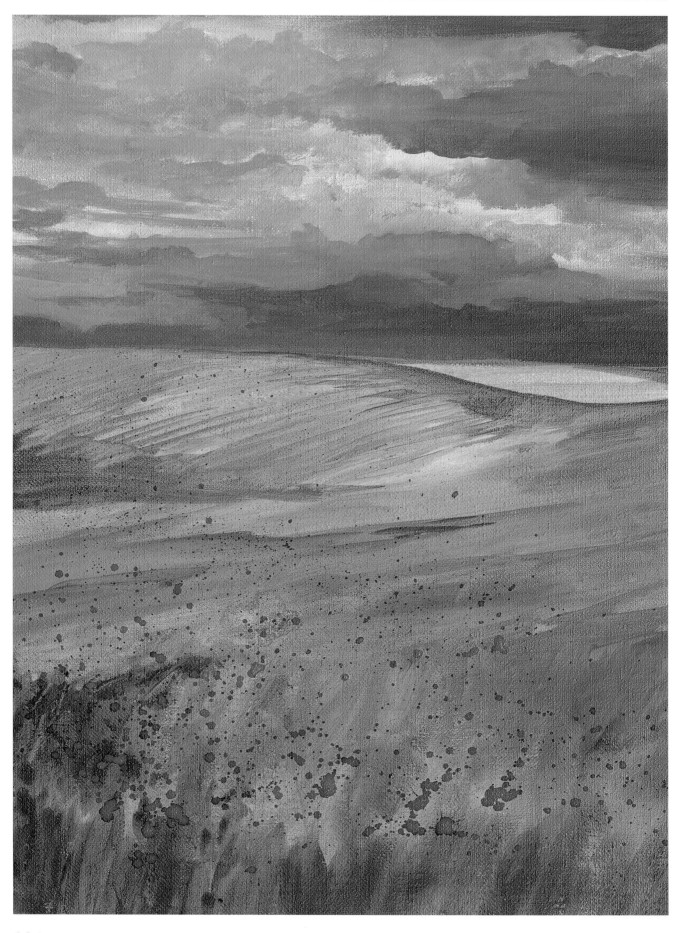

Spraying on paint with a brush

One can achieve a fairly even pattern of fine spray by spraying on paint with a toothbrush, a brush with short bristles or a spatter sieve. Draw your finger across the brush and small drops of paint will be sprayed on to the surface as the bristles spring back.

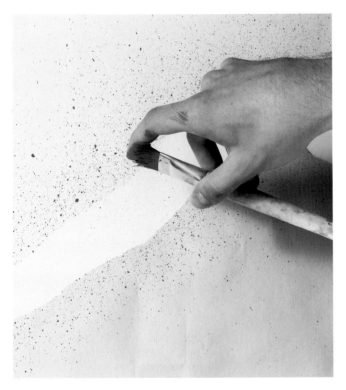

Spray technique with a spray gun

Using a spray gun is helpful if you want to apply an even spray pattern over large areas of a picture. There are models that can be filled with normal thinned acrylic paint. Although high-quality acrylic paints will dissolve well in water, it is still best to use a strainer when filling a spray gun to prevent dried paint left in bottles or tubes from blocking the nozzle. If you are going to use a small airbrush you need to use special airbrush paints. Normal paints would quickly block the fine nozzle because of their larger pigment particles.

The droplets in the spray will vary in size depending on the paint quantity and how you set the air pressure.

Spraying a surface with water followed by paint will create a different effect. The blobs of paint that hit the wet drops of water on the paint surface will run, so the pattern will appear softer.

The colour of the ground will remain if you remove the larger drops of water with a tissue when the paint has dried.

Another way to embellish areas in a picture is by spraying on acrylic medium or thinned acrylic binder. The acrylic binder will dry colourlessly and the next layer of glazed paint will not cover the spatters.

106

Norbert Drossel, 'Nautilus pompillus', acrylic on canvas, 100 × 100cm (39¼ × 39¼in).
The soft transitions in the water area were created with the use of a spray gun.

Airbrushing

The airbrush technique makes it possible to create pictures that make the viewer wonder whether it is a photograph or a painting, depending on how detailed and careful the work is. This effect is created from the interplay of very soft, continuous transitions and extremely sharp edges between individual areas. The fine colour transitions made with the use of an airbrush appear simple, but they are entirely dependent on the care with which the preparatory work is carried out. Each area needs to be cut out with masking tape and the areas in the picture that are not going to be worked on must be completely covered to prevent them from being sprayed with a haze of paint. You can find more detailed information about this remarkable technique in the relevant literature.

Armin Probst, 'Karotten' ('Carrots'), acrylic on cardboard, 50 × 17cm (19¾ × 6¾in).

Experimental techniques with acrylics

The much-praised simplicity of their use and the technical versatility of acrylic paints make it possible for artists to venture in new directions. Experimentation with new and old painting techniques that were previously limited to other paint systems continues to produce unusual results.

Although it is often said in artistic circles that in principle there is nothing new under the sun and one cannot expect any fundamental innovations in the art of painting, it is nevertheless still possible to achieve new results by combining the relatively new medium of acrylic paints with unusual materials. This is not only about two-dimensional work. Acrylic paints have been used for a number of years for decorating objects. Acrylics are also increasingly being used in commercial painting, theatre and set painting, interior and wall design, as well as for three-dimensional works of art. This leads to more and more experimental painting methods using established processes and imitation materials which are of interest to artists and amateur painters. Other types of acrylic-based paints, such as lacquers, are used for industrial applications, and we present some of these techniques here.

Oliver Löhr, 'Engel' ('Angel'), acrylic on canvas, 120 × 80cm (47¼ × 31½in).
A section from a painting by Caravaggio served as a model for this work. The figure of the angel was created on a multilayered background which was developed with further layers of glazing and also partially sanded down again.

Dripping technique

The American Jackson Pollock developed this technique in about 1947 and later used it for his most famous paintings. He was one of the most technically innovative exponents of Abstract Expressionism and was always looking for new techniques with which to achieve continuous lines. Pollock was interested in avoiding interrupted lines, which were the result of having to constantly dip his brush into paint. Pollock solved this problem by dripping ordinary household paint from a stick on to an unstretched canvas on the floor. Pollock controlled the intertwined lines by changing the degree to which the paint was diluted, the angle of the stick to the paint surface, and thus the speed of flow, and not least the dynamism of the movements, rhythm and energy with which he allowed the paint to flow and drip. These gestures remind us of the Surrealists' automatic drawings. This was the start of what became known as Action Painting. Pollock used other methods in addition to the dripping technique, such as hurling or pouring paints directly from their containers on to what were sometimes giant canvasses.

If you want to try this technique yourself then you will need to put your painting support on the floor with the larger formats, so you can walk around and work on it from all sides. Acrylic lacquers are most suitable for this technique.

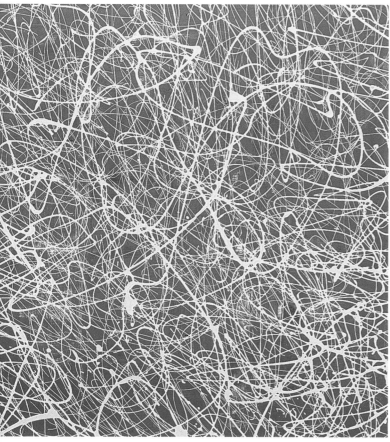

Acrylic lacquer trickled on to a dry ground using a wooden spatula.

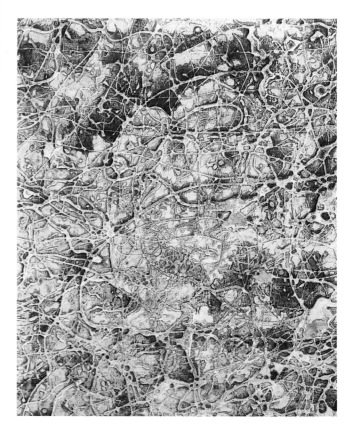

Dripping textures with glazing applied over them.

Spraying paint with water

If you want to soften the sharp outlines of the acrylic paints that result from trickling, it is advisable to dampen the fresh paint with water from a spray gun. This will create watercolour-style flows.

Applying paint with a roller

Well-stocked art shops and builders' suppliers have a large range of rollers for painting and lacquering. They can also be used for applying paint in art. The texture of the paint as you apply it depends on the material the roller is made from.

If you work over damp areas of paint with a dry roller you can create very exciting effects. Another possibility is to blot various colours on to the surface of the roller and then roll these off to create a pattern of repeating marks.

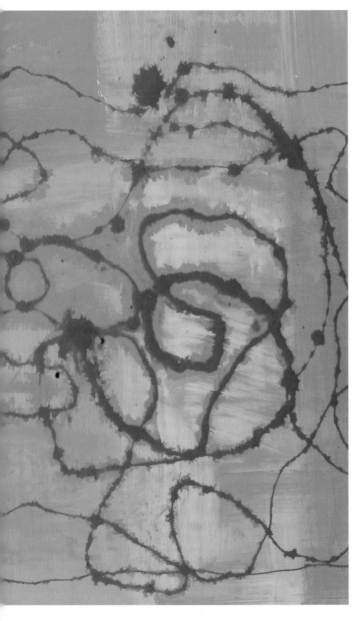

Paint applied with a lambswool roller.

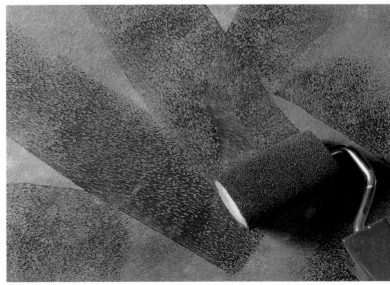

Paint applied with a foam roller.

Paint application with a sponge

Elements such as foliage or weathered stones can be created using various types of sponge to apply paint. Natural sponges have an irregular surface, while synthetic sponges generally have an even texture. You can use sponges to apply paint to larger areas. You can round off the straight edges of many synthetic sponges by cutting or pulling off pieces.

Sticking down areas

Straight lines or areas with very straight edges can be created with adhesive tape. Adhesive tape is easy to pull off from dry paint without harming the substrate. Once you have masked the areas you are going to paint over, you can apply the paint. When doing this you need to direct brushstrokes from the outside edges of the picture inwards. This leaves less paint being deposited on the edges of the adhesive tape and will make a cleaner edge. Pull off the adhesive tape as soon as the paint has dried a little, otherwise the adhesive tape may stick to the paint and become difficult to remove, particularly when painting over thicker layers.

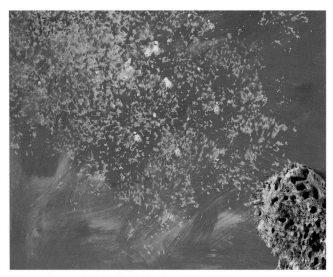

Applying paint with a natural sponge.

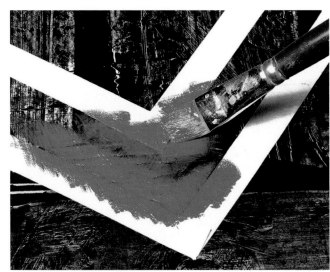

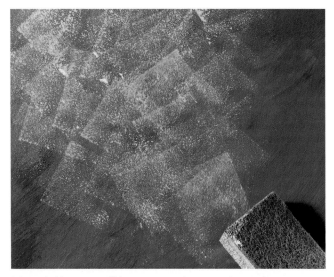

A household sponge will leave a somewhat neater impression with straight edges.

Sanding down a textured ground

The modelling and texture pastes that have been specially developed for artistic applications can be worked with again when dry by sanding them down. It is possible to correct very dominant elements in this way. Sanding down a previously painted area will create interesting effects by revealing the texture of the ground underneath. Use fine grade sandpaper (120–160) or wet-and-dry paper (waterproof sandpaper).

If you do not like the white texture, you can use coloured modelling paste to apply the ground.

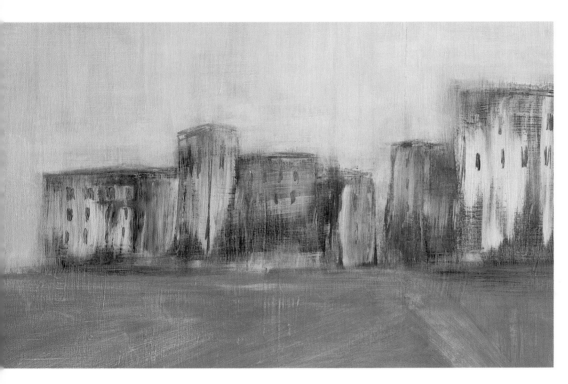

Ute Zander, n. t., 80 × 140cm (31½ × 55in). The outlines of the houses and the windows have been scratched out in multiple layers of colour. The paint has been applied with a cardboard spatula and sanded down afterwards, so that the lower layers are exposed again.

In this example, the light-bodied texture paste has been applied with a spatula. Once thoroughly dry, the paste was covered with a glaze and subsequently sanded down (painted by Ivonne Ernst).

Stencils

Paint can be applied with the help of stencils to create a shaped area in a picture. A wide choice of ready-made stencils is available from craft shops, but you can easily make them yourself. Supposedly 'kitsch' stencil patterns can also be used; an interesting area can be created by repeating and staggering the stencilled paint.

A stencil brush or blunt bristle stippler brush is particularly useful for applying the paint. You should be careful not to load too much paint on the brush. This can easily creep underneath the edges of the stencil, making the outline blurred.

If you wish to emphasise the relief of an element very strongly, you can prepare the stencil for this purpose and then apply modelling paste or a very heavy-bodied paint. The thicker the material from which you have cut the stencil, the more three-dimensional the effect will be.

A ready-made stencil pattern can create an interesting area by repeating and shifting it.

The squares have been created with modelling paste and a home-made cardboard stencil.

Decalcomania

The term decalcomania (or transfer) was coined by the Spanish painter Oscar Dominguez. He discovered a technique where paint is brushed on to a sheet of paper and another piece of paper is lightly pressed on to the first sheet. The top sheet is then carefully lifted off to make the imprint. Particularly delicate textures are created using paper that only absorbs a little of the paint. The German surrealist Max Ernst was the most famous artist to experiment with this technique. This technique can also be applied to acrylic paints.

If you place a thin piece of film on a pane of glass that is covered with acrylic paint (it makes sense to add retarding agent to slow down drying) and then pull this off again, you will create interesting textures. You then have the option of pressing the wet film on to the painting ground or putting a sheet of paper on the glass plate. You can then work further on the sheet of paper that has been textured with this method using various techniques or use it as material for a collage.

Bright colours are imprinted on dark paper.

You can create textures that are typical for the decalcomania technique if you squeeze paint between two surfaces and then pull these apart. The pattern always runs in the direction in which you pull.

115

Lifting off paint

If a painted surface is applied directly to a painting ground, then some paint can be removed if you pull it off carefully by placing crumpled paper, a piece of fabric or film over it. This method will keep the image areas intact.

This technique is also suitable for depicting wood, stone and rock textures.

This effect is created by lifting the paint off with crumpled and reflattened paper, which you lightly press on the paint ground before removing it again.

Using crumpled plastic film, which can also be pressed harder and removed again, creates a different effect because the film does not absorb any paint.

Simple printing techniques

Acrylic paints are also used for simple printing processes such as monoprints or block printing. You can also add retarders or even wallpaper paste because acrylic paints dry very quickly. Here, we must say that the possibilities of printing with acrylic paints are generally limited. More delicate textures and surfaces can only be achieved with printing inks developed especially for the purpose. However, backgrounds printed with acrylic paint have their own attraction and such kinds of printing can be worked on further with other techniques.

Monoprinting

In monoprinting only one print is drawn from cardboard, glass, perspex, metal or any other flat surface. As the name implies, the print cannot be reproduced because this technique does not use any printing blocks or plates. Every print is unique, because the printed image changes every time that paint is added to the printing plate and with every subsequent imprint. Monoprints are easy and quick to make. Put some paint on a level, non-absorbent surface, and spread it out with a plastic eraser or plastic roller or with a brush and develop a design. Place a sheet of paper on the surface, press on it with your hand or roll over it with a clean rubber roller. Lift the paper carefully from the plate and let it dry. If you want to make several different prints from the same plate, you can add more paint and print again. You can print from the same plate on the same sheet once the sheet has dried. When you are printing ensure that the paint on the plate does not become too dry – mixing retarder with the paint will keep it soft for longer.

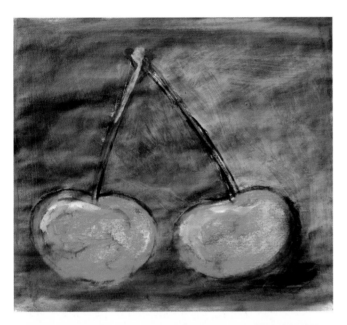

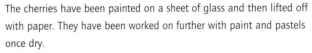

The cherries have been painted on a sheet of glass and then lifted off with paper. They have been worked on further with paint and pastels once dry.

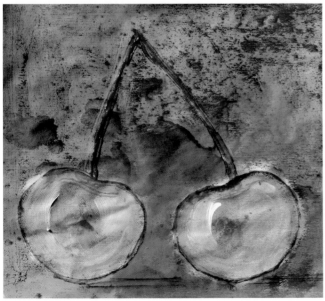

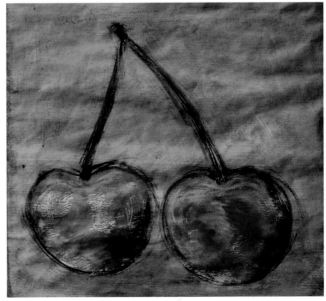

Drawn monoprints

To connect lines with planes in a monoprint, draw on the back of the print with a pencil or ball-point pen while it is still on the printing plate. The pressure of the pencil or pen will transfer the paint from the printing plate on to the paper. Several colours can be printed at the same time with this technique. However, the printing paper should be held on to the plate with adhesive tape on one side in order to prevent it from slipping out of place. The paint is spread on the plate during the first print run and the drawn elements are printed on to the paper. Only the elements that you require will be drawn at this time. After the first proof, the paper is pulled off and folded back from the plate along the adhesive tape. The plate is then carefully cleaned and the next layer of colour is applied. The printed sheet is folded back over the plate again and the next motifs in the design are added. Carry on like this until the print is completed. Attach a sketch under the glass plate so as to position the individual colour areas correctly if you are making a multicolour printing.

Many artists have worked with this fascinating technique and applied more colours to the completed monoprints. One of the most famous was Paul Klee.

Two simple examples of monoprints. These have been printed on light and black paper respectively.

Block printing

Acrylic paints are also suitable for simple block printing. Blocks are easy to make from different materials. It is easy to turn halved potatoes or other hard root vegetables such as carrots and swedes, or fruit such as apples, into blocks or stamps with linoleum cutting gouges or knives. These printing stamps must be used as soon as they are made because they quickly shrink or go mouldy. Before you begin, when the motif is either cut or inscribed in the printing block or stamp, there are a few features you should watch out for. Because the parts of the printing block that are not engraved will carry the paint, the engraved parts will stay white on the print. If you want the parts of the printing block that are cut to appear dark, then print using a light paint on dark paper.

The print is always a mirror image of the original pattern. Numbers and letters have to be carved in mirror image in the printing block if you are going to print them correctly.

When the block or stamp is ready, spread the acrylic paint over it with a brush or roller and then press it on to the print surface. This method also enables you to make a repeat pattern or a continuous sample.

Stamps and smaller printing blocks can be made from other materials such as sponges or Plasticine. If you use stamps made from sponge, you should wash them thoroughly after use in order to keep their flexibility. Plasticine can be used to make unusual printing stamps. It is crucial here that the top and bottom of the block that prints the drawing or the design is flat and even. You can also make prints with objects embedded in Plasticine such as coins, crown caps or staples. Paint printing blocks created this way with a brush, lay the paper for the print on top of the stamp (which is on its back) and press down carefully with your hand. The sheets that you have created can be applied in further collages or reworked with other techniques.

In this example the block is a stamp cut from a potato.

This example has been printed from coarsely woven strips brushed with paint – just one instance of the possibilities of printing from materials.

Paint applied with
a sponge.

Mixed techniques

The range of expression in painting can be expanded by combining techniques and paints from different paint systems, revealing new ways of creating both figurative and abstract work.

As has been previously described in the section on painting in layers, Renaissance artists already used different kinds of paints in the same picture. With the increasing development of paint technology the potential combinations multiply all the time.

For instance, in the mid-nineteenth century the French painter J.-F. Millet combined pastels, watercolours, oil paints and black Conté crayons in his studies. Twentieth-century artists disposed of all technical and stylistic conventions and created entirely individual forms of expression by combining the most unusual materials.

Jaxon oil pastels from the Honseil company (available in seventy-four colours) and their chalk pastels from the Jaxell series.

Acrylics and soft pastels

Acrylic paints and pastels can be used not only on top of each other but also mixed together. Because pastel crayons are soluble in water, the transition from the more graphically created areas to the painted ones can produce intriguing results. Some pastel artists use the textured masses in the underlayers of the picture composition and place the accents on the textured top surface with pastel crayons. Other artists incorporate ready-made mediums on layers of pastel in order to fix these and to achieve different colour effects. If you mix chalk pastels with acrylic medium or clear texture paste on the palette, you can also use them for impasto work with the character of pastel painting.

Areas of acrylic paint can be worked over with pastels without any problems. Larger areas can be created with either opaque or transparent acrylic paint and then reworked further with pastels. If pastels are used in the top layer, the picture must be finished with a layer of fixative.

In this example, the underlayer has been brushed out with a fine, coloured modelling paste. The cherry design was created with a thinned acrylic paint and further developed with pastels. The pastels adhere particularly well to the lightly textured ground.

In this work by Julia Weidle, the colour accents have been applied with chalk pastels and provide a beautiful contrast to the soft, translucent painting.

Colouring drawings with acrylic paint

Acrylic paints are suitable for colouring drawings which have been created using watercolours or India ink washes. Works created in pencil or crayon may lose some of their graphic character as the cross-hatching or the shaded areas can be washed over with acrylic paint. An acrylic wash can be added to pen drawings made with water-soluble India ink or with a stylograph to add further interest. Soluble colour pencils can be used with diluted acrylic paint in a similar way to watercolour paints. The possible combinations are endless if you add graphic elements to acrylic paint; you can add these elements with fine liner pens, fountain pens, ball-point pens, felt-tips and markers. Acrylic paints are commonly used for colouring in commercial artwork and, in a slightly modified form, for animated hand-drawn cartoons.

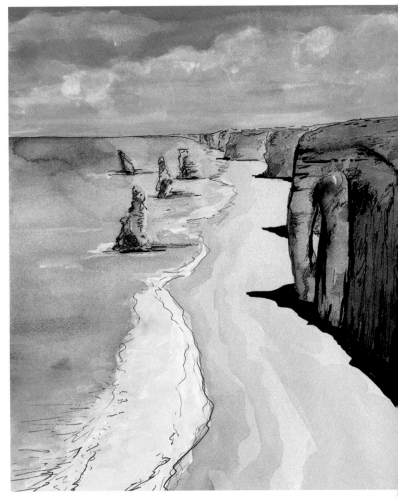

Drawing with a marker pen and fine liner pen, painted over with airbrush paints.

Coloured pencil drawing.

123

Acrylics and oil pastels
Oil pastel crayons can be applied to areas painted with acrylic. The coarse texture of the rubbed crayons can make an appealing contrast to the saturated colour areas. If you add a glaze to a surface treated with oil pastels, the colour of the pastels will come off in small beads.

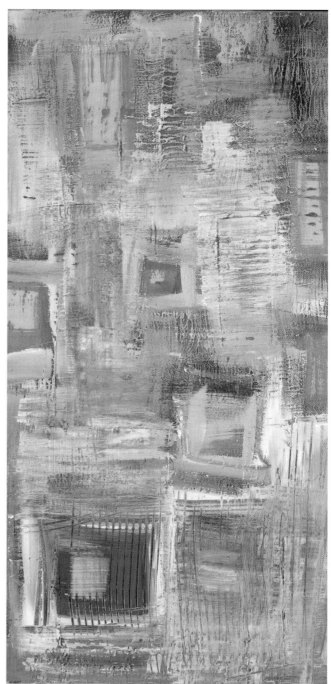

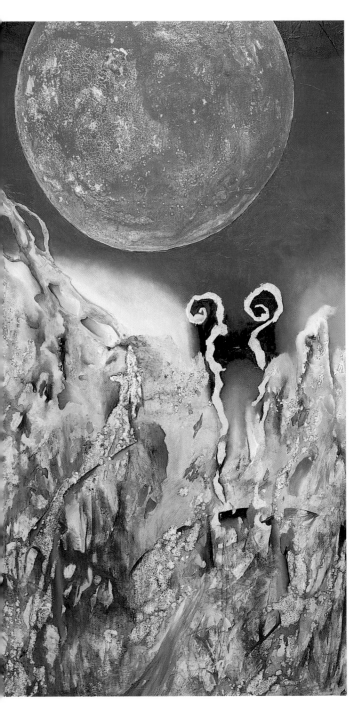

Acrylic and oil pastels / alkyd resin paints
In the combination of acrylic and oil paint, acrylic is excellent for underpainting as the relatively short drying time enables direct overpainting with oil. Unless you are deliberately trying to achieve a crazed surface, you should never put a coat of acrylic on top of oil paint.

Oliver Löhr, 'June V', acrylic on hardboard, 100 × 80cm (39¼ × 31½in).
The painting ground under the red area was sprayed with glue and sprinkled with vermilion pigment.

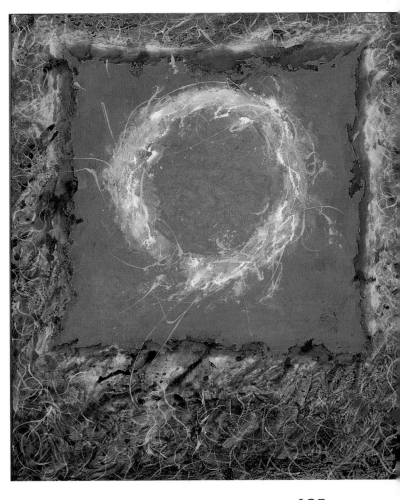

Oliver Löhr, 'Karo kiling', acrylic, watercolour and oils on hardboard, 120 × 80cm (47¼ × 31¼in).
The white primer was applied with a spatula. A multilayered image with glazes was then laid over this ground. Accidentally created textures were reworked with oil paint. The sky and the flowing transitions were also painted in oil.

Acrylics and airbrush paint

If you work with glazes a lot, you should experiment with an airbrush. Airbrushing uses highly concentrated water-based paint made with extremely fine pigments to avoid clogging up the nozzle of the airbrush, which can be easily damaged. Usually only a few drops of this concentration are needed to cover large areas. Most manufacturers provide bottles with droppers, which makes measuring the dosage much easier. The flow characteristics are different from those of strongly diluted conventional acrylic paint because of the change in the proportion of medium to fine pigments. This makes airbrushing paint suitable for glazing techniques.

Acrylics and oxides

To give surface areas and certain parts of a picture an eroded and antique character, you can add patina solutions. There are different products available from retailers. These products consist mostly of a primer colour with metallic particles and an appropriate oxidation medium. In order to achieve a rusty surface, a primer is applied to the area to be painted and brushed over with the oxidation medium when it is completely dry. The chemical reaction occurs after a few hours and the areas that are treated begin to 'age'. You can create verdigris and other patina effects in this way. Distinctive strong effects can be achieved depending on how thickly the primer and the reaction solution are applied. Follow the manufacturer's instructions in all cases. It is advisable to use inexpensive brushes if you are going to work with these materials because they will attack the brushes. The American manufacturer Modern Options offers a large selection of different patinating sets.

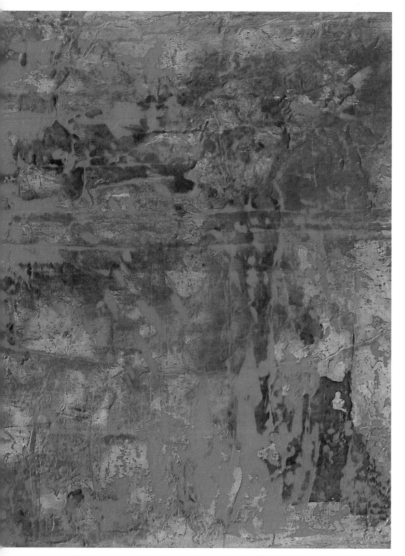

The transparent background was glazed with airbrush paint. After drying, the red paint was applied with a large cardboard spreader.

This canvas was covered with modelling paste and painted in several layers. The patination solutions were applied next.

Acrylics and shellac

Shellac is made from the resinous secretions of certain species of beetle and is used for the high-quality finishing of wooden surfaces. Shellac flakes are available commercially. They are dissolved in denatured alcohol and have a bright yellow to dark amber colour depending on the type. A coat of shellac gives pictures depth, and a yellowish, apparently aged surface. Because of the high gloss finish it creates, it is possible to use shellac to create attractive contrasts between glossy and matt surfaces.

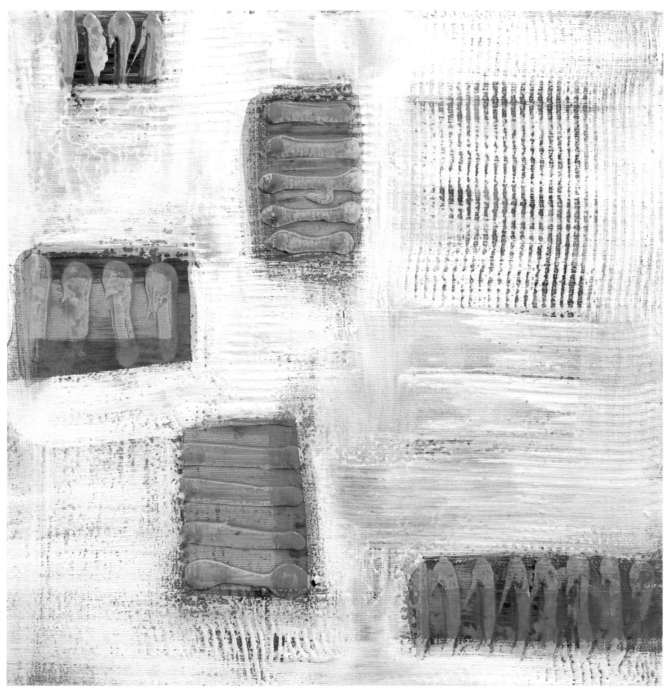

Kristina Schaper, n. t., shellac and sand on canvas, 40 × 40cm (15¾ × 15¾in).
Shellac was applied only to certain parts of the picture.

Acrylics and watercolours
Acrylics and watercolours, which have different features, can of course be combined. It is possible to build up the underlying layers of a picture with acrylic glazes, as well as the places that are not to be changed by overpainting, and then to develop these with watercolour paints.

Acrylic with crazing medium
Crazing mediums or crackle-finish lacquers are available from craft shops. This is a liquid that can be used to create interesting cracks in the top paint layer. The liquid in the crazing medium itself is colourless so the underlayer shows through. Brushing a crazing medium over a blue surface and then brushing red paint over it when it is dry will create a red surface with blue cracks. Always follow the manufacturer's instructions.

This coloured undercoat was brushed with a crazing medium and then painted over.

When it was thoroughly dry, the picture was given further layers of paint. In this method the cracks show less strongly in the foreground.

Options for correction

The short drying times of acrylic paint commonly lead to a somewhat rapid working method. A mistake in selecting a colour may show up only when the last paint layer is applied. As long as the paint is still fresh, you can remove it with water. Pictures that are painted on rigid carriers or canvas can be soaked in the bath and then you can simply wash off the top coat. This does not affect the lower layers which are already dry. Stretchers and wooden boards must not be left in water longer than absolutely necessary, otherwise they will warp. Let the picture dry out before you carry on painting.

For works on paper which cannot absorb any more water, the last layer of fresh paint can be dissolved directly on the painting. You can then remove the liquid with an absorbent cloth or kitchen paper.

If part of a picture has not succeeded but the paint has already dried so can no longer be removed, you can correct it by overpainting that section. The overpainting can be carried out in the actual colour or underlaid with white so you can apply the new colour when the white is dry. This procedure is an advantage if a lighter colour is to be placed over a dark underlayer.

If you need to brush up or darken a particular section of a picture, you can do this using the dry-brush technique or using glazes.

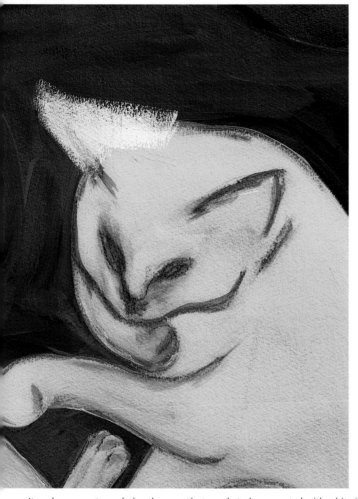 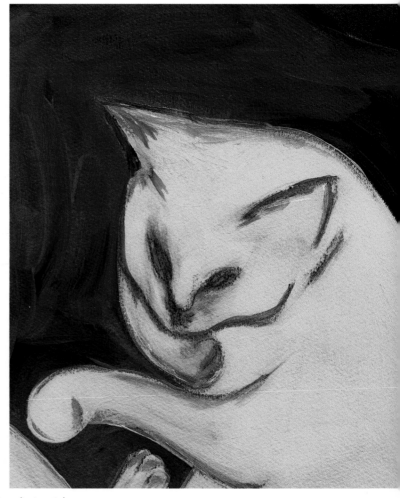

It makes sense to underlay the area that needs to be corrected with white in order to retain the lightness of the yellow paint.

Reworking

If you decide to remake a picture that has not turned out to your satisfaction, you do not necessarily have to do so on a blank canvas. Arrange a new composition and recreate the colour palette, then underlay the original textures and colouring in the reworked picture.

Unsuccessful pictures that cannot be overpainted can be recycled in other artistic works – by removing a section on which you can work again, or by using parts of it as elements in a collage in an entirely new piece of work.

Kristina Schaper, n. t., acrylic and fabric on canvas, 60 × 70cm (23½ × 27½in). Pieces torn from a painting that did not come out satisfactorily were recycled in this collage (detail).

Kristina Schaper, 'Mosaik I' ('Mosaic I'), acrylic and lacquer on burlap, 90 × 90cm (35½ × 35½in).
A large picture was cut into thin strips. These were then woven into a continuous canvas, put on a stretcher and painted over again.

Kristina Schaper, 'Mosaik 2' ('Mosaic 2'), acrylic, pigment, lacquer and paper on ramie cloth, 70 × 70cm (27½ × 27½in).

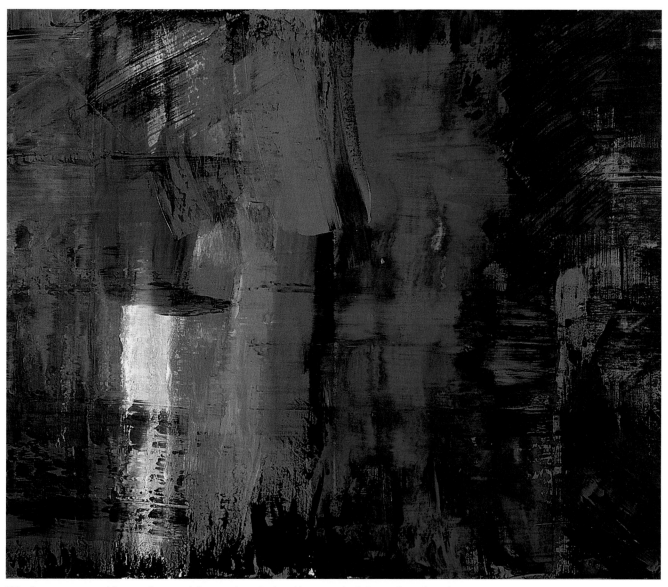

This picture was created in one of our workshop sessions. During this course the leftovers from the palettes were made into a communal painting on one canvas.

When you look at paintings, collages and drawings, it becomes clear that there is an abundance of themes and subjects that inspire people to express themselves through art. The question of which artistic genre you will choose – figures or landscapes, still lifes, portraits or a composition of shapes and colours as in abstract painting – depends on which is best suited to the kind of expression you aspire to. The reasons for choosing a certain type of painting are as numerous as the possibilities for transforming these themes into pictures.

A subject such as a landscape or objects from everyday life can inspire you to capture the thoughts or moods you have when contemplating them. When ideas and feelings about a central theme are already in your mind, the question is what subjects, objects, colours or shapes best express the substance of your idea. Many painters do not use real-life subjects as a model or reference, as is common in figurative painting, but work only with shapes, textures and colour. Others choose to paint representational themes from memory only.

When you choose your subject, remember that something of which you already have some knowledge usually works best. If, for instance, you are thinking of including a floral subject and want to achieve a near lifelike rendering of the subject, you are strongly advised only to picture a few flowers or leaves when you begin, rather than an exuberant lush summer bouquet. Trying to express the spirit radiated by a bunch of flowers in all their abundant blaze of colour and joy in a picture is something quite different. These impressions can also be expressed solely through the colour and the style of the brushwork without any previous experience of drawing.

If you can bring together a certain flair for colour and shapes and have a basic knowledge of using acrylic paints, then there is no subject or theme you could not paint in your own individual style. The fact that you possess the required imagination to develop the most diverse themes on your own makes you different from those people who are not creatively active.

Heinke Böhnert, 'Frühling' ('Spring'), acrylic and synthetic cloth on linen, 60 × 80cm (23½ × 31½in). The brightness of these tulip petals is reinforced by the use of fluorescent paint.

134

Colour and form

For an object or a figure to be painted as naturalistically as possible, you will need to make a careful study of the way the light falls and the shadows, textures and proportions. Preparatory sketches are usually made for this type of painting, in which these details are worked out. The outline shapes of the subject are sketched as accurately as possible on the canvas. Whether you want to paint landscapes, people, animals or still lifes, figurative works require a great deal of practice in drawing to train the eye.

If you choose a style that does not aim at realism, the extent of abstraction of form and colour becomes a decisive part of the composition. A preparatory drawing can be useful here for making a harmonic arrangement of the elements in a painting. When you observe a subject, you should try not to see it only as a collection of physical objects in a three-dimensional space, but to also observe it as a pattern of forms and colours. If you are working from a photograph, it might be helpful to have a black and white copy to make it easier to capture the variations in tone. When composing a picture, positive and negative elements are created; the positive shapes that describe the objects lie next to the negative shapes, namely those areas between the objects or surrounding them. Seemingly complicated subjects such as foliage or trees may be easier to understand when you direct your focus towards the negative shapes. When the shapes are linked up, you get the sum of them, and this can in turn be used to simplify the image. When these elementary forms are painted in a simplified colour palette, a naturalistic subject can be transformed into an abstract composition.

Wulf Peter Bestmann, 'What you see is what you get', acrylic and sand on canvas, 110 × 70cm (43¼ × 27½in).

Composition

When painting physical objects, it is necessary to make sure you adopt a view point that allows you to turn the object into a composition. Along with the use of contrast, the composition is the most important aspect of a painting. Composing a picture means achieving an optical balance by arranging the individual elements of the picture in a pleasing way. There are different views on how this balance can be achieved. Artists of the past have put forward numerous theories on the subject that mainly reflect the aesthetic norms of their age, while art critics have described various rules that they think compositions should follow.

Paying close attention to how other artists compose their pictures will train the eye in realising one's own artistic vision. Work on the composition starts with the search for a suitable subject. In still-life painting, objects can then be arranged in such a way as to create a good composition. In landscape painting, an interesting composition can be created by choosing a particular picture area or by emphasising or omitting certain elements. In portrait painting, you need to decide how the person is placed in the frame and which elements should be depicted in the background. When painting people or animals, it is important to capture movement and body tension.

The first consideration when composing a picture is the question of the focal point – what do I want to place in the centre and how can I ensure that the viewer's gaze is directed towards it? Where there is a central subject or part of the picture that needs to be given special significance, it is advisable not to include too much detail or contrast in the background or the surrounding areas as this will distract the viewer's gaze. If you are trying not to accentuate certain parts of the picture, then the different colours and areas need to be arranged in such a way as to create a harmonious, uniform effect.

In a good composition the gaze is guided around the picture or is drawn towards important sections. Tricks such as cutting across subjects, deliberately asymmetrical arrangements, skilful contrasts or opting for extraordinary formats can further enhance your composition.

Norbert Drossel, 'Tiefseefische I' ('Deep-sea fish I'), acrylic on gold leaf on canvas, 75 × 75cm (29½ × 29½in).

136

Still lifes

Still-life painting is a genre in which the theme is restricted to an arrangement of inanimate objects.

The still life, that is the precise observation of apparently meaningless objects, was first elevated to an independent art form by such painters as Albrecht Dürer and Lucas Cranach the Elder at the start of the sixteenth century. The still-life style reached an early peak in seventeenth-century Dutch art. At that time, the Dutch still-life painters developed such distinctive subjects as the kitchen and game.

In modern art, those painters who have been interested in representational painting have handled the still-life genre in very different ways. Cubists such as Georges Braque and Pablo Picasso and Expressionists such as Max Beckmann or Emil Nolde developed their own forms of expression within their particular style and frequently returned to the depiction of the still life in order to work with the ideas of space and form.

Oliver Löhr, 'Birne' ('Pear'),
acrylic on gold leaf on linen,
40 × 30cm (15¾ × 11¾in).

One of the best-known modern artists, who has worked intensively with the still-life genre within the mediums of painting, drawing and prints, is Horst Janssen.

Arranging and painting still lifes has some very clear practical advantages. By putting objects together you can study the effects of space, composition, colour moods and the arrangement of shapes, all in a calm manner and at your own pace. The choice of the subject, the lighting and the viewing angle are under your control and quite independent of the changes in light and weather conditions to which you are subject when painting outdoors.

A still life can be put together from the most unlikely things – your own home and the immediate environment offer a multitude of objects that could be arranged into a still life.

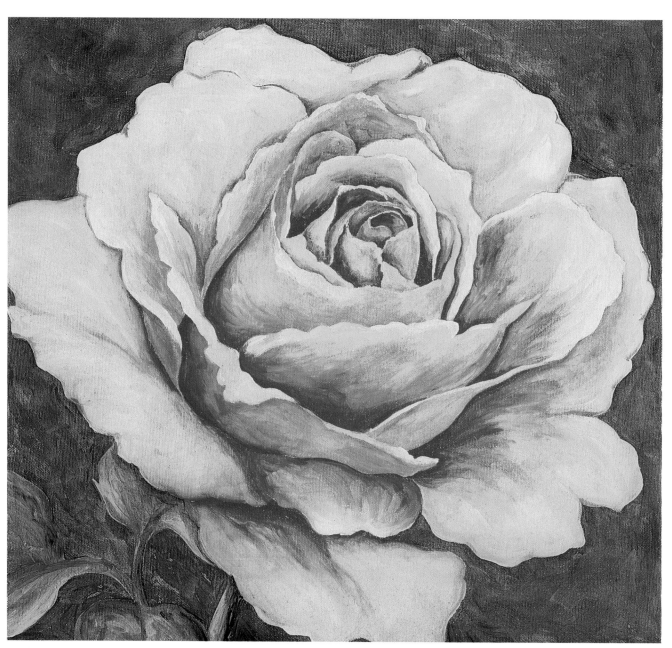

Kristina Schaper, 'Rose', acrylic on linen, 40 × 40cm (15¾ × 15¾in).

Flowers in vases, fruit or other foods, fabrics in all kinds of colours and textures, metallic objects, tools: the types of item that you can use are unlimited. However, when arranging your subject concentrate on the aspect of the objects you are using that most inspires you. Is it the interplay between individual colours or the contrast between very different surfaces? Or are you more interested in studying the forms and tonalities of an object? With certain subjects it may be more exciting to focus on only an enlarged part rather than the entire object. You do not need many objects to make a still life interesting. Very often an arrangement of objects is more harmonious if the individual elements have some sort of connection to each other. Sometimes casually arranged objects create more atmosphere than a complicated, overloaded arrangement.

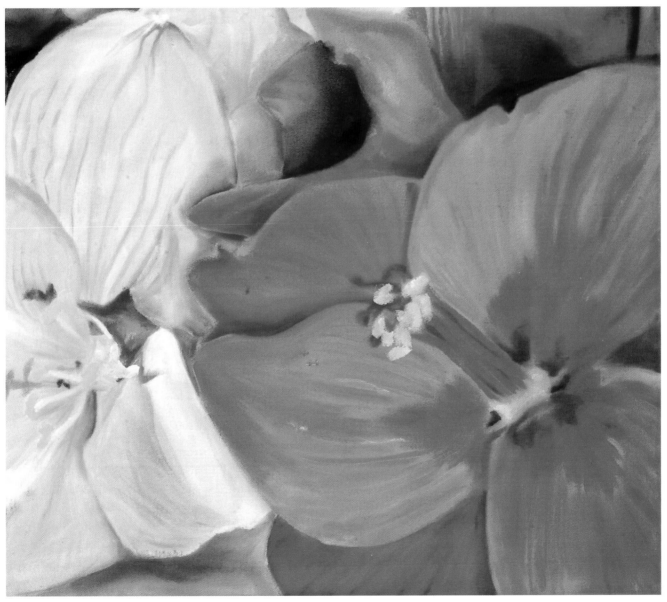

Julia Weidle, 'Große Orchidee' ('Large orchid'), acrylic on canvas, 130 × 130cm (51¾ × 51¾in).
Julia Weidle prefers to paint her flower subjects on unprimed textiles. For this she mainly uses old table linen. Because these textiles have been washed they absorb paint very well, which creates a very idiosyncratic colour effect.

Sometimes a still life can have a lot of atmosphere if the subject is 'found' rather than deliberately arranged. Such 'found' subjects are often set out naturally in a more interesting way than if you were to spend a lot of time trying to compose them yourself, and their random quality is often refreshing. For example, your own work area after a painting session could itself form a subject for a painting, or you could use a pile of old flowerpots in the corner of the garden.

As you gain experience you will find more and more such subjects; it is recommended you keep a sketchbook with you to record such impressions immediately. When it comes to still lifes, simple sketches are often just as interesting as paintings created in the studio.

Once you become intensely involved with the still-life genre you will start to see ordinary, everyday objects in an entirely new light.

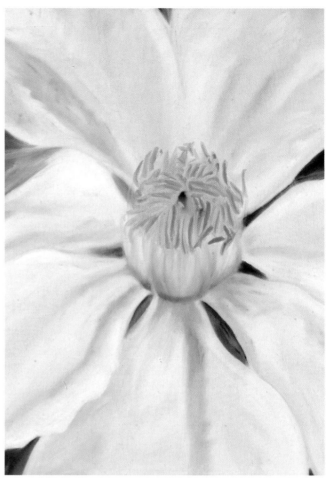

Julia Weidle, 'Weiße Blüte' ('White blossom'), acrylic on canvas, 60 × 50cm (23½ × 19¾in).

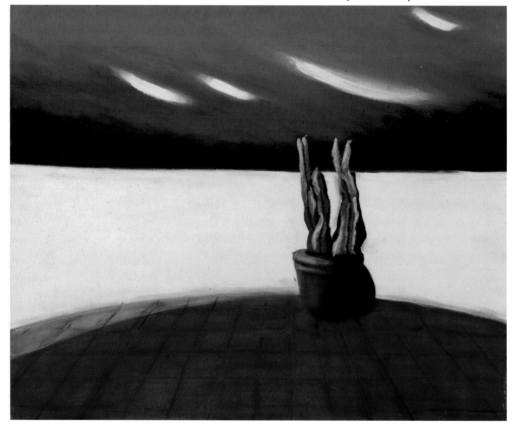

Sabine Lange, n. t., acrylic on hardboard, 50 × 60cm (19¾ × 23½in).

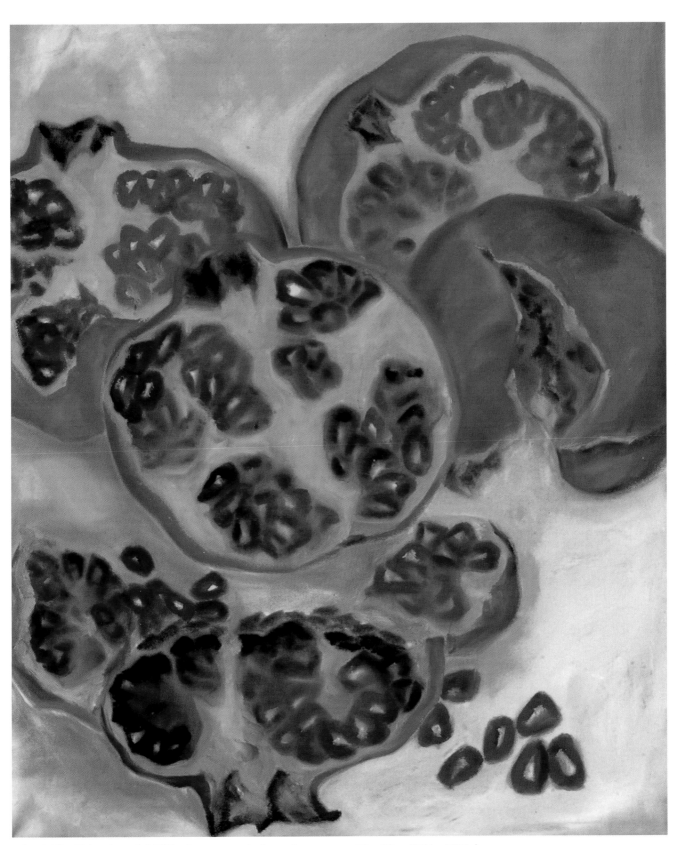

Julia Weidle, 'Kleine Granatäpfel' ('Small pomegranates'), acrylic on canvas, 80 × 60cm (31½ × 23½in).

This fruit still life was built up in the studio. The photos show the same arrangement from differing angles.

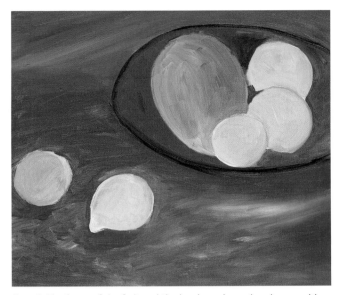

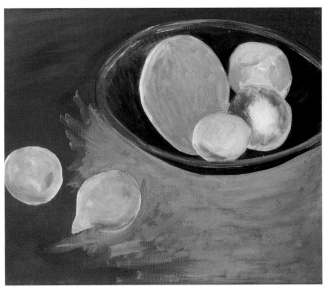

Step 1: The forms of the fruit and the bowl are drawn in advance with red pastels. The first application of colour with lightly thinned paints is intended to verify the composition and colour effect. It is not so important at this stage to put a lot of effort into drawing the shapes. You need to work briskly, using a broad brush.

Step 2: The bowl and the fruit are now developed further. If you have painted over the shapes of the fruit or the bowl when applying the background, you can mix in a little white with the colours. You can then add the next layer without using any white. The dark blue base is dull and too heavy. For this reason the artist has applied a large amount of pink over it using dry-brush techniques so the blue shows through in certain places. This gives a lively surface.

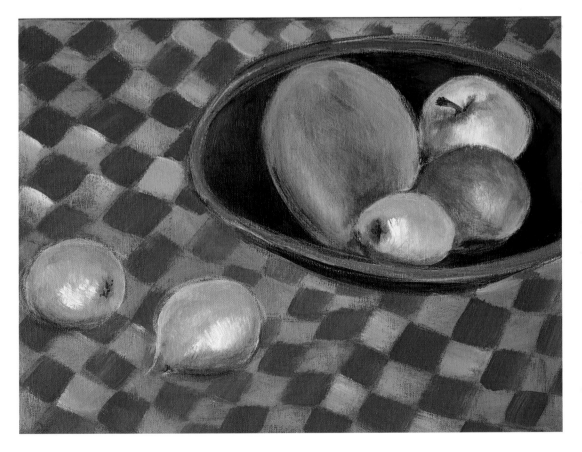

Step 3: To liven up the background, a diagonal checkerboard pattern was drawn with pastel crayons and filled in with gentle brushstrokes. The checkerboard pattern contrasts with the rounded shapes of the dish and the fruit. The final accents were done with coloured pastels.

143

Step 1: The cropped area is defined by sketching in grey chalk.

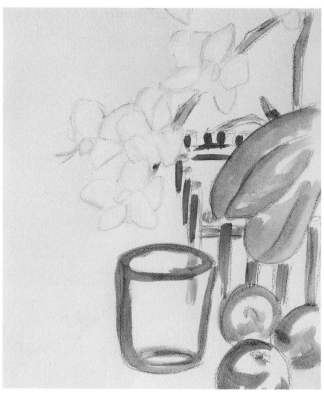

Step 2: The outlines of the major elements are applied using thinned paint. The flower blooms are brushed in with white paint to create a lightly textured substrate.

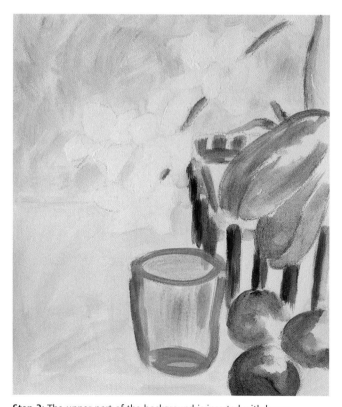

Step 3: The upper part of the background is inserted with loose crosswise brushstrokes, while a glaze is used for the lower part. Further layers are also applied to the motifs and the structure of the blooms is reinforced with more opaque paint.

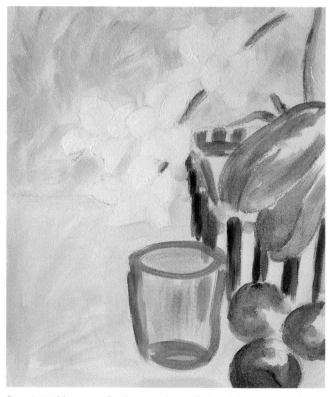

Step 4: At this stage, all colours are intensified and the areas are closed up as far as possible. The colour distribution of the fruits is achieved by dabbing on two colours, which will show through the glaze that follows.

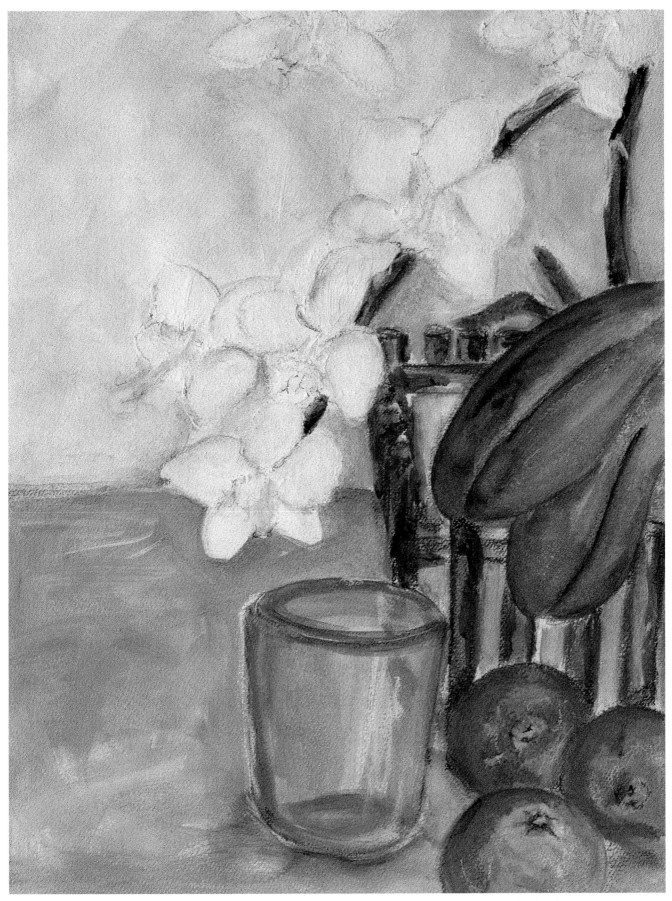

Step 5: After a glaze has been applied to the leaves and fruit the shadow areas in the background are applied. To give the picture more contours, some elements are now emphasised using coloured chalks and pencils.

Landscapes

There is a long tradition of landscape painting in art history. A whole series of well-known painters have expressed themselves in the landscape genre in the most diverse ways over the centuries. Often, the style of such landscape paintings tells us a lot about the dominant interpretations of nature at the time. Landscape paintings may be a central theme in certain artistic movements, such as Romanticism. Painters like Caspar David Friedrich created landscape paintings which, because of their impact, remain synonymous with the Romantic style. Since the Renaissance, painters of every kind have been interested in the theme of landscape. Artists such as William Turner and John Constable are some of the greatest representatives of the landscape movement from the early nineteenth century. Their efforts to capture changing light conditions led the Impressionists to develop open air painting fifty years later. Paul Cézanne originated a new way of looking at form and colour. He pioneered abstract painting, which was then developed in diverse ways in subsequent stylistic movements until it led to completely non-figurative painting.

As with all genres of painting, both past and present approaches to landscape painting are a treasure trove of new ideas for artists. The range of possibilities for landscape painting cannot be overestimated.

The constantly changing light conditions are a vital aspect of landscape painting. The weather, time of day and season create diverse moods and colour effects. The silhouette of a house will be defined sharply in clear autumn light, but appear fuzzy in the shimmering heat of summer. The house will look quite different again under a murky wet sky or during a storm. Colour and light play a major role here, because colours and therefore mood change with constantly changing light conditions. If you are going to work outdoors, trying to capture these often fleeting light effects can be challenging. Works that do this successfully have their own particular vivacity. Even when you work from photographs, the way you represent light is hugely important. The skilled use of different tonal values is also important in achieving three-dimensional effects. If you allow your gaze to move across a landscape you will notice that the colours in the distance appear increasingly cool and bluish. The contrasts between textures and tonalities of objects soften as they recede into the distance. This means that the strong colours in the foreground stand out while the cooler colours and weaker tonalities appear to recede.

Another means of achieving spatial depth is to utilise the perspective foreshortening of roads, rivers or other elements that lead into the picture. The intersections of shapes also create spatial effects.

If we select colours for a realistic representation we need to ensure that the colours actually match the lighting conditions for the particular season being depicted. If a subject is bathed in hot summer light then the parts that are lit up should be dominated by suitably warm tones. The brightness of a summer landscape under intense sunlight can be increased by contrasting the bright areas with cool, shaded ones. A winter landscape will be emphasised by the use of cool colours. Contours dissolve in a winter fog and subdued tones will predominate.

Landscape painting does not need to be restricted to picturesque subjects. City scenes or industrial complexes can be made into exciting subjects, for example if light is reflected from metal or glass, or strange shadows are formed, or if they include colours that are not normally present in nature.

Textures and shapes found in water, sky, foliage and grass, wood and rocks demand very precise observation. You will need experience of basic painting techniques if you want to represent the various colours and tonalities that make a landscape or if you want to simplify these values to such a degree that only the essence of the landscape is captured and revealed to the observer. If you have had the chance to develop your skills in this area then you will start to understand that the challenges of landscape painting are some of the most interesting there are within the field of art.

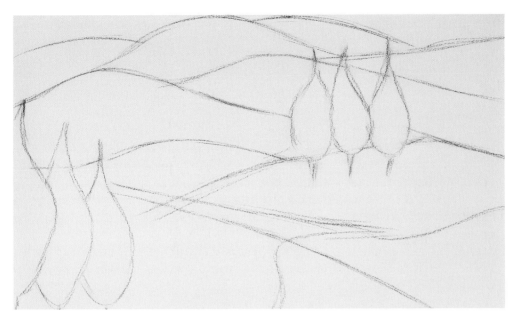

Step 1: The impressions that you gain from nature should be captured as soon as possible. Red chalk is used to make a quick sketch. The advantage is that this will not leave marks on subsequent paint layers.

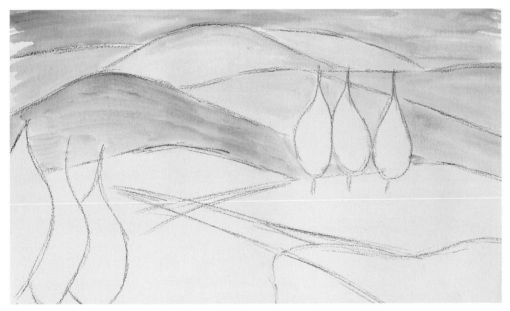

Step 2: Once the preliminary drawing has been completed, a glaze is applied to the individual areas of colour in order to preserve the first impressions of the colour effects.

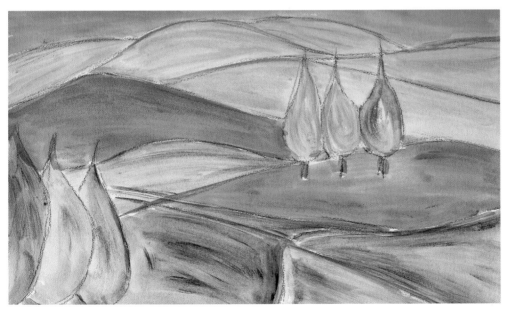

Step 3: Now the entire picture is glazed – which has the advantage that you can recognise any colour changes and take account of these when the opaque colour is applied – the red chalk almost completely disappears with the glazing.

147

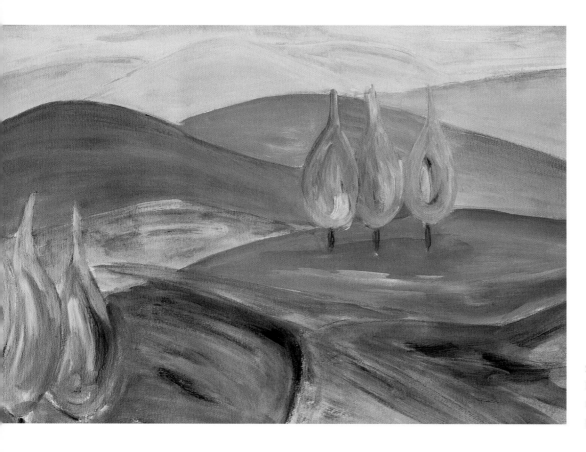

Step 4: Once opaque paint has been applied to the subject, more glazing is applied to some parts to make them more lively.

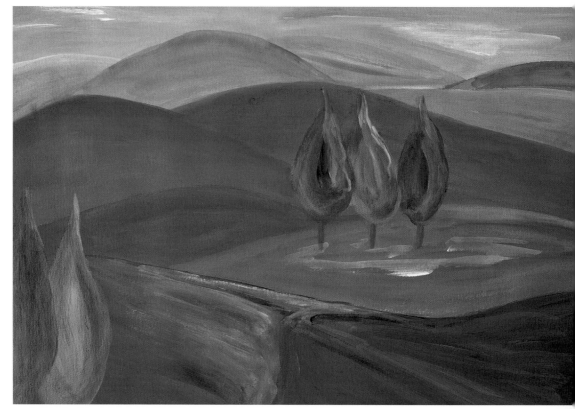

This example shows how the same subject has an entirely different impact when using a cool palette.

148

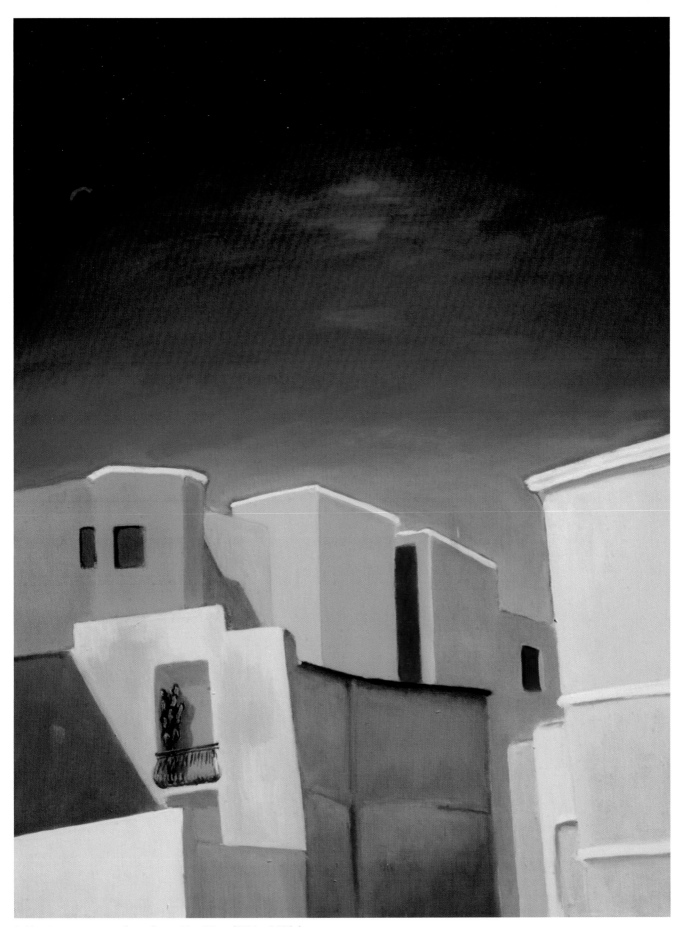

Sabine Lange, n. t., acrylic on linen, 70 × 50cm (27½ × 19¾in).

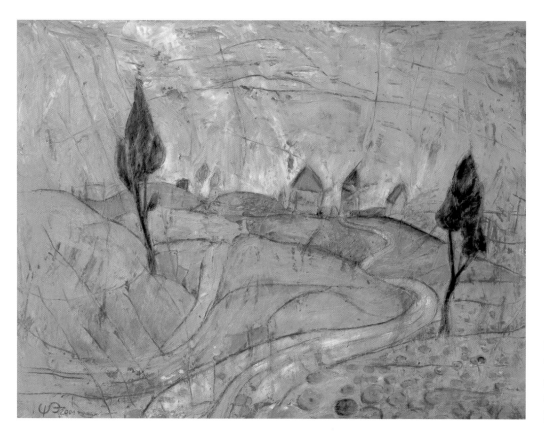

Wulf Peter Bestmann, 'Someone's paradise II', acrylic and sand on canvas, 90 × 125cm (35½ × 49¼in).

Norbert Drossel, 'Wolken III' ('Clouds III'), acrylic on linen, 100 × 120cm (39¼ × 47¼in).

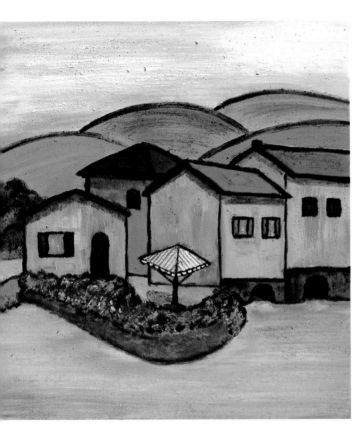

Rüdiger Steffens, n. t., acrylic mixed with sand, on linen, 50 × 50cm (19¾ × 19¾in).

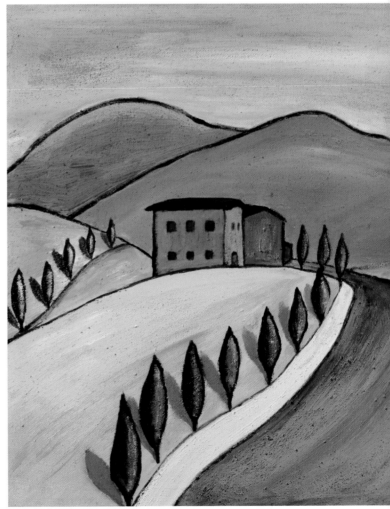

Rüdiger Steffens, n. t., acrylic mixed with sand, on linen, 70 × 60cm (27½ × 23½in).

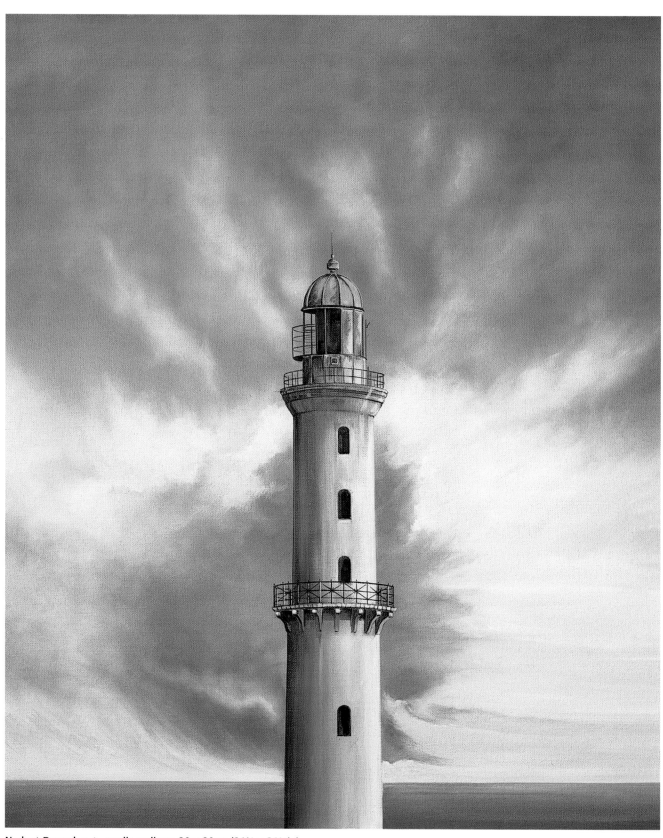

Norbert Drossel, n. t., acrylic on linen, 80 × 80cm (31½ × 31½in).

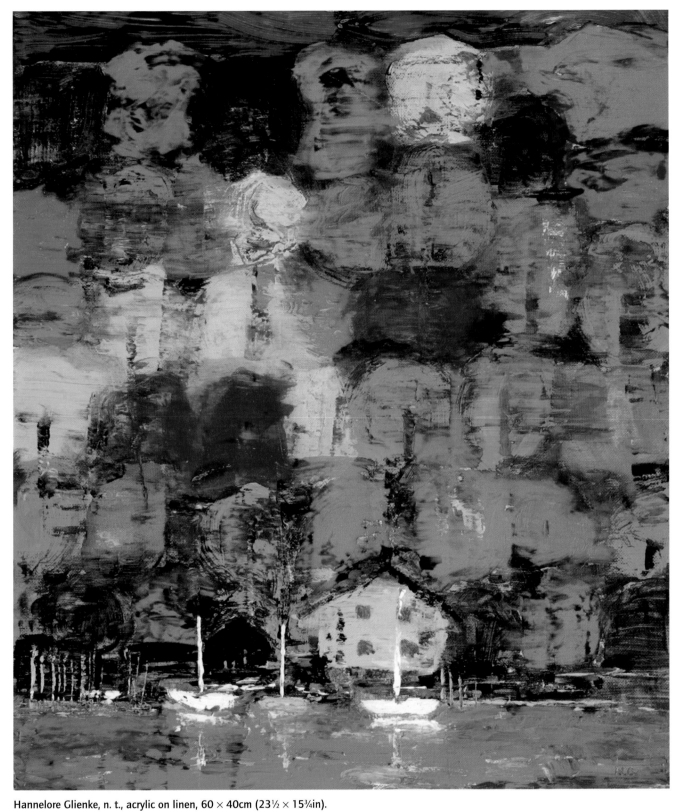

Hannelore Glienke, n. t., acrylic on linen, 60 × 40cm (23½ × 15¾in).
The autumn foliage on the wooded cliff was created by applying individual areas of colour that were then scraped
with a cardboard scraper and combined before they dried.

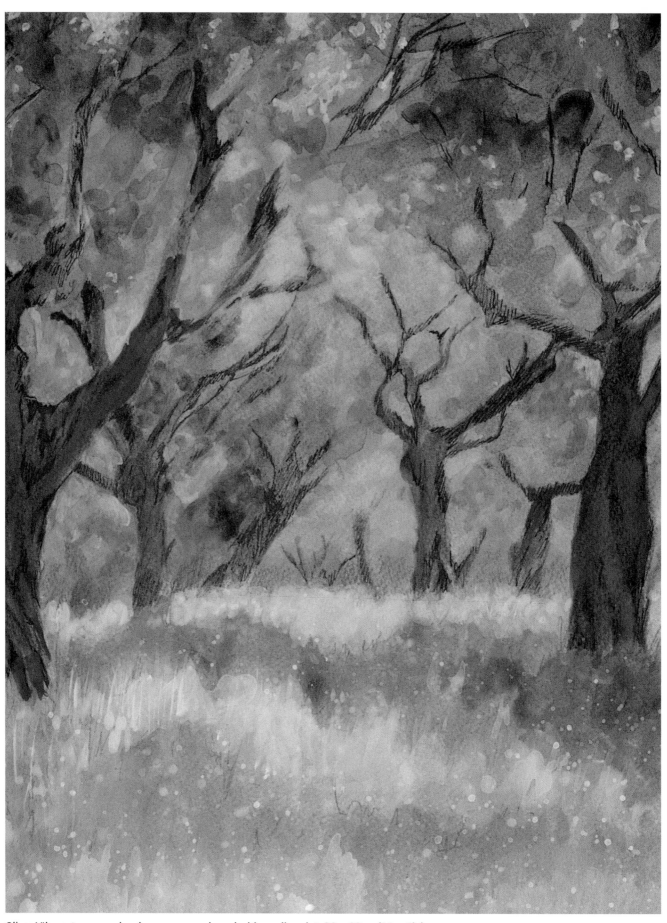

Oliver Löhr, n. t., crayon drawing on paper coloured with acrylic paint, 38 × 23cm (15 × 9in).

Portraiture

Although it was predicted that this branch of painting would disappear with the development of photography, it continues to thrive. The word 'portrait' comes from the French and refers to a representation of one or more persons, ranging from focusing only on the face to including the entire human figure.

The theme of the human face runs through the entire history of painting in many cultures, starting from ancient Egyptian tomb paintings to contemporary artistic trends. In this genre we can tell a lot about the people who appear in portraits, the age in which they lived and the artist's viewpoint, simply from their attitudes and poses, their clothing and jewellery, the degree to which they are unclothed, their marks of rank and their facial expressions.

Portrait painting was a profitable business for painters until photography was invented – at about the same time as Impressionism – and was a means for artists to gain a high social status. Because only a few people could afford portraits of themselves or their family, most portrait commissions came from the aristocracy and high-ranking church dignitaries. Quite a number of famous artists, such as Francisco Goya, started their careers as court painters through painting commissions. Until the mid-nineteenth century there was only one generally accepted notion of portraiture, which either favoured a very realistic depiction and precisely detailed physiognomy and clothing or, alternatively, tended towards flattering its subjects. However, artists could at least create a self-portrait without the pressure of having to please their customers. Rembrandt painted a series of self-portraits, from which we can see the development of his technique as well as changes in his self-image.

After the first affordable photographic plates came on to the market, artists turned more and more towards abstract shapes and colours, even in portraiture. This gave them other resources for depicting personality in their portraits, by incorporating a psychological aspect.

A knowledge of anatomy is helpful when painting a portrait. Knowledge of perspective foreshortening is also useful if you are aiming for a naturalistic portrait. However, portraits can be painted using abstract or geometric shapes, which could make it easier to communicate a person's typical traits and attitudes than through meticulously reproducing every wrinkle and hair. There are plenty of instruction manuals for portrait painting using every imaginable technique. Presenting the characteristics and moods you see in a portrait subject in an abstract manner requires both an ability to empathise with the model and precise observation. The same compositional demands apply here as in other genres of painting. When planning a portrait it is important to consider how the figure is going to be placed in relation to the background. The background often plays only a subordinate role, yet the colours and shapes of the background are an integral part of a portrait and can reinforce the overall effect of what is portrayed. The background may reveal a view or objects that contribute to the definition of the personality of the subject. The background should never be too detailed or clashing, so as not to distract from the portrait.

Whether you choose to work from photographs or live models will have a marked impact on your work. Sessions with a model always entail an interaction between the painter and the subject, which goes far beyond the actual work. Movements and alterations in light need to be taken into account as well as changes in gestures or facial expression, which can occur during long sessions due to tiredness. Nevertheless, many portraitists believe that it is only possible to interpret the personality and nuances of skin tone to their best effect through direct interaction with live models.

To begin with it is certainly easier to work from photographs or to first try painting your portrait in front of a mirror. The most patient model you are likely to find to start with is yourself.

It is very true that frequent sketching trains the eye and improves technical skills in portraiture, just as in any other genre. Making small pencil drawings while you are out and about will hone your powers of observation and teach you how to capture essential facial features in a few lines. With time you will gain a solid understanding of proportion, posture and expression so that you can then start working with a model.

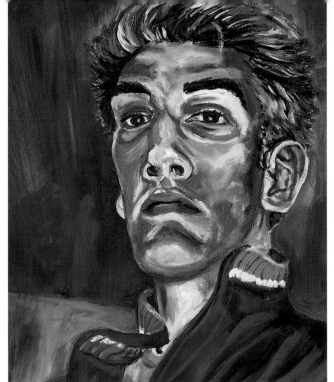

Andreas Meyen, 'Selbstporträt' ('Self-portrait'), acrylic on canvas, 50 × 50cm (19¾ × 19¾in).

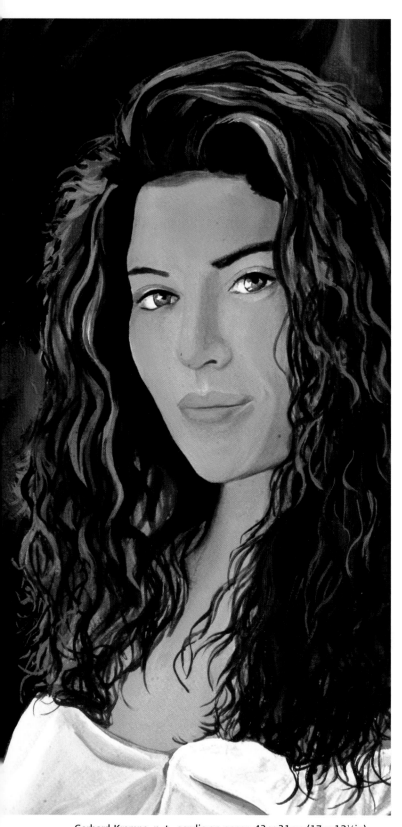

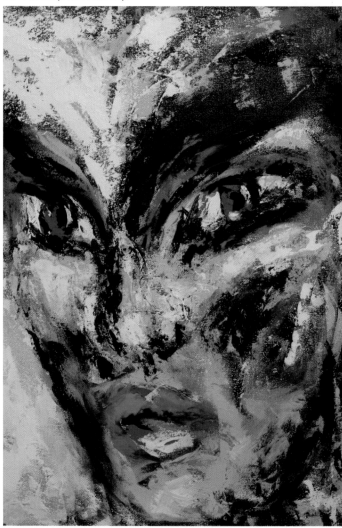

Gerhard Krempe, n. t., acrylic on paper, 43 × 31cm (17 × 12¼in). A magazine photo was used as a reference for this picture.

Bettina Malinowski, 'Erie', acrylic on canvas, 70 × 60cm (27½ × 23½in).

156

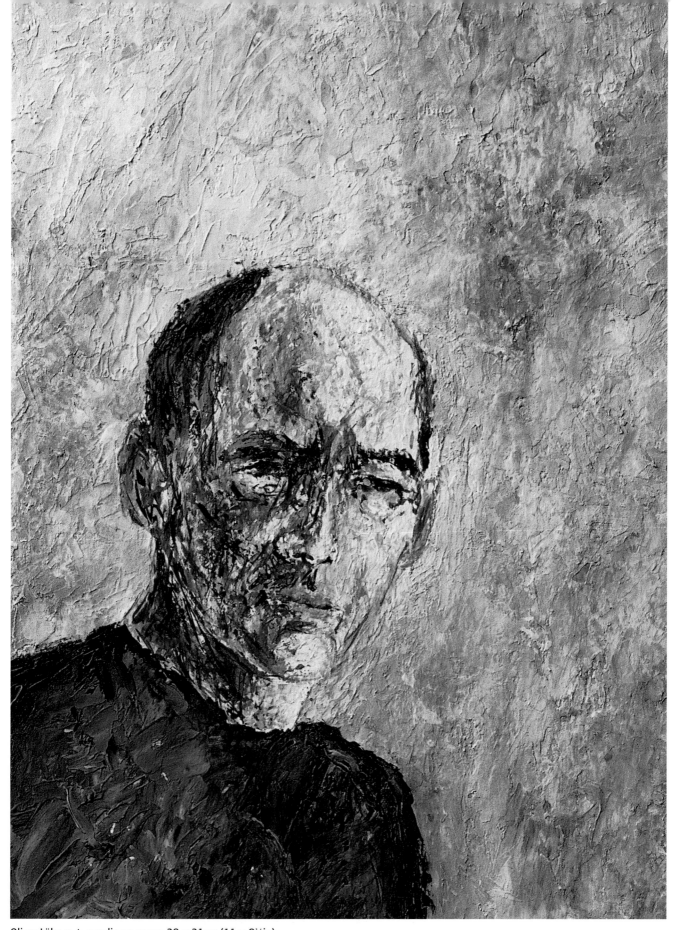

Oliver Löhr, n. t., acrylic on paper, 28 × 21cm (11 × 8¼in).

The paint was applied almost purely with a palette knife in this example. The individual paints were mixed with modelling paste and applied in several layers. A thin glaze was applied over the background at the end.

Step by step: African woman
Both airbrush paints and opaque acrylics as well as coloured crayons were used for this picture. While the face and shoulders were built up in several layers, the jewellery was added with opaque paints in only two layers.

Step 1: It is necessary to make a detailed preparatory drawing to capture areas of light and shade as well as the face painting and the different parts of the jewellery. A wash with strongly thinned acrylic paint is laid over the pencil drawing. The wash is a ground colour that will coordinate all the colour tones in the subsequent layers.

Step 2: The sketch is now drawn over with a fine liner pen so as not to lose the details of the drawing in the subsequent overpainting with glazes and semi-opaque paint layers. Now the shadow areas of the face are applied using the wet-on-dry technique.

158

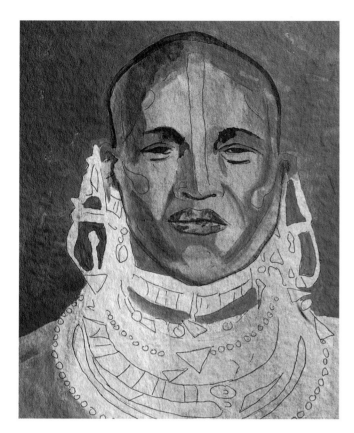

Step 3: The background is painted over with a second, opaque layer of paint. To achieve this, the face, the body and the earrings are covered with airbrush film and the various colours are dabbed on with a stencil brush, so that the background shows through. The face is modelled with thinned paints. At this stage only the shadows are intensified and the lighter parts are left unpainted.

Step 4: After the shadows in the face are painted over with glazes in various shades of brown, the bright skin areas of the face are defined with a glaze of white and violet airbrush paint. After drying, the shiny areas of skin are dabbed on with white acrylic paint. The adornments and the face painting are then applied using opaque colours. The dark areas of the eyes, mouth and jewellery are finally intensified with black crayon.

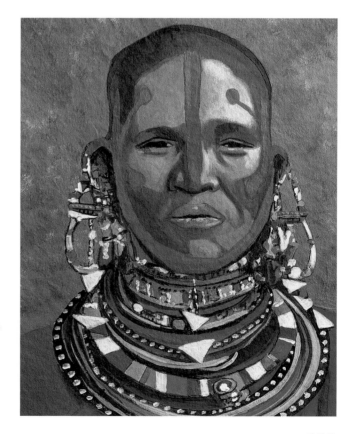

Sabine Lange, n. t.,
acrylic on paperboard, 60 × 50cm
(23½ × 19¾in).

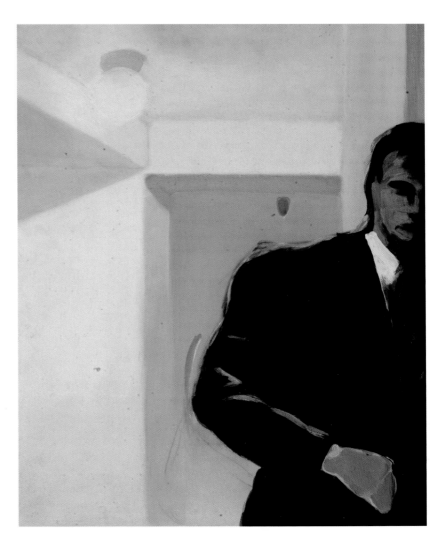

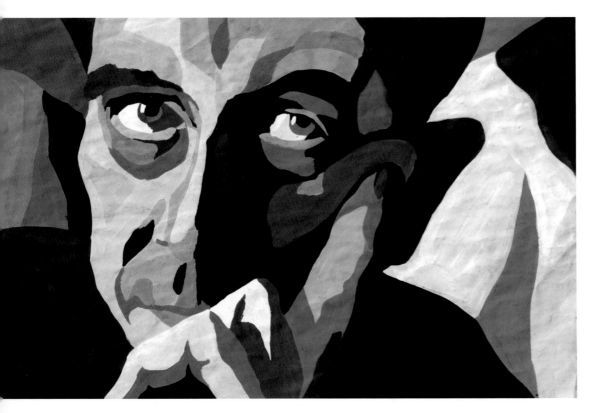

Oliver Löhr, n. t., acrylic on
paper, 38 × 51cm (15 × 20in).

Oliver Löhr, n. t., acrylic on paper, 32 × 22cm (12½ × 8¾in).
All the areas were first applied with very thin paint in this portrait. The
face was next stippled in several layers with a fine stencil brush. The
streaks of colour that run across the entire picture were created with
the use of a glass plate. This was done by rolling various colours on the
glass plate with a paint roller and then applying these to the picture.
Unwanted areas were then lifted off.

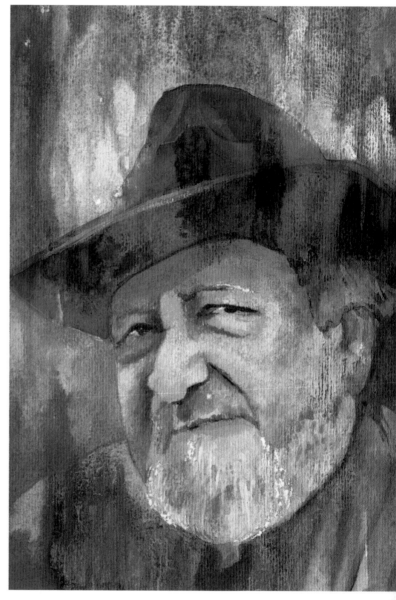

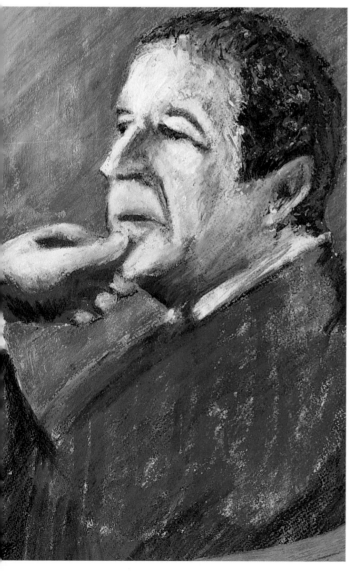

Oliver Löhr, n. t., acrylic and pastel crayons on watercolour paper,
38 × 27cm (15 × 10¾in).
This portrait was created by applying several layers of acrylic paints.
The acrylic paints shine through the layers of pastel colour.

Inspirations

Although acrylic paints are universal in their application and have many technical advantages for painters, they cannot take the place of the actual work of developing ideas and turning these into paintings. Sometimes our inspiration runs dry and we need to find new stimuli to keep working.

An artist's work does not begin when we take our brush or crayons in our hands. Much more important is to be aware and consciously observe the world around us. The thing that sets an artist apart is the ability to see something extraordinary in everyday, inconspicuous things, places and actions. We think in images and when we remember something we see an image in our mind's eye. It is important to direct your awareness to such images and to retain them, so you can recall them more or less 'on demand'. This is a skill that develops gradually and eventually becomes automatic.

To collect and develop ideas it is advisable to carry a sketchbook or ideas folder on your travels and everyday life.

If you don't have time to record impressions and ideas with a pen or pencil, then a camera can be very useful. Snapshots can then be evaluated at leisure and serve as a reference or aide memoire. Write down any ideas that come to mind. This artist's diary will become a valuable part of your equipment. Postcards, magazines and books also provide a multitude of stimuli.

Collect anything that attracts your attention. A particularly fine piece of fabric may be a source of inspiration for a new picture in the same way as something you find while beachcombing or even a colourful sweet wrapper. Travelling is particularly likely to provide new and enjoyable impulses. We often absorb impressions more readily when we are far away from our everyday stress. Contact with the art of foreign cultures can also influence our work. The formal language of other cultures and their use of colours will suggest possibilities, enabling us to engage with our own new or old themes and subjects in an entirely fresh way.

Texture of bark.

Artists such as Paul Gauguin and Jean Dubuffet were influenced by Asiatic woodcuts and Polynesian and so-called primitive popular African art. We can make use of museum visits and exhibitions as a source of inspiration. Contact with historical works of art can be utilised in the same way. Looking in detail at works by other artists and making efforts to understand why and, most of all, how certain subjects were depicted in different centuries will not only train the eye to see how composition and technique were executed but also open up direct insights into the past. An Italian fresco, a Chinese ink drawing or a large-scale work by an American abstract expressionist is much more than just a collection of marks on a piece of paper or fabric. Behind every painting there is a man or woman with their own very personal view of the world. You will not only find a vast treasure trove of painting techniques in historical works but also a marvellous source of inspiration for your own work. In the same way, literature can be used as a stimulus for developing ideas. Transforming literary themes into art or illustrating passages of text is very challenging because we need to make concrete the images that appear before our mind's eye while we are reading.

Once you have collected ideas or a number of subjects that cannot be incorporated into a single picture, you have the chance to turn them into a cycle of paintings. Many artists work in series and do so in one or two ways: either by transforming one subject in various ways or painting several paintings on one theme in the same style. It is particularly interesting for learning purposes to use various techniques to present the same subject. In this way you can discover the techniques that can be used to depict subjects most effectively. You can also of course do this in other ways, for example by looking at how other artists have developed themes. Your artistic development will in any case progress more rapidly if you get together with other like-minded souls. You learn more effectively if you look at the way that others work and approach art. Moreover, there is always an automatic exchange of ideas within a group.

Driftwood.

163

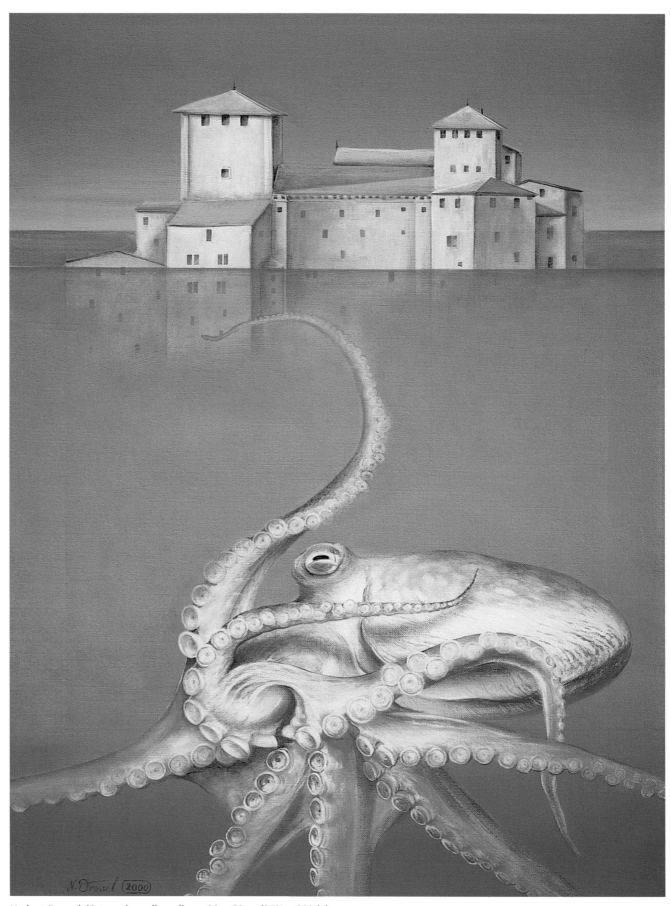

Norbert Drossel, 'Octopus', acrylic on linen, 90 × 60cm (35½ × 23½in).

Ute Zander, 'Fleurs' ('Flowers'), acrylic on canvas, 120 × 50cm
(47¼ × 19¾in).
The flower design was built up in several layers using glazing; the
accents were applied using chalks.

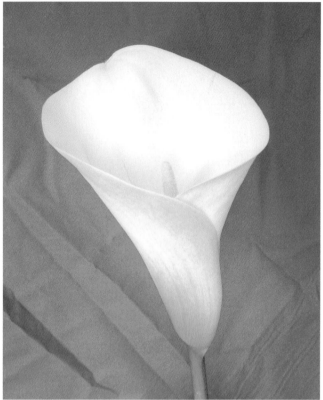

A photograph of a calla lily served as a reference for this painting.

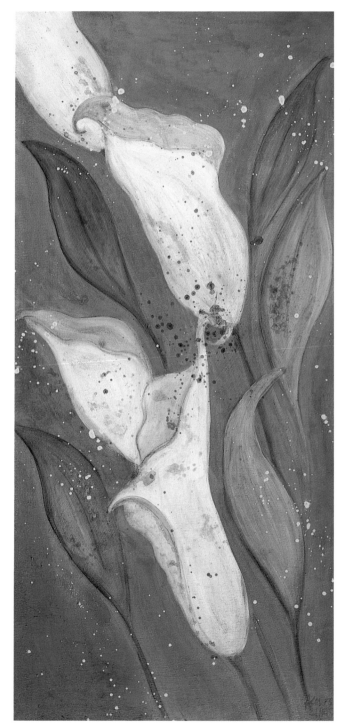

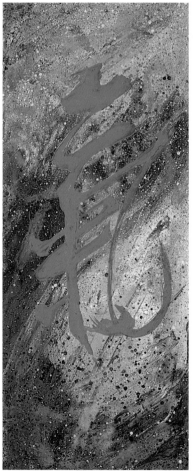

Oliver Löhr, 'Ki', acrylic
on linen, 50 × 20cm
(19¾ × 7¾in).
This Japanese ideogram,
which means 'energy',
was written with a
Japanese brush. The
splashes of paint in the
background were created
using a spray gun.

165

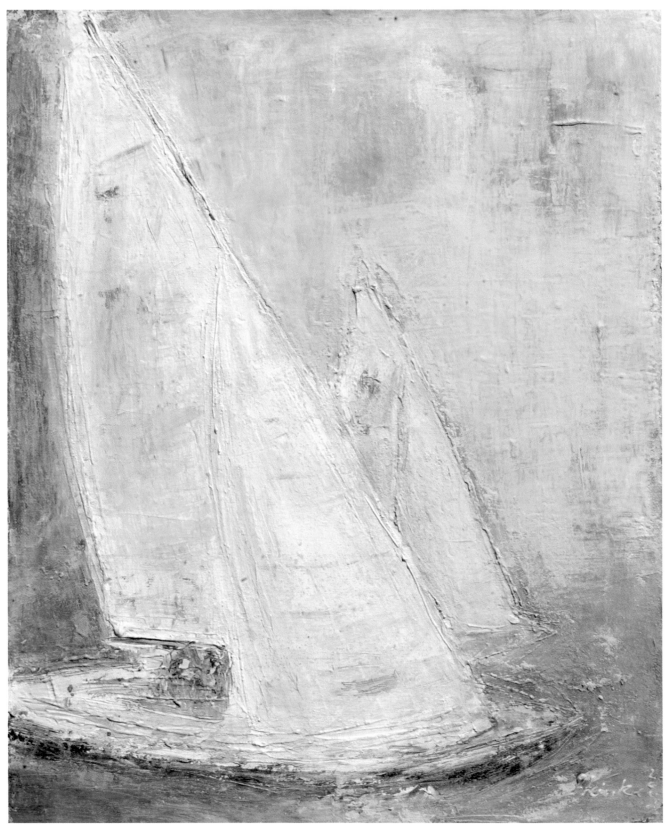

Heinke Böhnert, 'Drachen' ('Dragons'), acrylic on linen, 50 × 40cm (19¾ × 15¾in).

Ursula Barlage, n. t.,
collage, acrylic on paper,
10 × 15cm (4 × 6in).

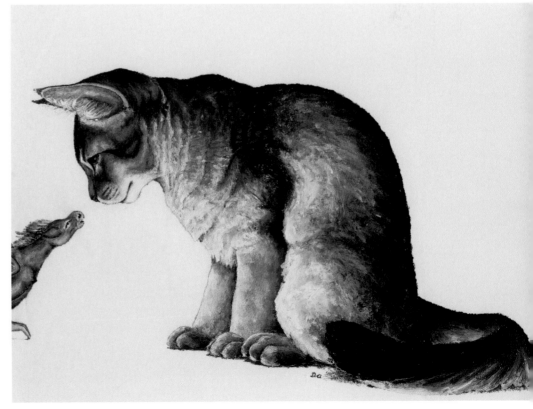

Petra Damke-Rösch, n. t.

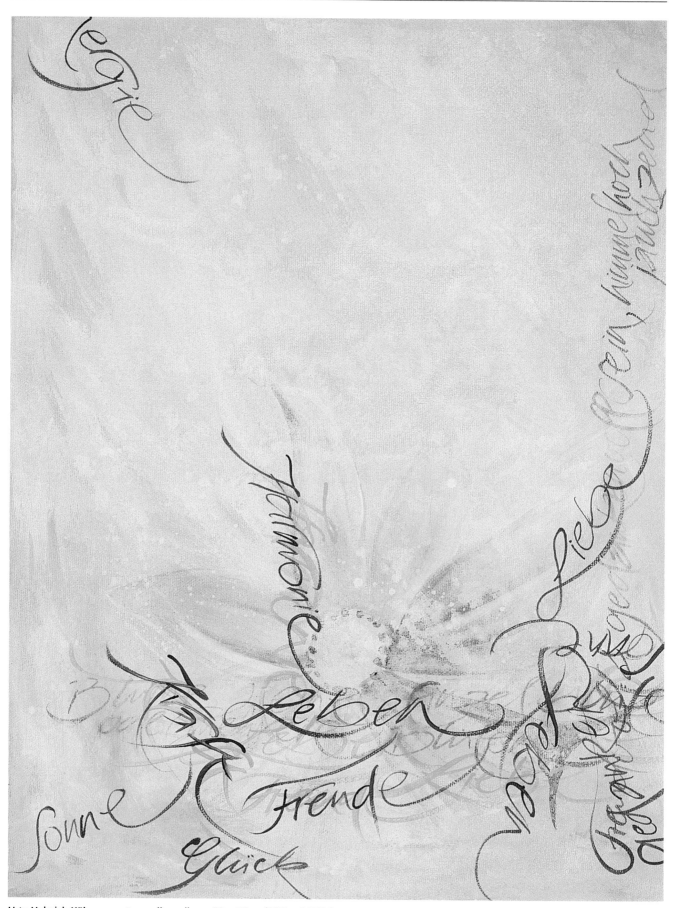

Urte Helmich-Köhnsen, n. t., acrylic on linen, 60 × 50cm (23½ × 19¾in).

Abstract Expressionism: A trend in abstract art that originated in New York around 1950. The painting process itself is particularly significant in this style of painting, as it is the expression of the artist's own dynamism and spontaneity. Subjective feelings are involved in the artistic process in a direct way.

Abstraction: A term for reducing or highly simplifying the physical subjects in a painting, which may go as far as complete disassociation from their original appearance.

Acrylic binder: Binder based on the dispersion of synthetic resins used to make acrylic paints.

Acrylic lacquer: Paint developed for protective coatings with a very high binder medium content, which ensures superior flow properties.

Acrylic painting paper: Very robust paper developed for painting with acrylic paints. Some varieties have linen-like surface textures.

Acrylic paints: These paints consist of pigments, a synthetic resin dispersion as a binder medium and water. For further details see page 10.

Action Painting: A way of working directed by the unconscious and the emotions which are then reflected directly in the picture without any representational references.

Alla prima: From the Italian for 'the first time'. With this technique, the paint is applied in a single layer without underpainting and without glaze overpainting. The picture is completed in one session. This style of painting requires practice and knowledge of colour effects.

Arrangement: The organisation of various objects into one harmonious image.

Artists' paints: Paints that are made from high-quality ingredients which meet the high demands of professional users in relation to durability, light-fastness and brilliance of colour.

Black lava: Special acrylic texture gel that looks like black lava sand when dry.

Brushstroke: Individual way of holding and moving a brush.

Calligraphy: Rhythmic decorative writing which can be effective as part of a picture.

Canvas: Primed or unprimed fabric used as a support.

Canvas carrier: Wooden device which can be used to transport several damp pictures without them touching each other.

Cardboard scraper: Piece of cardboard cut in the shape of a spatula.

Carrier: The substrate on which a painting is executed. Carriers are, for example, canvas, paper, wood or plaster.

Chalk pastels: Medium made of pigments partly with added binders, but generally powdery in application. Chalk drawings need to be fixed when finished.

Clear gel: This type of gel has an adhesive effect suitable for collages. It dries transparently and can be used to achieve a three-dimensional effect.

Collages: Derived from the French word *coller* (to glue). Paper and other materials are used in pictures in this technique, which was invented by the Cubists.

Colour wheel: Diagram used in colour theory. The primary, secondary and tertiary colours are organised into a wheel shape.

Colourants: Colouring substances are termed colourants.

Colouring substances: All colourants that can be dissolved in liquids (e.g. inks) are termed colouring substances.

Complementary colours: Colours that are diametric opposites on the colour wheel.

Composition: Balanced, harmonious organisation and arrangement of the elements of a picture.

Consistency: The thickness of a substance. In relation to paints we talk of, for example, a fluid, heavy or buttery consistency.

Contrast: Opposing effects of colour and tonal values.

Cropping frame: Two right-angled pieces of cardboard that can be put together to form a viewfinder. The cropping frame is held with the arm outstretched and the subject is viewed through the opening.

Dripping: A technique which uses flows and dripping of paint to create image structures.

Dry-brush technique: Paint with a high viscosity is applied over a ground with a dry brush. The brush will only release a small amount of paint, so the ground remains visible, resulting in a halftone effect.

Emulsion paints: Paints available from builders' suppliers for walls. Such paints are of only limited use for artistic purposes.

Ferrule: A metal ring that holds the hairs of a brush and connects it to the brush handle.

Field easel: A usually three-legged wooden frame for working on pictures outdoors. Field easels can be folded and are much lighter than easels used in studios.

Figurative: Realistic representation of a subject.

Filler: Extender that is added to other substances in order to increase their volume or weight or to improve their technical applicability. Coloured pigments are, for example, mixed with chalk in order to increase the covering power of the colours. The addition of quartz powder makes paint thicker.

Fixative: A protective film used to protect chalk and crayon drawings; it is usually sold in the form of a spray.

Fluorescent paints (also neon paints): These absorb light from ultraviolet rays and convert it into longer-wave, visible light in their own inherent colour.

Gesso: White primer that was formerly made of animal glue and chalk. Modern gesso primers contain pure acrylate dispersion and titanium dioxide pigments.

Glazing: A transparent paint application that can be superimposed in layers.

Gold leaf: This is generally available in 23 carats, and is mounted on transparent tissue paper (8 × 8cm [3¼ × 3¼in]); one book holds 25 sheets. It is also available under the name of 'Turm- und Wettergold' because it is weatherproof.

Gouache paint: Water-soluble opaque paint with good flow and blending properties.

Granulating: The movement of a brush across textured surfaces with unthinned paint and light pressure. The paint adheres to the raised surfaces.

Graphite: Compressed carbon, usually contained within wood in a pencil lead or stick form. Used for preparatory drawings.

Grisaille: Derives from the French *gris* (grey). Monochrome painting mostly done in grey shades. Used for underpainting or to imitate techniques applied on sculptures.

Imitation gold leaf: An alternative to gold leaf, consisting of zinc–copper alloys (see pages 17/18). Can be manipulated in the same way as gold but is not weatherproof.

Impasto: Thick paint application. The thicker the paint layers, the more raised the surface of a painting.

Imprimatura: Thin monochrome paint application to change the colour of a ground before painting.

Inhibitor: A medium that delays the drying time of acrylic paints.

Interference colours: Colour phenomenon that arises when two or more spectrum frequencies appear at the same place due to superimposition or diffraction. Light is refracted at the pigment plane and an iridescent lustre occurs.

Iridescent paints: Paints with a mother-of-pearl shimmer.

Japanese spreader: Thin, flexible plastic or metal spatula without a handle.

Light texture paste: Modelling paste with a low specific gravity.

Mask: This is used to cover certain parts of a picture to protect them from paint. Adhesive film, masking tape or masking liquid can be used.

Masking film (or liquid frisket): This is latex-based and is used to cover areas of a picture that are not painted over.

Masking tape: Single-sided adhesive tape for masking off areas that are not to be painted.

MDF panels: Medium density fibreboard, made of compressed softwood fibres bound with wood glue.

Medium: A substance mixed with paints to modify the technical properties of the paint.

Mixed technique: Use of various materials and techniques in one picture.

Modelling: Derives from sculpture but also signifies developing picture elements with different tonalities. This creates an impression of spatial depth in a picture and makes elements look more three-dimensional.

Modelling paste: Light-coloured acrylic paste with added fillers which can be worked with a spatula.

Modifiers: Special additives that alter the properties of paints.

Mounting board: Acid-free card about 1.5mm thick available in different colours.

Oil pastels: Paint crayons made of compressed pigments with added binders (such as oil) which can be smeared out when applied.

Paint box: Case for carrying and storing paints and tools.

Painting ground: Substrate on which one paints, e.g. canvas, paper, cardboard, wood, etc.

Palette: Surface of wood, ceramic, glass or plastic used to mix paints. 'Colour palette' is also used to describe a selection of colours.

Palette knives: Tools for mixing paints and mediums and for applying impasto using a spatula technique.

Perspective: Drawing method for presenting three-dimensional objects on a two-dimensional picture plane.

Photo Realism: Artistic movement in the late 1960s and 1970s. This artistic style is characterised by extreme detailed naturalism which goes as far as *trompe l'oeil* and often makes use of photographs as references.

Pigment: Pulverised, coloured raw material used as a colourant to make paint in conjunction with a binding medium.

***Plein air* painting:** Painting in the open air in the immediate presence of the subject.

Pointillism: Artistic movement in France around 1885 that developed out of Impressionism. Small dots of colours are closely applied so the colours blend in the beholder's eye from a distance and create the impression of spatial depth. One of the best-known exponents of this style is Georges Seurat.

Pop Art: Fashionable artistic movement in the 1960s and 1970s. Pop Art developed independently in the 1950s in America and the UK. Pop Artists look for their subjects in modern urban industrial culture, advertising and comics.

Portrait: An artistic image of a person that depicts their personality.

Primary colours: The three basic colours red, yellow and blue, from which other colours can be mixed.

Priming: Preparation of a painting ground with primer. Porous, unevenly absorbent substrates can absorb subsequent paint layers better with the correct preparation.

Proportion: The relationship between part or parts of a design to each other and to the whole.

Rags: Lint-free, absorbent cloths for removing paint from painting grounds and for wiping paint and water from tools.

Relief: Semi-sculptural, raised areas.

Retarder: *See* Inhibitor.

Scraping: Technique where superfluous wet paint is removed using a card scraper.

Screen printing (serigraphy, silkscreen): A printing process where paint is pressed through a fine, tightly stretched gauze screen. The areas that are not to be printed are covered with a stencil. This process has been widely used in advertising graphics and Pop Art.

Secondary colours: Orange, green and violet. Intermediate hues resulting from mixing a primary hue with an adjacent primary hue.

Serrated spatula: Spatula with a toothed edge.

Siberian chalk: Product made from the ash of burned birch wood. It is sold in a compressed form as a stick and is used for preparatory drawing. Also known as compressed charcoal.

Sketch: Preliminary study of a picture. Proportions, composition and colour values can be developed using sketches.

Spatula: Thin, flexible tool for applying paints and fillers.

Special effect paints: Paints that are available in addition to the usual colours and which contain special effect pigments, such as pearlescent, gold and metallic colours or neon and luminous colours.

Spectrum colours: These arise when light is refracted through a prism resulting in the separation of the colours. A rainbow includes all colours of the spectrum.

Stencil: A stencil enables shapes to be repeated. In stencil technique, shapes are cut out of card, foil, etc. Paint is applied over the stencil on to the painting ground, so the covered parts remain clean.

Still life: Derives from the Dutch word *stilleven*. Genre of painting where inanimate objects are depicted in naturally occurring or deliberate arrangements, such as fruit, dishes or flowers.

Stretcher frame: A wooden frame that can be easily tensioned and is used to stretch linen or cotton canvasses.

Strip palettes: Pad of several pages of transparent paper in a palette shape mounted on a card, from which you can tear off palettes after they have been used.

Student paints: Inexpensive acrylic paints that have been developed especially for practice and study purposes as well as for decorative work.

Studio: A space specially organised for artistic work in which completed works as well as materials, paints and tools are stored.

Studio easel: Wooden frame for setting up and securing pictures. Easels make it possible to work on a picture in a vertical position. Studio easels are very stable. One can work on very large formats using studio easels.

Subject: Object, material or theme of a picture.

Textiles: Cloth or material whose threads are woven vertically and horizontally. The density, surface and material varies.

Texture: Three-dimensional application of modelling paste or paint; characteristics of the surface of objects and painting grounds.

Thickening agent: Medium that makes acrylic paints heavier.

Tonal value: The relative brightness or darkness of a colour. White is the brightest degree and the black the darkest.

Underpainting: Preparatory technique covering the preliminary drawing of a composition and the first indication of light–dark values or colours on the primer. Basic decisions about the design of the picture are taken at this stage of the work.

Varnish: Colourless coating that seals the painting at the finish and protects it from, for example, the rays of the sun, nicotine and other environmental influences.

Wash: Paint that has been strongly thinned with water, which is applied in a thin layer on the painting surface.

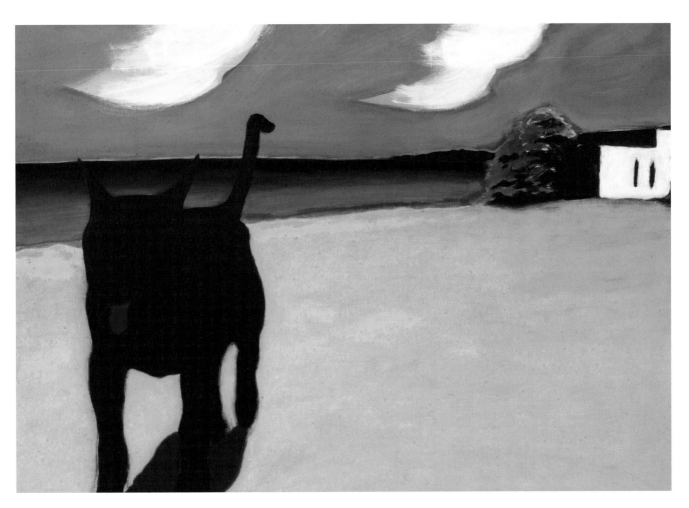

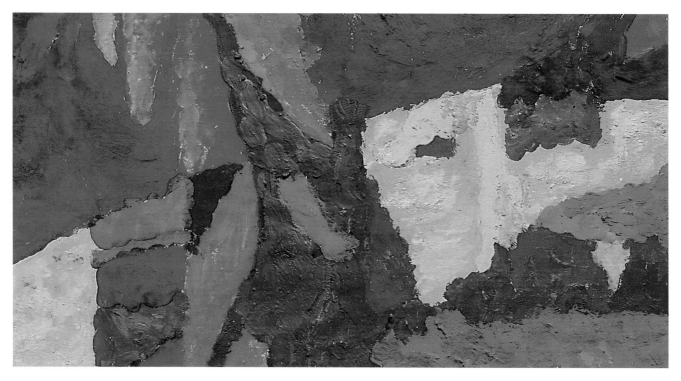

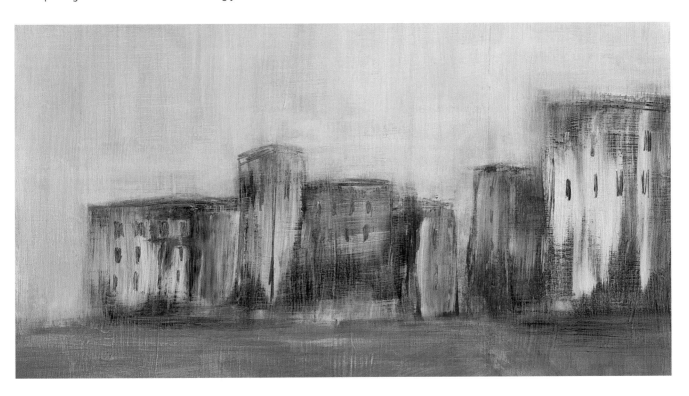

Acknowledgements

Stefan Boekels for the photographs and for the care that he took even when his studio was turned upside down during the production work; Knud Förster, who supported the initial stages with both deeds and advice; Hans-Dieter Franken of Schleicher & Schuell for the information about acrylic painting paper; Ullrich Hollmann of Art Select for the information about special pigments and the Lascaux product range; Olaf Kirschnik of Schmincke & Co. for the detailed explanations on pigments and how to mix one's own acrylic paints; Armin Probst of Goetheschule Einbeck and his pupils for their practical experiments; the paper suppliers Schacht & Westerich for generously making available a wide range of art materials for the photographs; Joachim Jürs for the explanations on the subject of stretching canvasses yourself; the manufacturers appearing in this book for their support, without which this book would not have seen the light of day; all our workshop participants who, with their questions, encouraged us to look at many aspects of acrylic painting; and all the artists who made their works available to us:

URSULA BARLAGE
WULF PETER BESTMANN
HEINKE BÖHNERT
MIRIAM BRÖLLOS
PETRA DAMKE-RÖNSCH
NORBERT DROSSEL
HANNELORE GLIENKE
KAIA
GERHARD KREMPE
REGINE KÖSTER

URTE KÖHNSEN
SABINE LANGE
BETTINA MALINOWSKI
ANDREAS MEYEN
REGINA PORIP
ARMIN PROBST
RÜDIGER STEFFENS
JULIA WEIDLE
SUSANNE WESTPHAL

First published in Great Britain 2011 by Search Press Limited,
Wellwood, North Farm Road, Tunbridge Wells, Kent TN2 3DR

Original edition ©: 2002
World rights reserved by Christophorus Verlag GmbH, Freiburg, Germany
Original German title: Löhr, Oliver; Schaper, Kristina; Zander, Ute: Das Handbuch der Acrylmalerei – Materialien, Techniken, Beispiele und Übungen

English translation by Cicero Translations

English edition edited and typeset by GreenGate Publishing Services

ISBN: 978-1-84448-605-2